Capture Rochester 09™

Presented by

Democrat and Chronicle

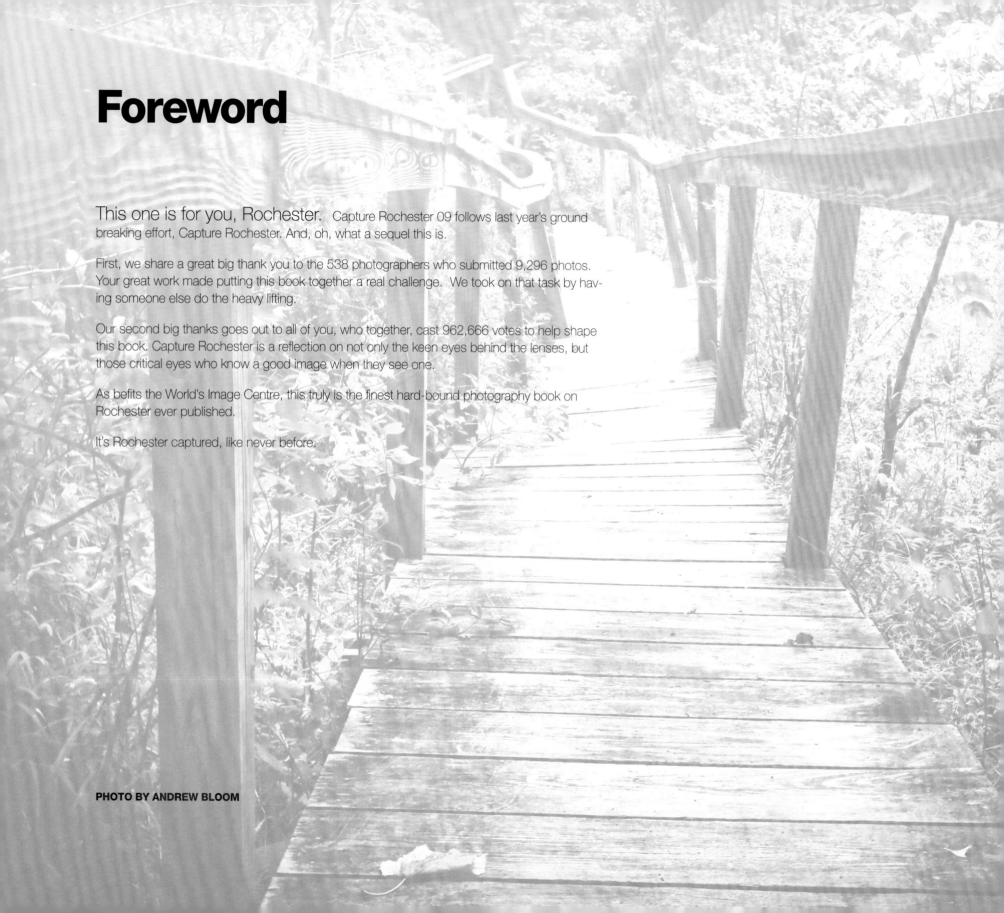

Foreword

This one is for you, Rochester. Capture Rochester 09 follows last year's ground breaking effort, Capture Rochester. And, oh, what a sequel this is.

First, we share a great big thank you to the 538 photographers who submitted 9,296 photos. Your great work made putting this book together a real challenge. We took on that task by having someone else do the heavy lifting.

Our second big thanks goes out to all of you, who together, cast 962,666 votes to help shape this book. Capture Rochester is a reflection on not only the keen eyes behind the lenses, but those critical eyes who know a good image when they see one.

As befits the World's Image Centre, this truly is the finest hard-bound photography book on Rochester ever published.

It's Rochester captured, like never before.

PHOTO BY ANDREW BLOOM

Table of Contents

 FRIENDLY FACES 4

 SPORTS & RECREATION 38

 NEWSWORTHY 118

 EVERYDAY LIFE 16

 SCAPES OF ALL SORTS 66

 ARTS, CULTURE & FOOD 124

 SCHOOLS & INSTITUTIONS 28

 PETS 110

PHOTOGRAPHER DIRECTORY 140
PRIZE WINNERS 143
SPONSORS 144

About this book.

Capture Rochester™ is the most unique book project ever conceived. It started with a simple idea: Lots of folks take lots of pictures of the Rochester area — many of which would be worthy of publishing in a fine-art, coffee-table book. Knowing that thousands of photos would be submitted, the question was posed: How do we pick the best from the rest?

The answer was genius. We put the editing power in the hands of the people. Local people. People that know the Rochester area. People just like you. We asked photographers, doctors, union workers, musicians, moms, right-handed people, pants-wearing folks, or anyone from any walk of life to vote for what they considered to be the photos that best capture the Rochester area.

From nearly 10,000 photo submissions to the pages of this book, almost 1,000,000 votes helped shape what you hold in your hands. It's something that's never been done before: publishing by vote. Enjoy it.

How to use this book.

Open. Look at the best pictures you've ever seen. Repeat. Actually, maybe there's a little more to it. First, be sure to check out the prize winners in the back of the book (also marked with ★ throughout). You'll also want to watch the DVD. It's got more than a thousand photos on it! Here's the caption style so you can be sure to understand what's going on in each photo:

PHOTO TITLE *(position on page)*
Location photo taken, if available
Caption, mostly verbatim as submitted. 📷 **PHOTOGRAPHER**

Copyright info.

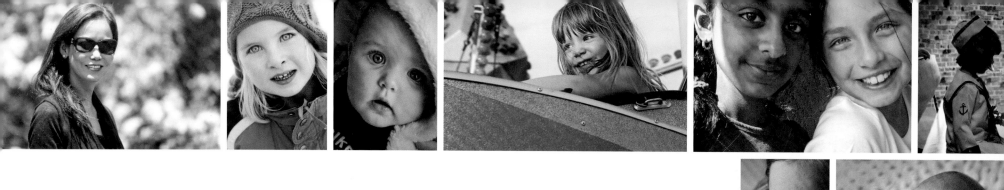

Friendly Faces

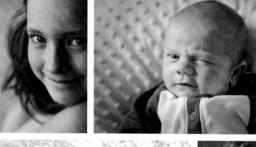

 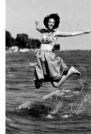 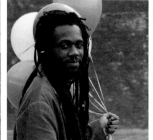 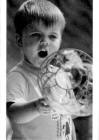 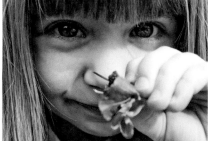 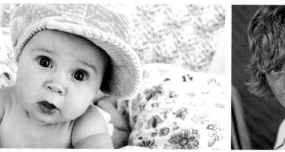

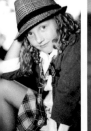 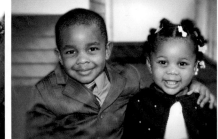 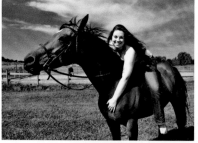 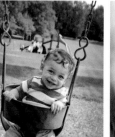 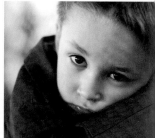

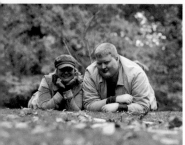 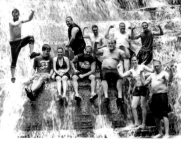 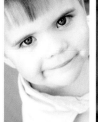 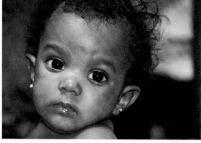 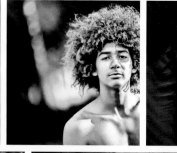

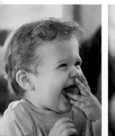 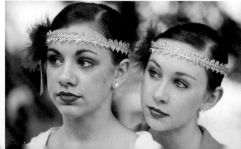 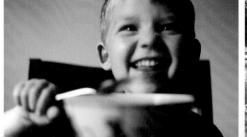 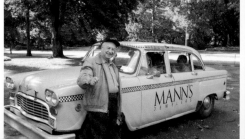 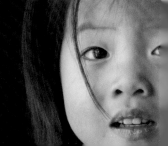

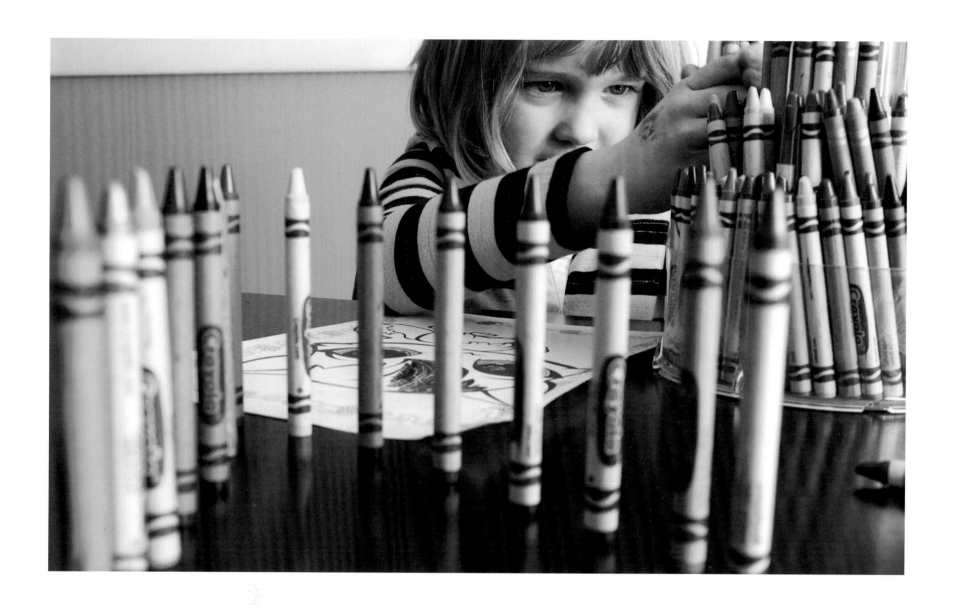

★ **GRABBING COLORS** *(above)*
Ontario, NY
Sarah and I love to crayon together. We each tear a page out of one
of her favorite coloring books and then present them to each other
as gifts when we are finished. She usually does a better job than I do
staying within the lines! 📷 **JOEL PAIGE**

5

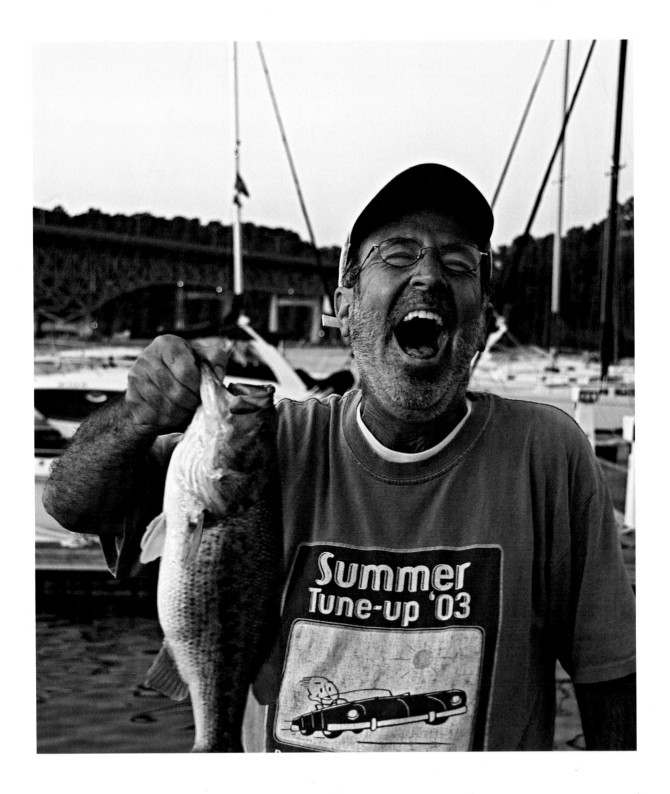

"We were chatting about the Capture Rochester photo contest and the Buffalo Bills football team. It was kind of quiet and I think the guy wanted to fish the last of the light before sundown, so I said "take care" and off I went. Nice guy, I thought to myself, I hope he has some luck. The next thing I know, there's a commotion and I hear someone yelling "here's your picture!" Sure enough! Nice capture!

— AARON WINTERS/SANDY AND THE FISH

SANDY AND THE FISH *(right)*
Irondequoit Bay
Where else can you have so much fun with a fish? Only at the Newport House and Marina on Irondequoit Bay. 📷 **AARON WINTERS**

WAITING STINKS *(opposite left)*
The Garden Factory, Rochester
A simple request to wait patiently until mommy returned before we continued with the fun and games was made, and met with this expression. The photo was taken at The Garden Factory's annual holiday season festivities. There is so much to do and see, and the patience of a 4 year old spans only a handful of seconds it seems. 📷 Rob Hickey

TYTAN'S SUMMER LOVE *(opposite top)*
Victor
Tytan enjoying every drooly moment of his summer day. 📷 Jennifer Forrester

MAX'S NEW SHOES *(opposite bottom)*
West Irondequoit
Max tying up his new shoes! 📷 **JEFF GEREW**

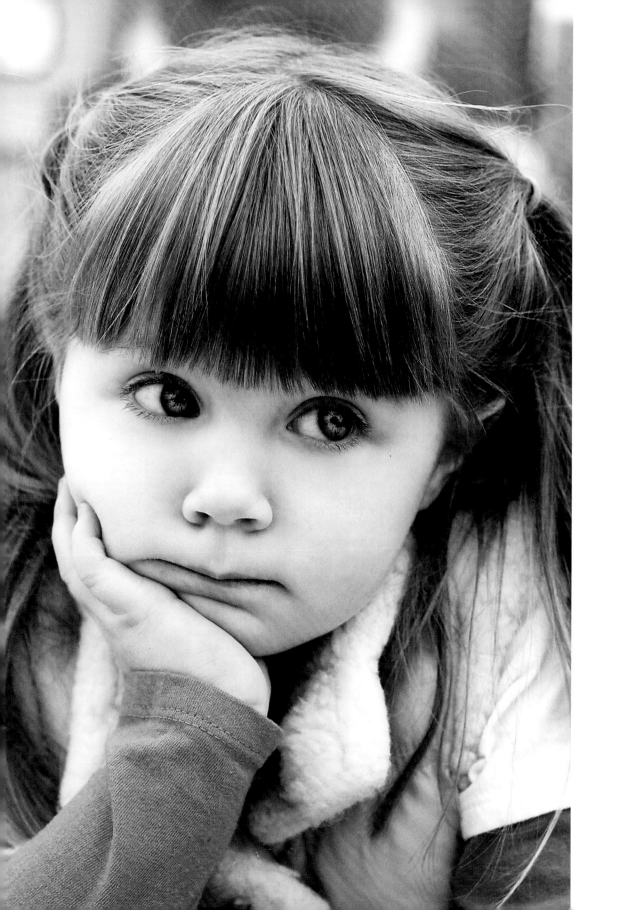
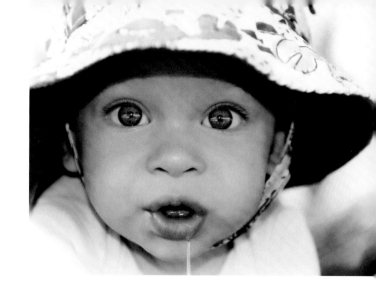
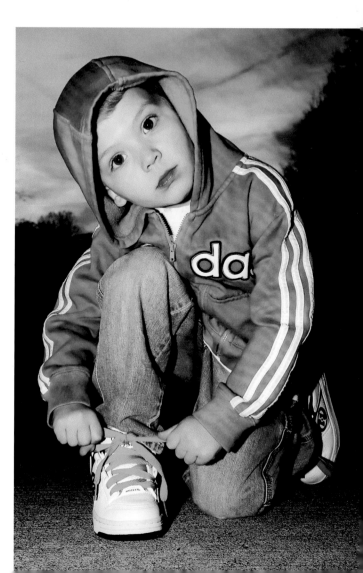

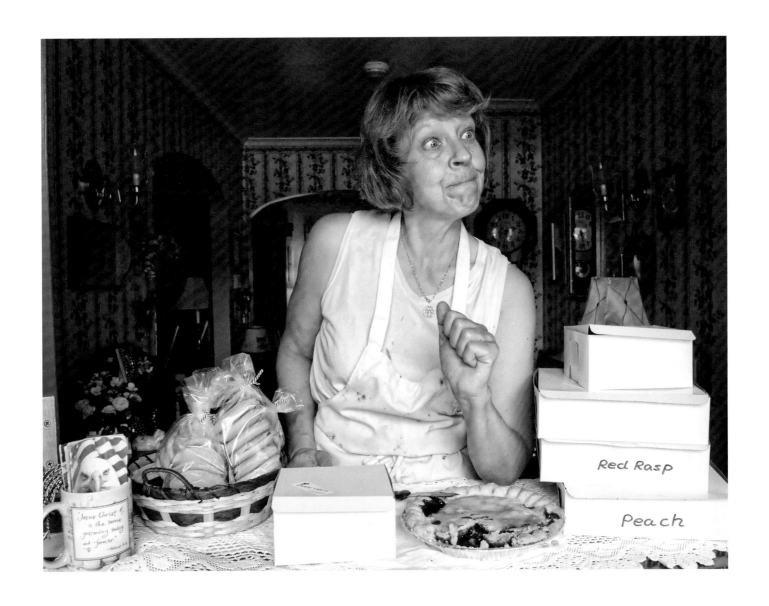

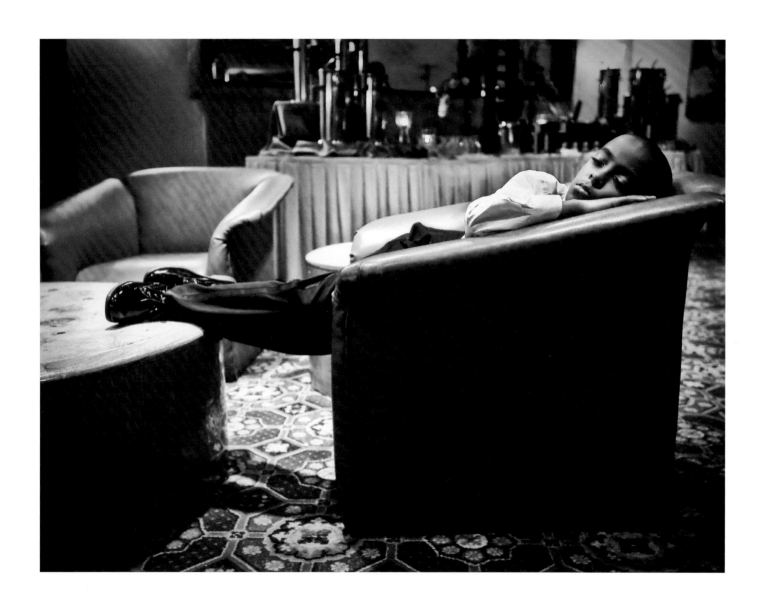

CINDY BAKES
GRAPE PIES! *(previous left)*
Naples
During the fall harvest season in 1965, Al Hodges introduced patrons, at his Redwood Restaurant in Naples, to a new dessert made with sweet-tart Concord grapes. Grape pie was such a sensation that Hodges hired his neighbor, Irene Bouchard, to make pies for the restaurant in her kitchen. More than 300,000 pies later, this unassuming village at the southern tip of Canandaigua Lake has earned its reputation as the world's grape pie capital. I explored Canandaigua Lake, and discovered Cindy Trzeciak selling pies in her front hallway in downtown Naples. I tasted her grape pie on the spot, and was an easy sale! I bought a peach pie too. Both were delicious!
📷 **MARTIN PINKER**

THE SLEEPER *(previous right)*
Eat, dance and out for the count.
📷 **ELIUD RODRIGUEZ**

LOCAL COMEDIAN
JB BROWN *(right)*
Liberty Pole
Comedian JB Brown imitates Ray Charles.
📷 **RICH PAPROCKI**

JULIA O *(opposite)*
I loved taking Julia's picture! She was a dream in front of the camera. Those eyes were the best! 📷 **DEEDEE DIMARCO**

10

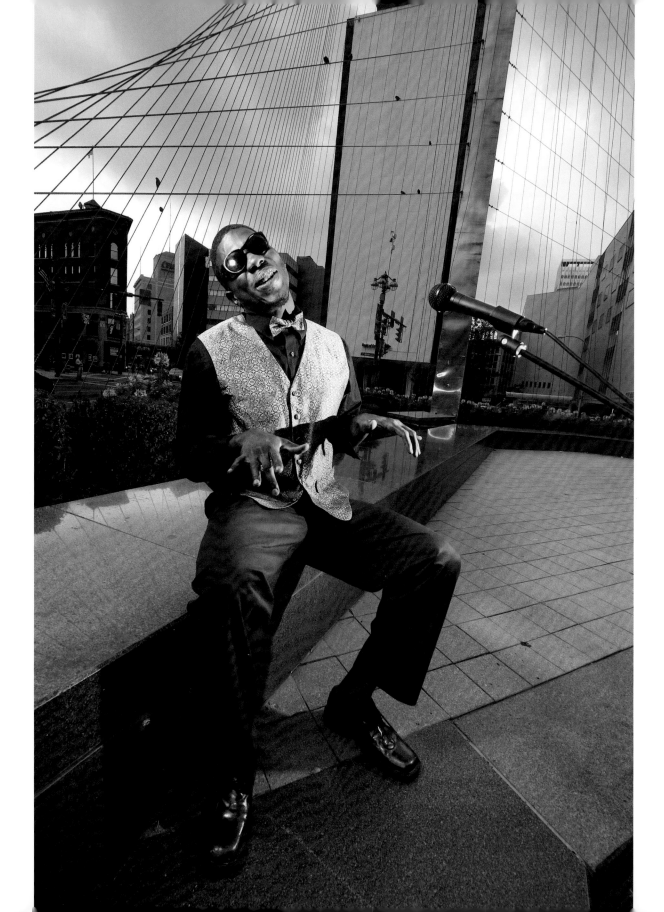

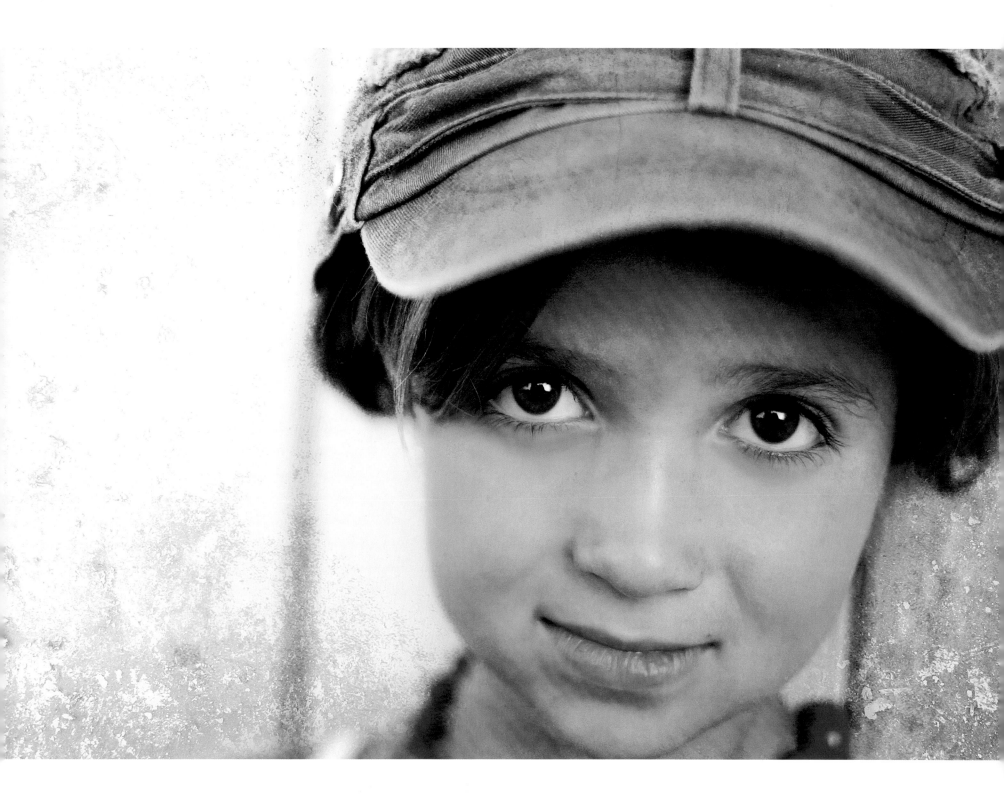

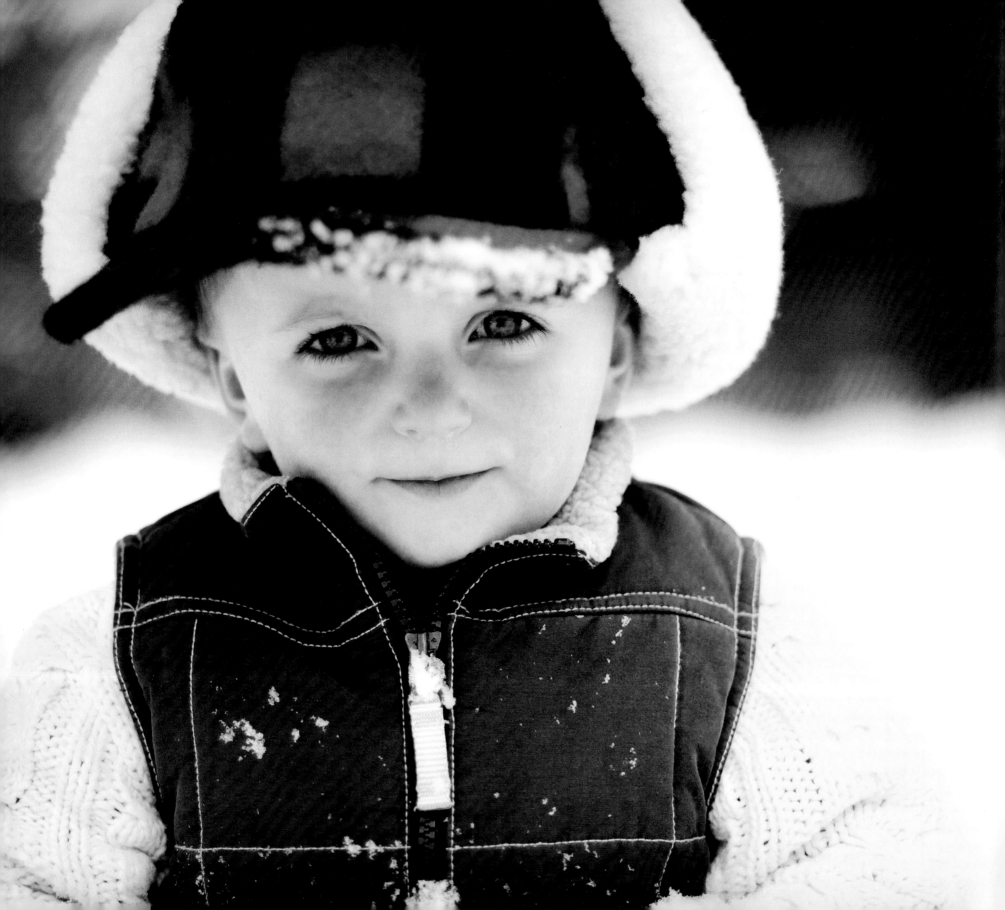

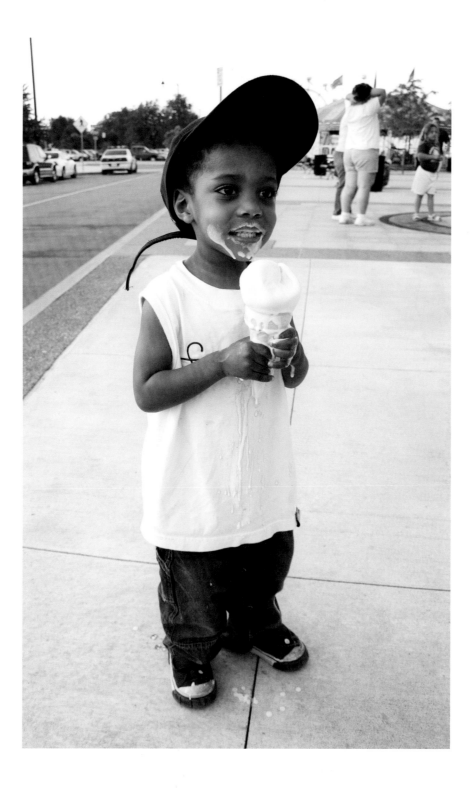

ENJOY LIFE *(left)*
Charlotte Beach
Steven Simmons enjoying an ice cream at the beach. 📷 **ANTHONY SIMMONS**

★ **WILLIAM** *(far left)*
I think my finger about stuck to the camera it was so cold this day. 📷 **DEEDEE DIMARCO**

WHAT'S UP MOMMA? *(following left)*
Irondequoit
My son, Matt, is a comedian in Chicago. He needed me to take some shots of him laying in the Grass for a Lawn Show here in Rochester. This is one of the comedic results of that shoot. 📷 Sherry Griffo

A BOY AND HIS BIKE *(following right)*
Happy with his new ride. 📷 **ELIUD RODRIGUEZ**

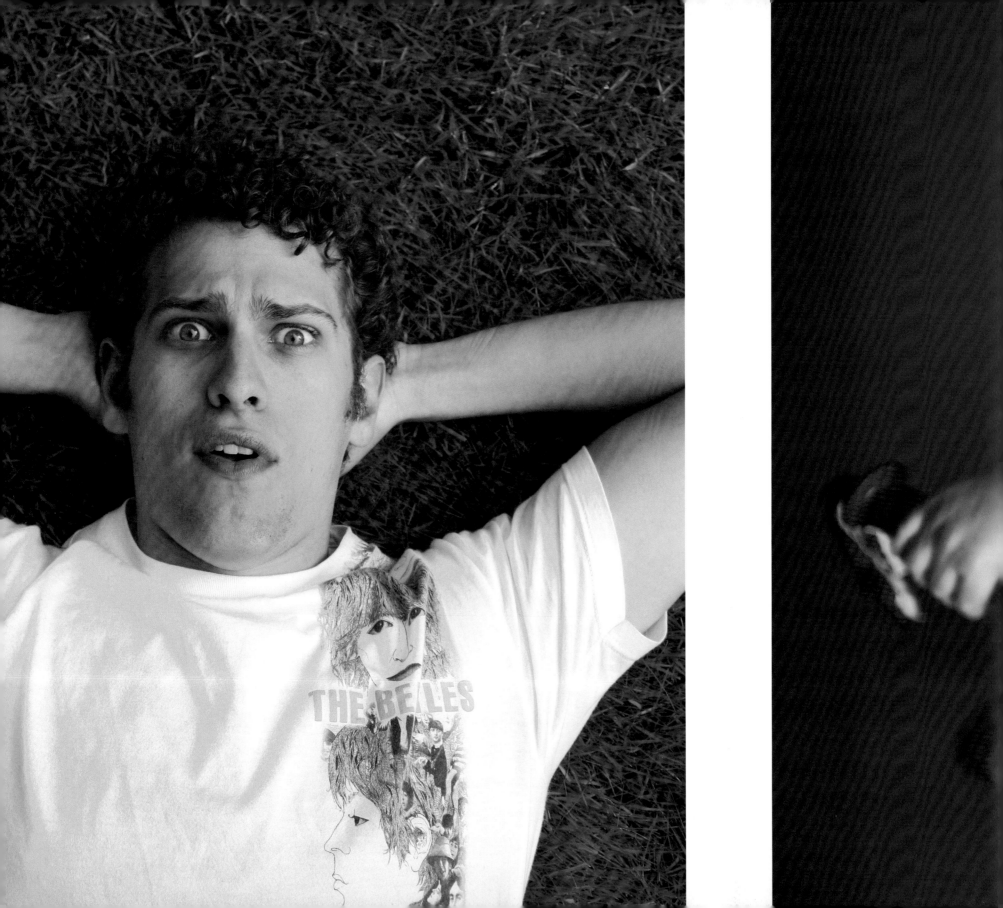

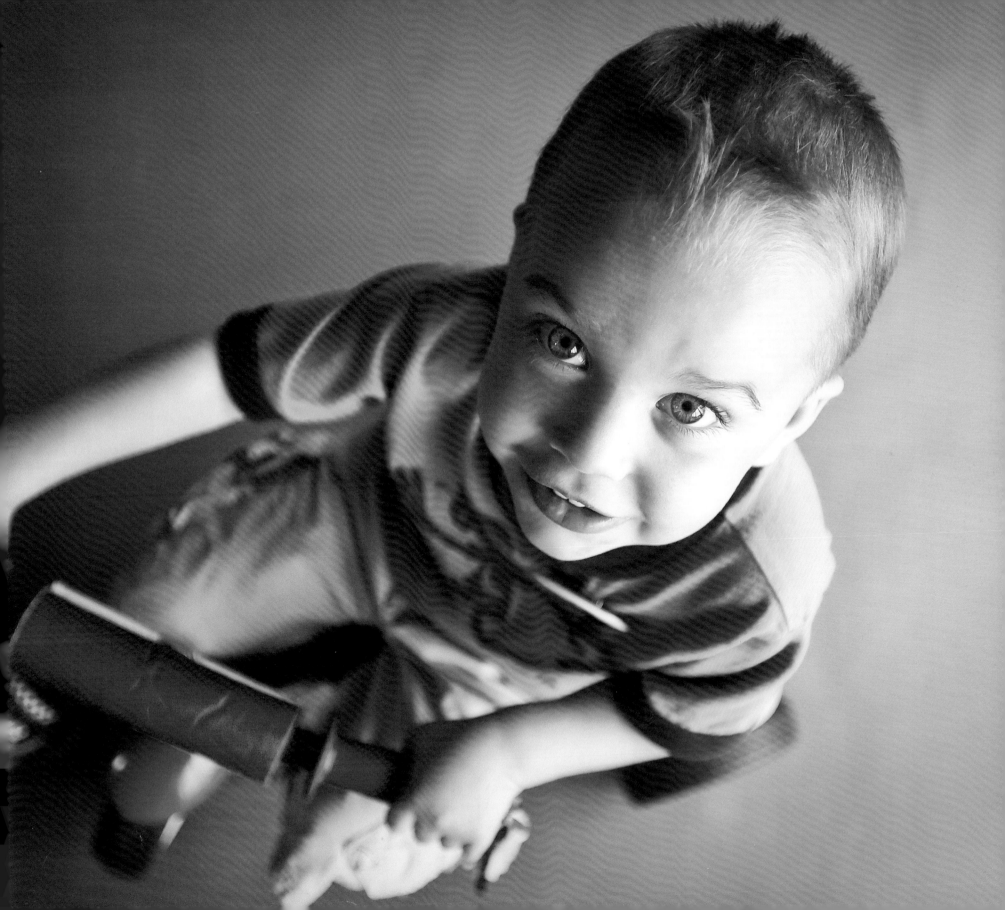

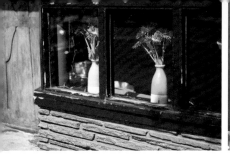
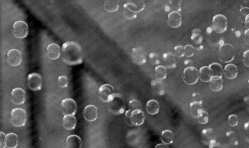

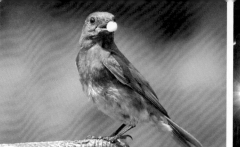
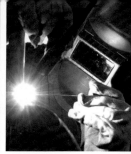

Everyday Life

SPONSORED BY ROWE PHOTO AUDIO & VIDEO

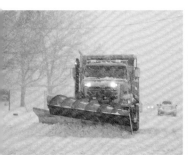
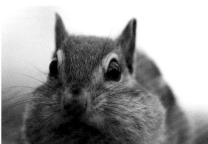
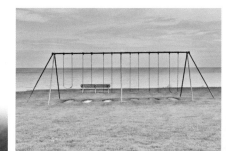
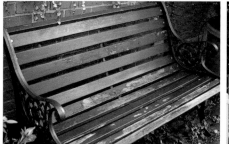
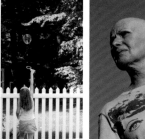

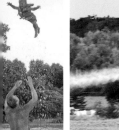
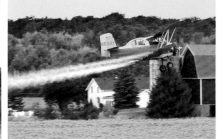
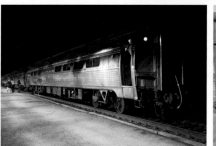
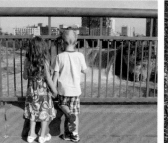

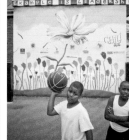

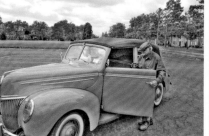
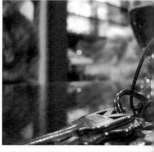

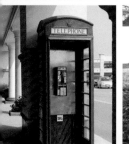
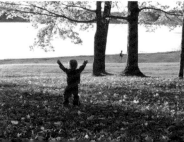
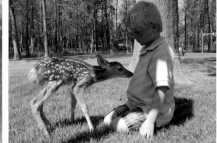

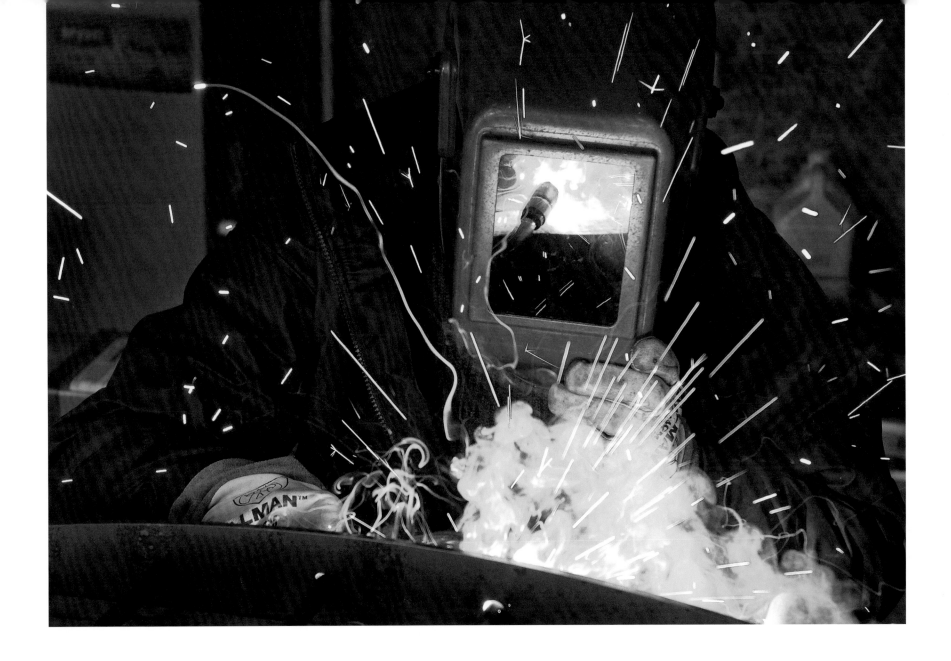

WORKING (above)
Rochester
Sparks fly at the initial contact of this gas metal arc welder
(GMAW). This is now the most common industrial welding process.
📷 **MATTHIAS BOETTRICH**

CAPTURING WATERFALLS (following left)
Holley
Rochester native Matt Conheady explores upstate New York waterfalls
for his nature photography Web site. 📷 Matthew Conheady

FRIENDS FOR LIFE (following right)
Lake Ontario
Brother and sister journey down to Lake
Ontario to build their own world out of sand.
📷 **PATRICK CASTANIA**

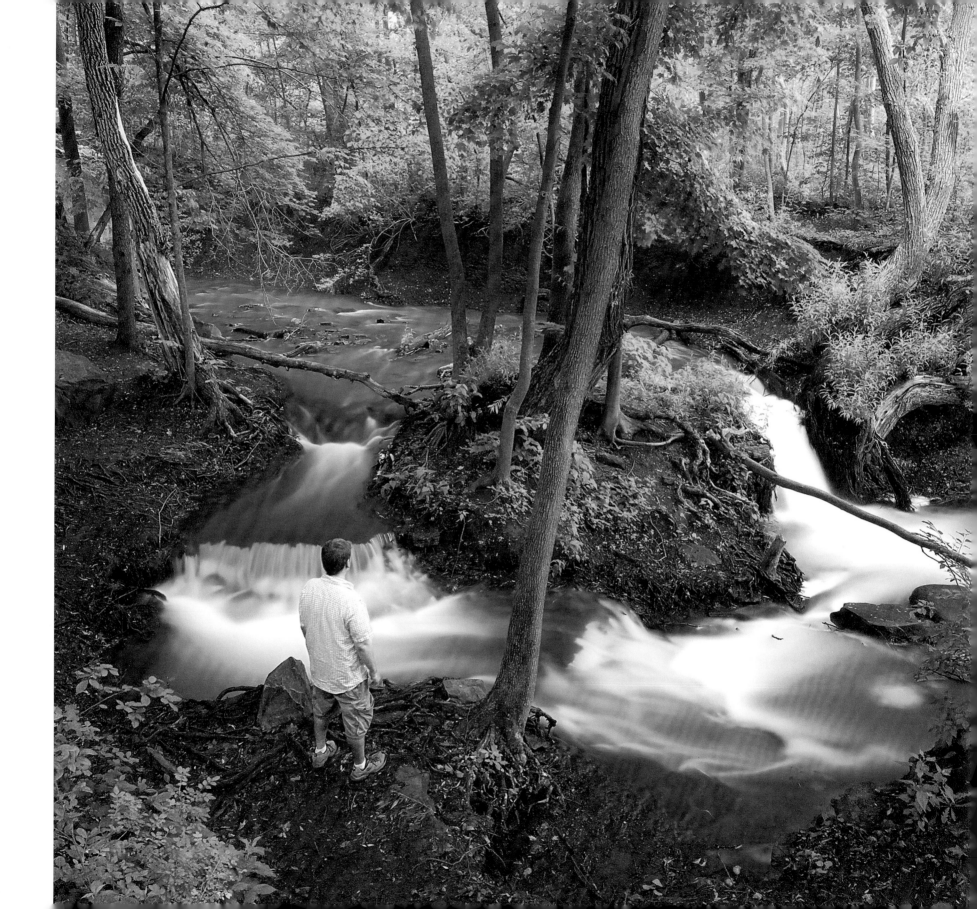

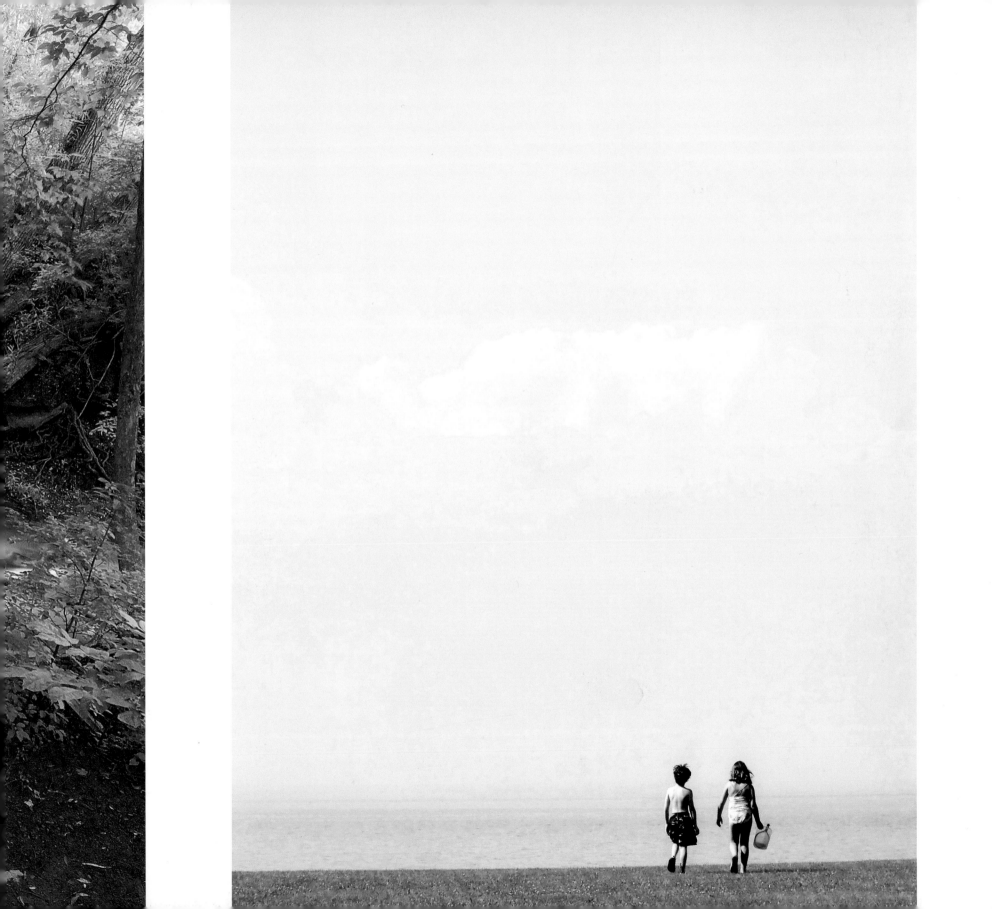

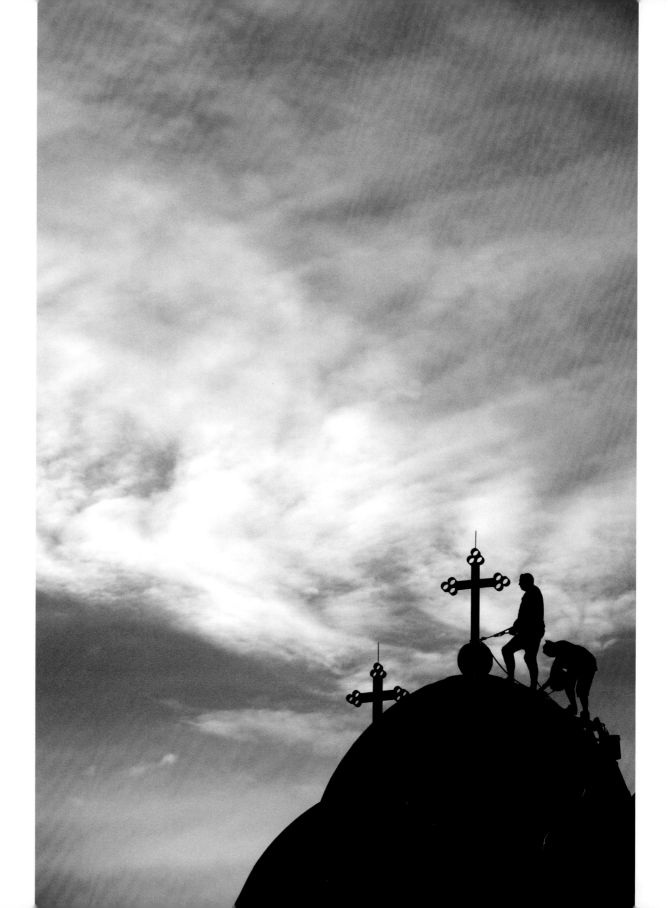

★ **HOLY PAINTERS** *(right)*
Irondequoit
Painters tend to the crosses atop St. Josaphat's prior to the annual Ukrainian Festival. 📷 Sean McGinnis Scanlon

JAMMIN' OUT *(opposite left)*
Rochester
Sarah chilling out with my guitar.
📷 **EMMA DIMARCO**

MORNING WALK *(opposite top)*
Ellison Park
A walk in the park with a good friend.
📷 **STEVE LIGUORI**

SPLISH SPLASH! *(opposite bottom)*
Ava and Sarah having fun in the tub with way too many bubbles. 📷 **DEEDEE DIMARCO**

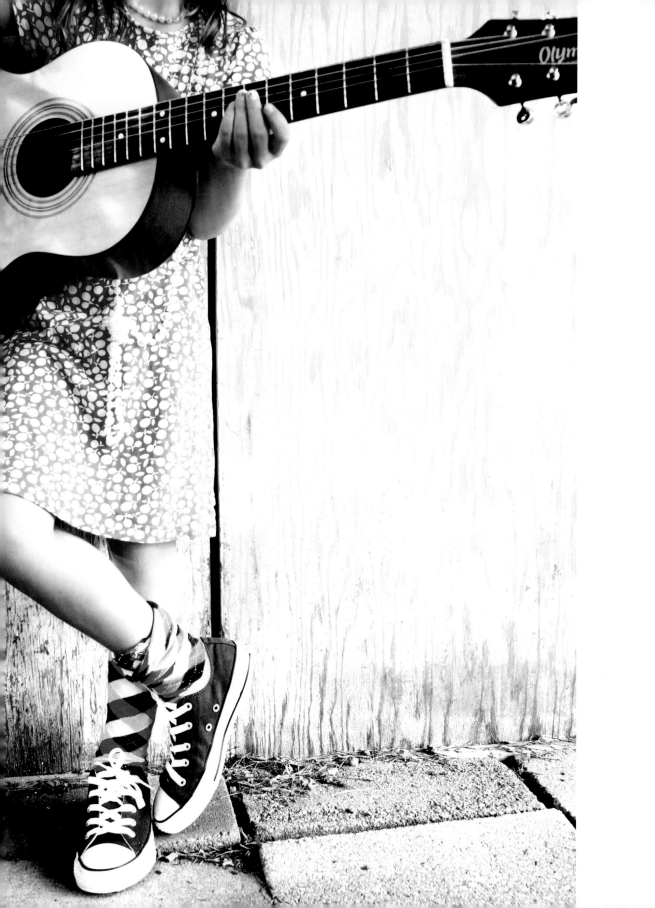
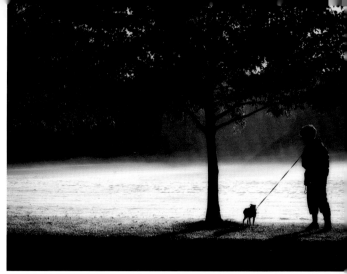
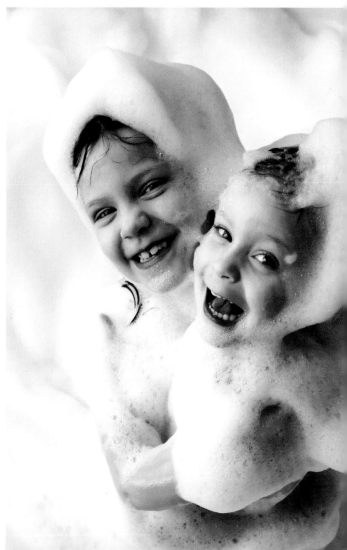

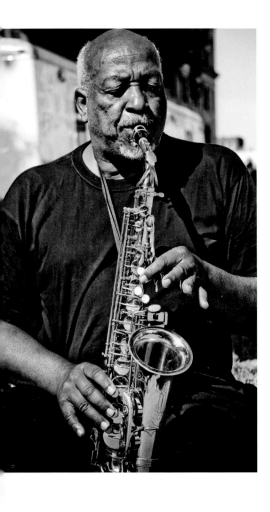

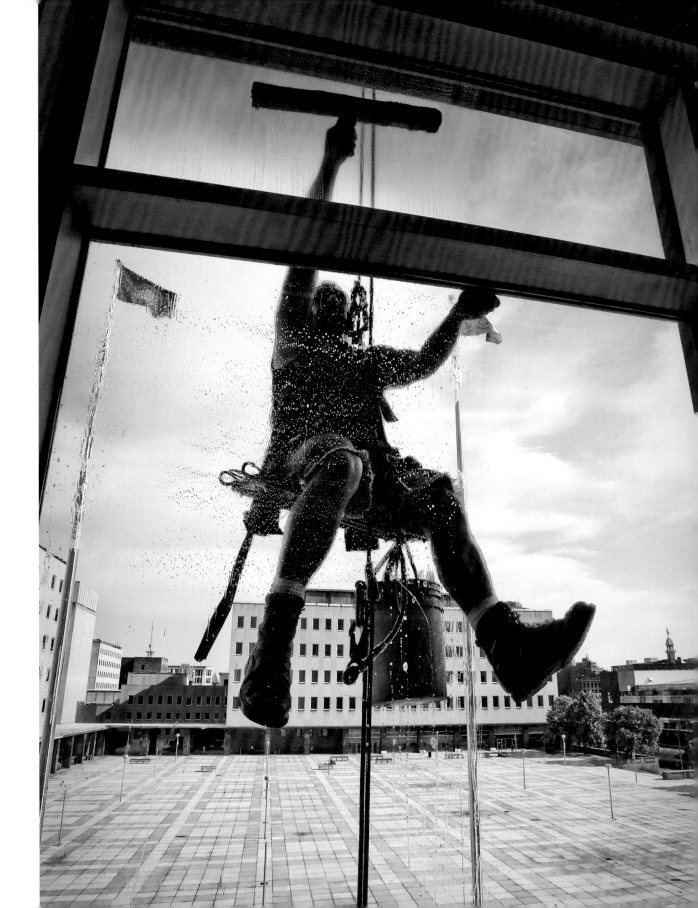

**PLAYING FOR THE
CROWDED BUS STOP** (above)
Downtown Rochester
This saxophone player sounded very sweet.
📷 **ANDREW BLOOM**

THE WINDOW WASHER (right)
Rochester Public Safety Building
All in a days work. 📷 **ELIUD RODRIGUEZ**

**POSING IN FRONT OF
THE LIBERTY POLE** (opposite)
Downtown Rochester 📷 **ANDREW BLOOM**

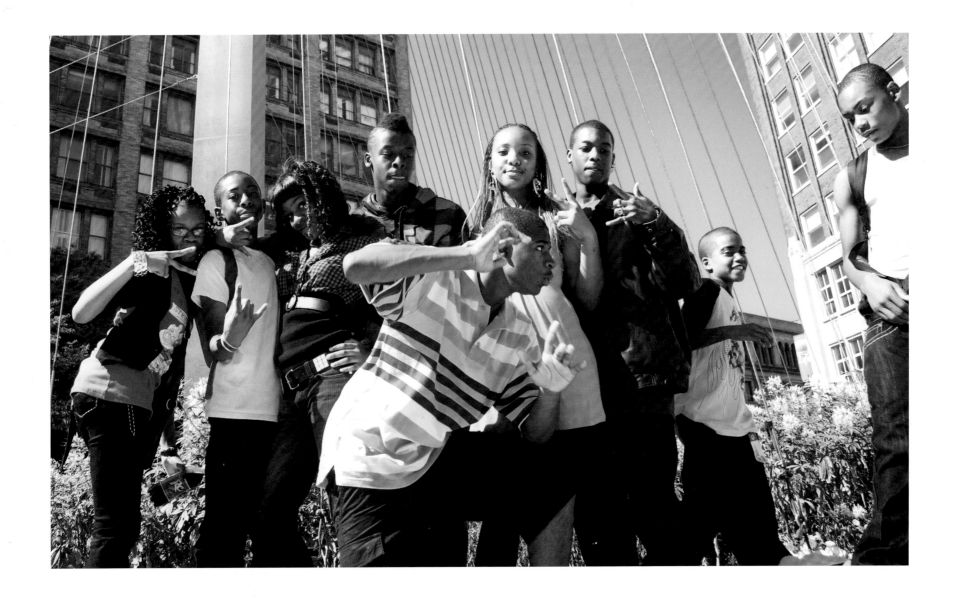

THE SHAKESPEARE AISLE *(following left)*
Webster Public Library
We love the Webster library! I took the kids recently and just managed to capture my son, Connor, before he left the isle. 📷 **KIM PRICE**

MAY I HELP YOU? *(following right)*
Boulder Coffee is a popular spot for a quick cup. The staff is always extra friendly.
📷 **DON MENGES**

"Two kids asked if I was taking pictures. 'Yes,' I said, and before I knew it, they were all climbing on the wall in front of the Liberty Pole to pose for the camera. — **ANDREW BLOOM**

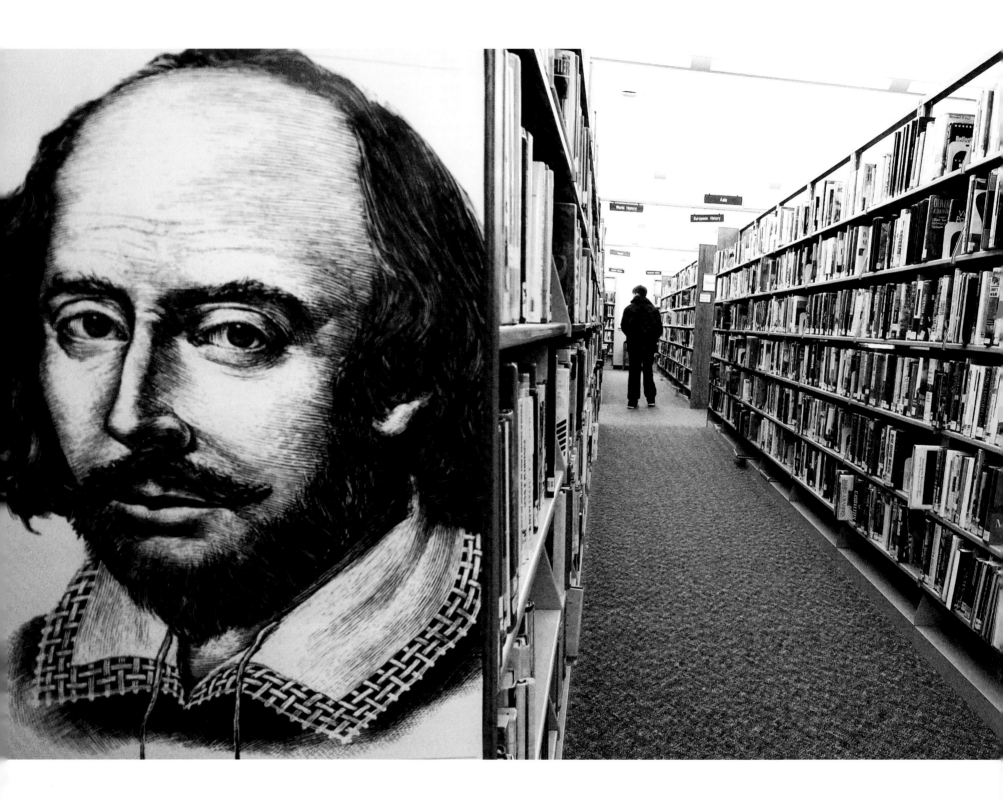

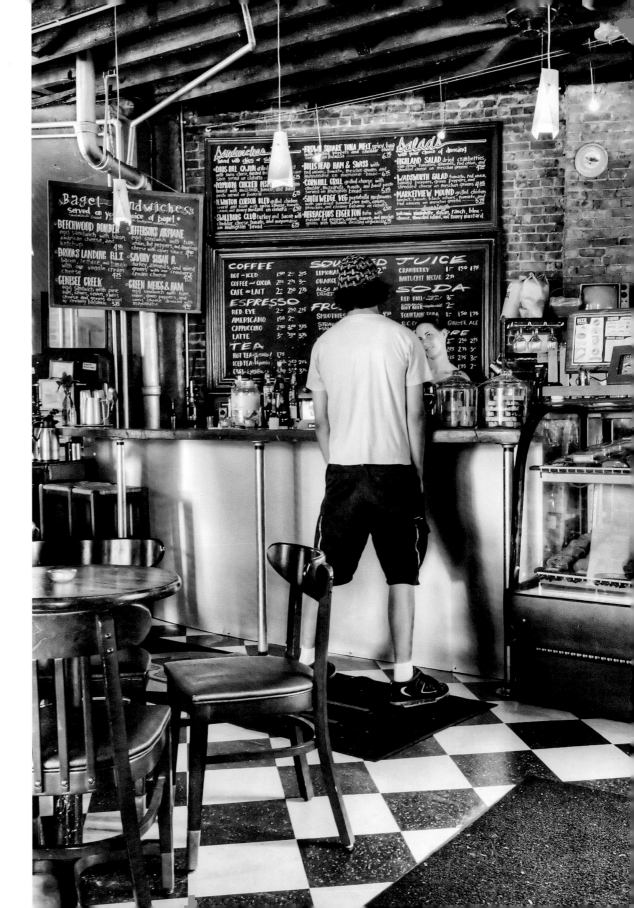

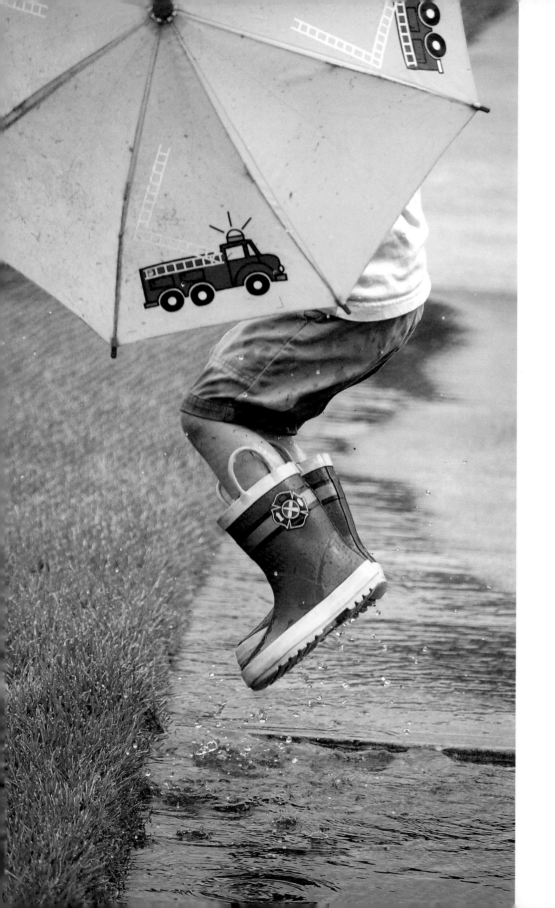
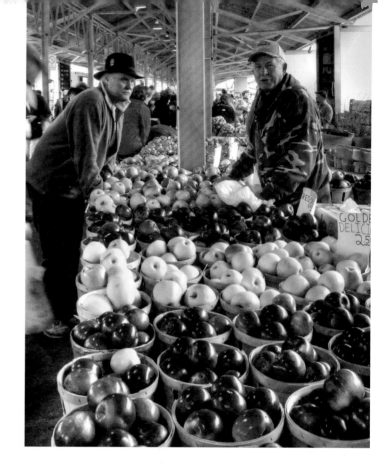
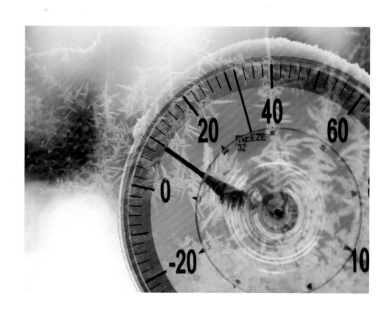

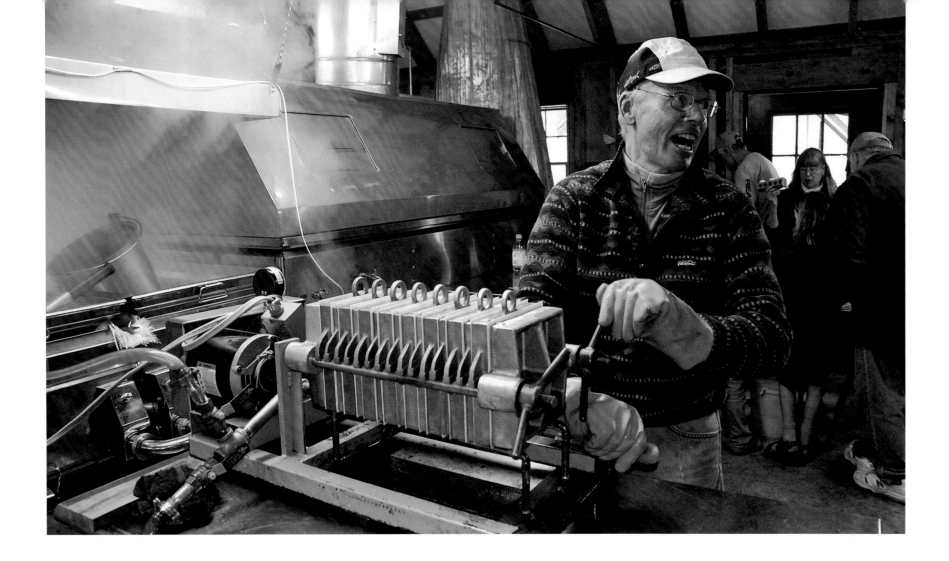

MAPLE SYRUP (above)
Finger Lakes
New York is the second largest maple syrup producing state after Vermont, producing about 325,000 gallons annually. Pictured is a filter bank, the final stage in production.
📷 **MATTHIAS BOETTRICH**

★ **SPLASHING!** (opposite left)
Henrietta
3-year-old Dominic couldn't wait to jump in the puddles after a record rainfall.
📷 Regina Migliorini

AT THE MARKET (opposite top)
There are always opportunities for fun and photos on Saturday mornings at Rochester's Public Market. 📷 **JUDY KNESEL**

IT'S COLD OUTSIDE (opposite bottom)
It was a cold winter in Webster. Just one week later, it was down to zero. 📷 **JUDY KNESEL**

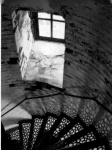
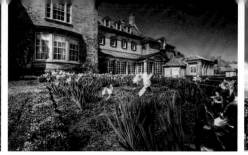
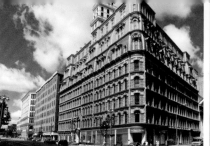

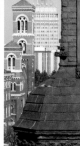

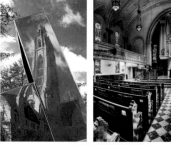

Schools & Institutions

SPONSORED BY ST. JOHN FISHER COLLEGE

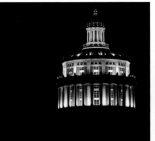
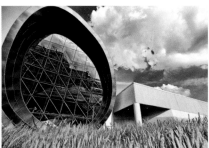
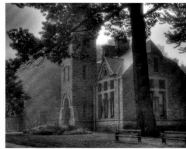
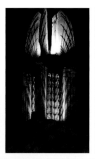

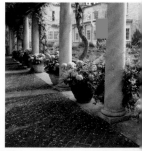

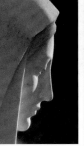
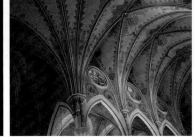
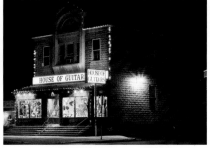
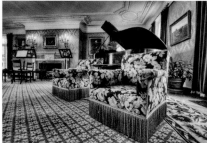
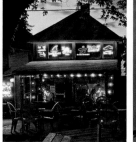
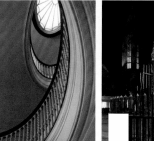

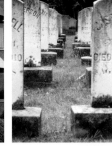
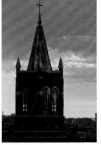

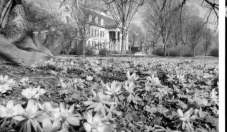

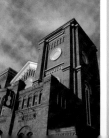
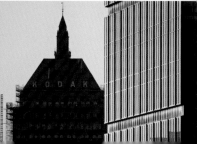

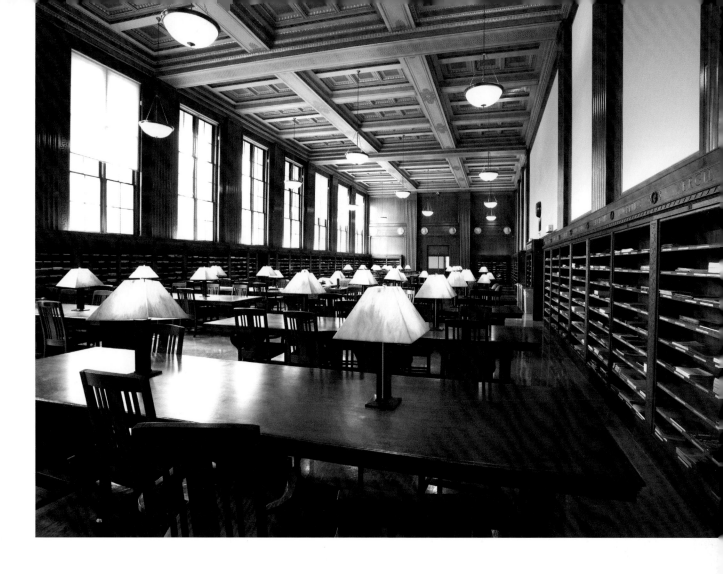

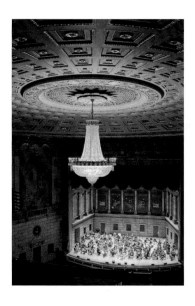

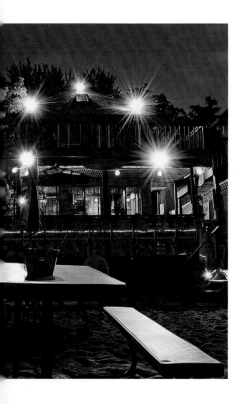

RUSH RHEESE *(above)*
Rush Rhees Library at University of Rochester 📷 **DAVID SELBY**

REHEARSAL *(left top)*
Eastman Theatre
Student rehearsal at the Eastman School of Music, February 2009.
📷 **AARON PEER**

MARGE'S BEACH *(left bottom)*
Rochester
Historical landmark Marge's Lakeside Inn. Photo taken from the beach on Lake Ontario. 📷 **LINSEY RAMPELLO**

★ **COUNTY STAIRS** *(following left)*
The stairway between the second and third floors at the Monroe County Office Building is a popular spot for wedding photographers. The stairs are also spectacular without the people on them! 📷 **DON MENGES**

★ **LINCOLN AND HIS SOLDIER** *(following right)*
Washington Square Park
Abraham Lincoln towers above a soldier at the Soldiers and Sailors Monument in Washington Square Park. 📷 **JEFF HAMSON**

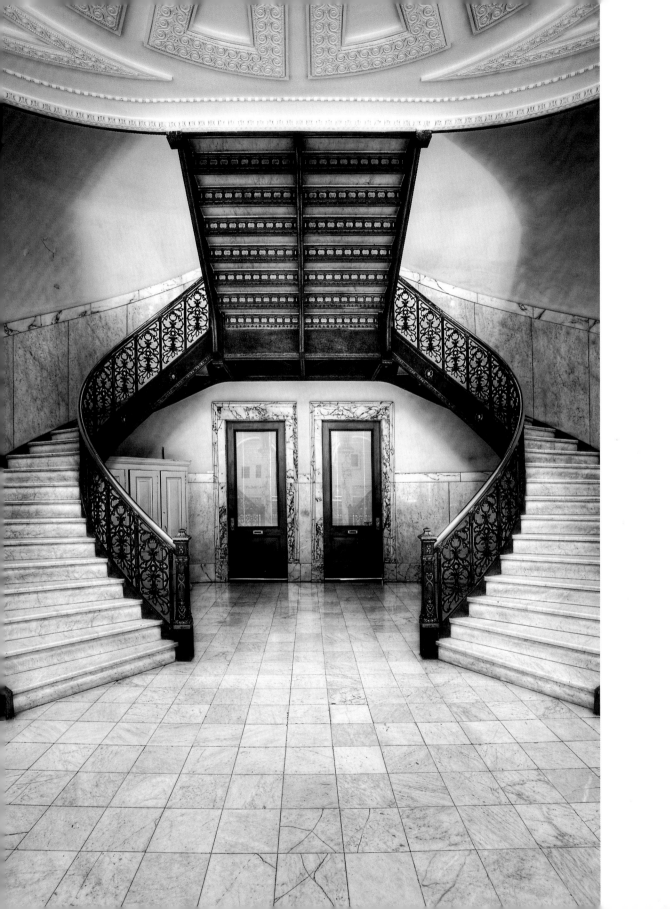

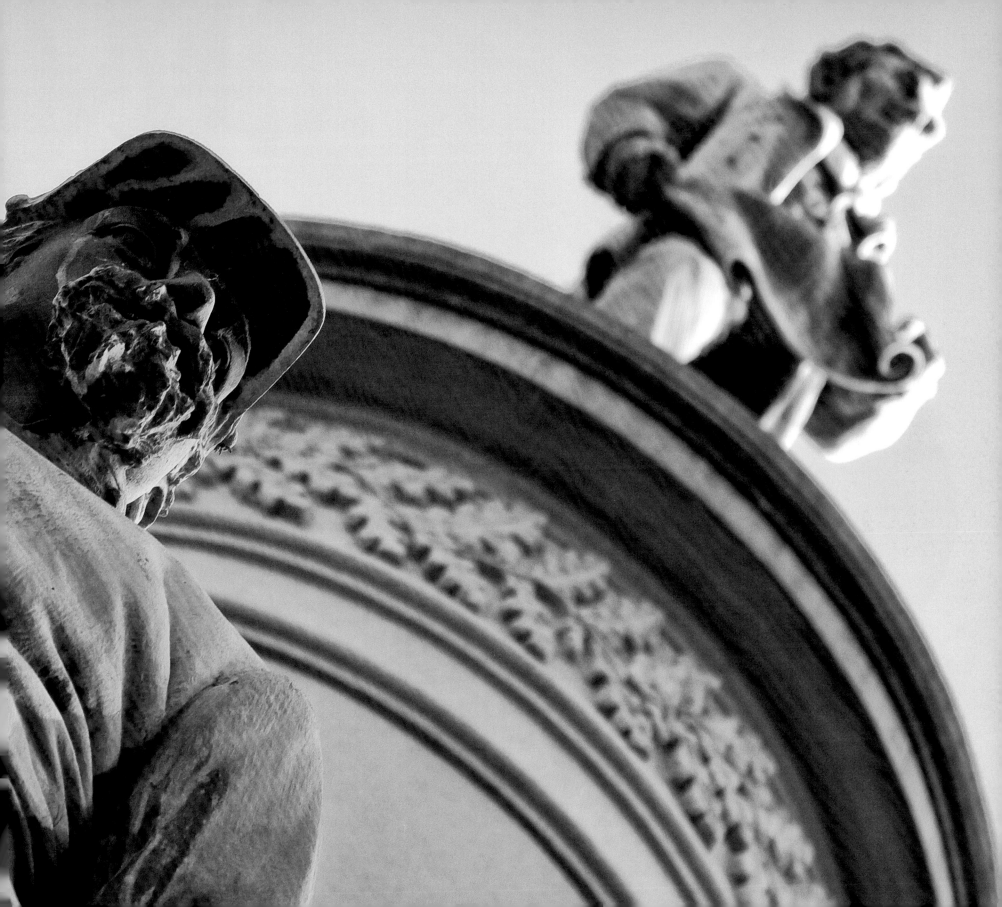

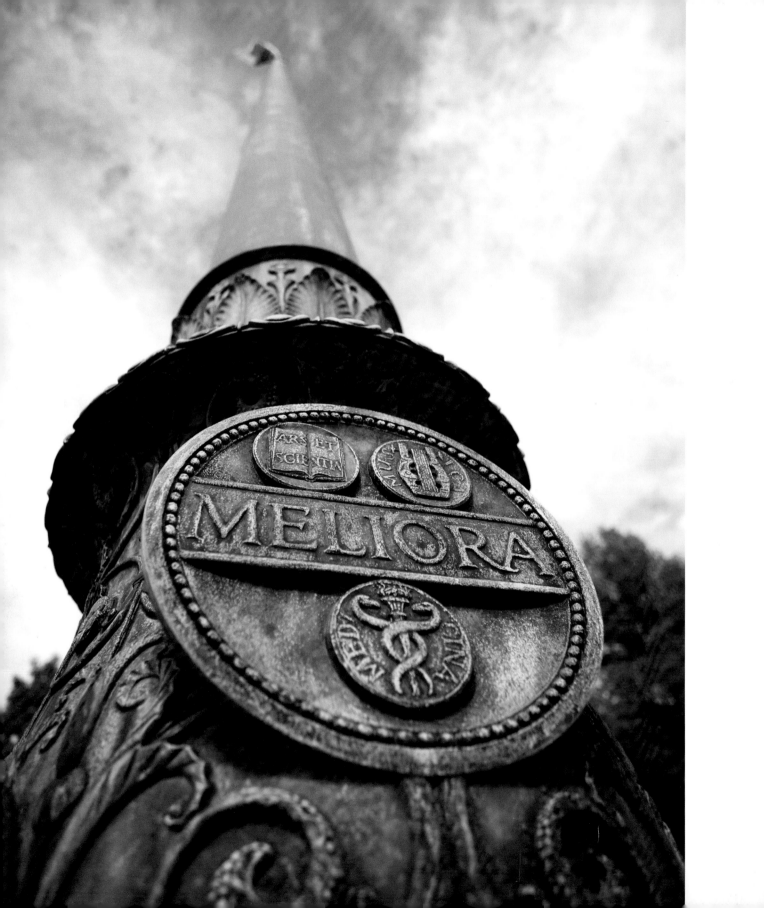

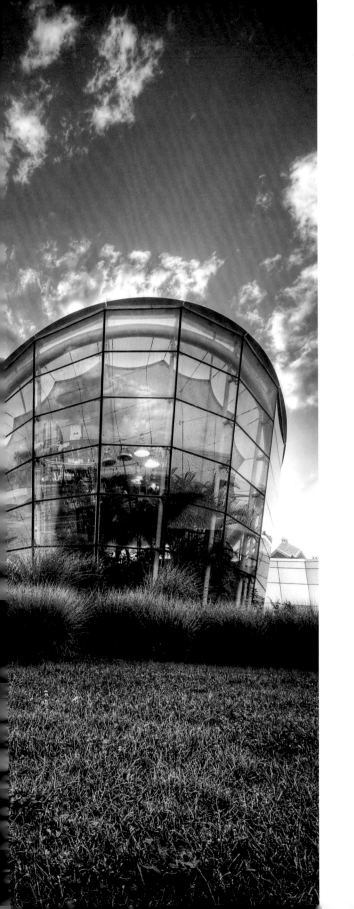
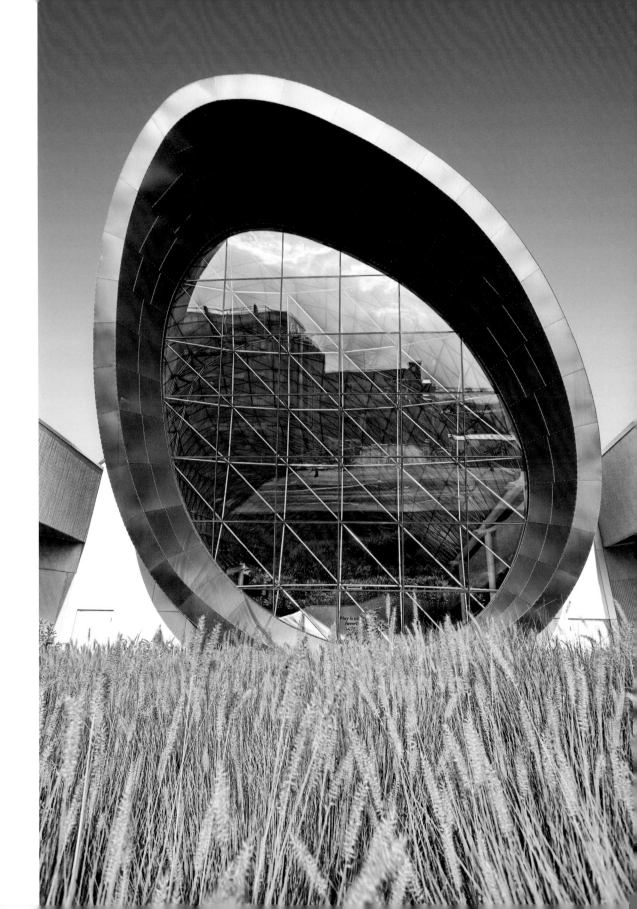

MELIORA *(previous left)*
Meliora at University of Rochester.
📷 DAVID SELBY

THE CATERPILLAR *(previous middle)*
Dubbed "The Caterpillar," this undulating, 3-story-high, 200-foot-long caterpillar-like structure at the Strong National Museum of Play is the first space frame in the world with this amorphous shape. It has the sweeping curved shape of a Frank Gehry-designed structure (Gehry designed the Guggenheim Museum in Bilbao, Spain). The Caterpillar was constructed by Triodetic of Canada, a pioneer in space frame and dome design, whose projects include the John F. Kennedy Library and Museum in Boston, the Las Vegas Convention Center, the Melbourne Sports and Entertainment Centre in Australia, and Toronto
📷 TIM LEVERETT

DANCING WINGS *(previous right)*
I stopped by the Strong National Museum of Play while strolling through downtown Rochester. This part of the museum is called the "Dancing Wings Butterfly Garden," and is the only year-round indoor butterfly garden in upstate New York. 📷 KIM PRICE

I'LL WATCH OVER YOU *(right)*
Mt. Hope Cemetery
The Rochester Area Nature Photography Group met at Mt. Hope Cemetery this winter. I had never been there before and I was amazed by the beauty all around me. 📷 KIM PRICE

EASTMAN GARDENS *(far right)*
George Eastman House
A shot from the stunning George Eastman House, Fall 2009. 📷 KIM PRICE

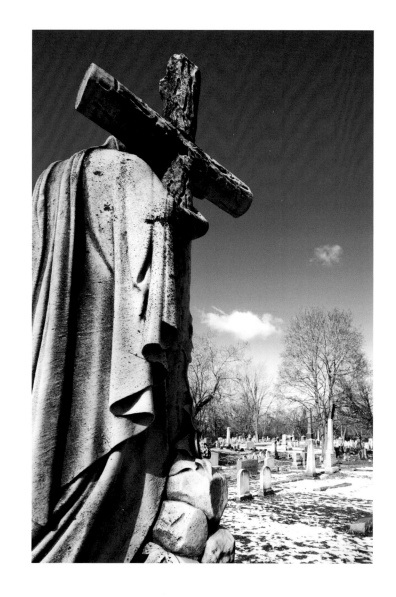

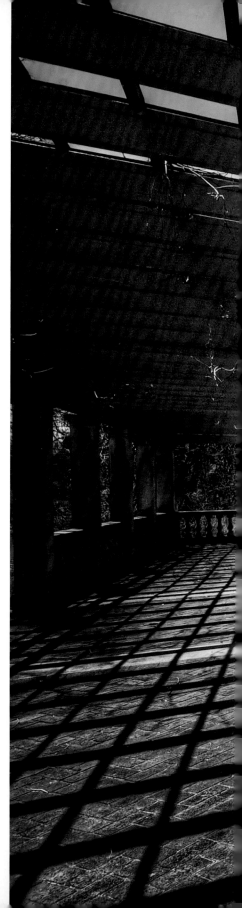

"I've come to realize that this is one of my favorite places to take pictures - I could probably come here every day and find something new to photograph.
— KIM PRICE/EASTMAN GARDENS

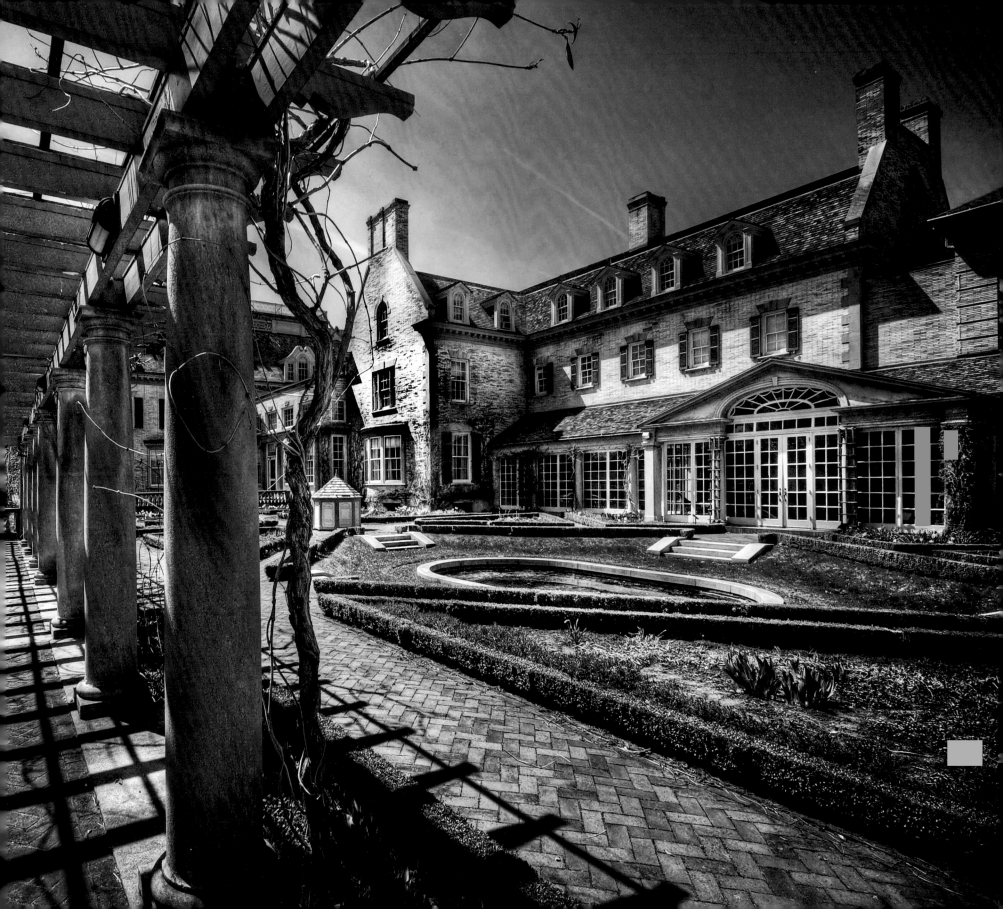

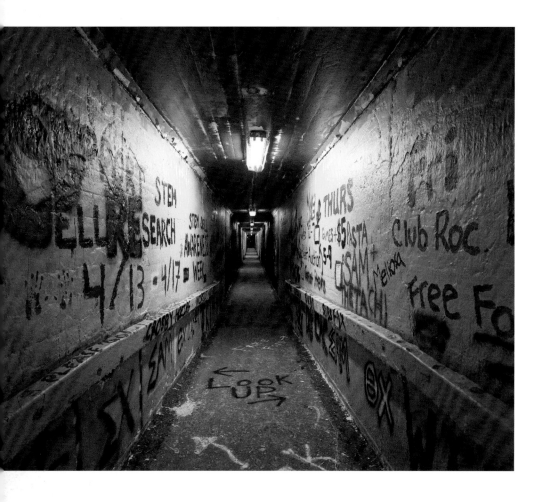

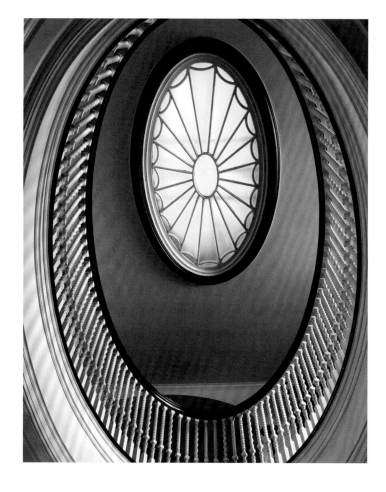

COLOR PORTAL *(above)*
Rochester
A colorful tunnel allows students to run
between dorms at University of Rochester.
📷 Josh Jones

BIG BLUE EYE *(above)*
The spiderweb window at the George Eastman
House. 📷 K HILL

GLOW IN THE DARK *(opposite)*
The Eastman Theatre chandelier is a shining
star in its own right! 📷 **VALERIE WEYAND**

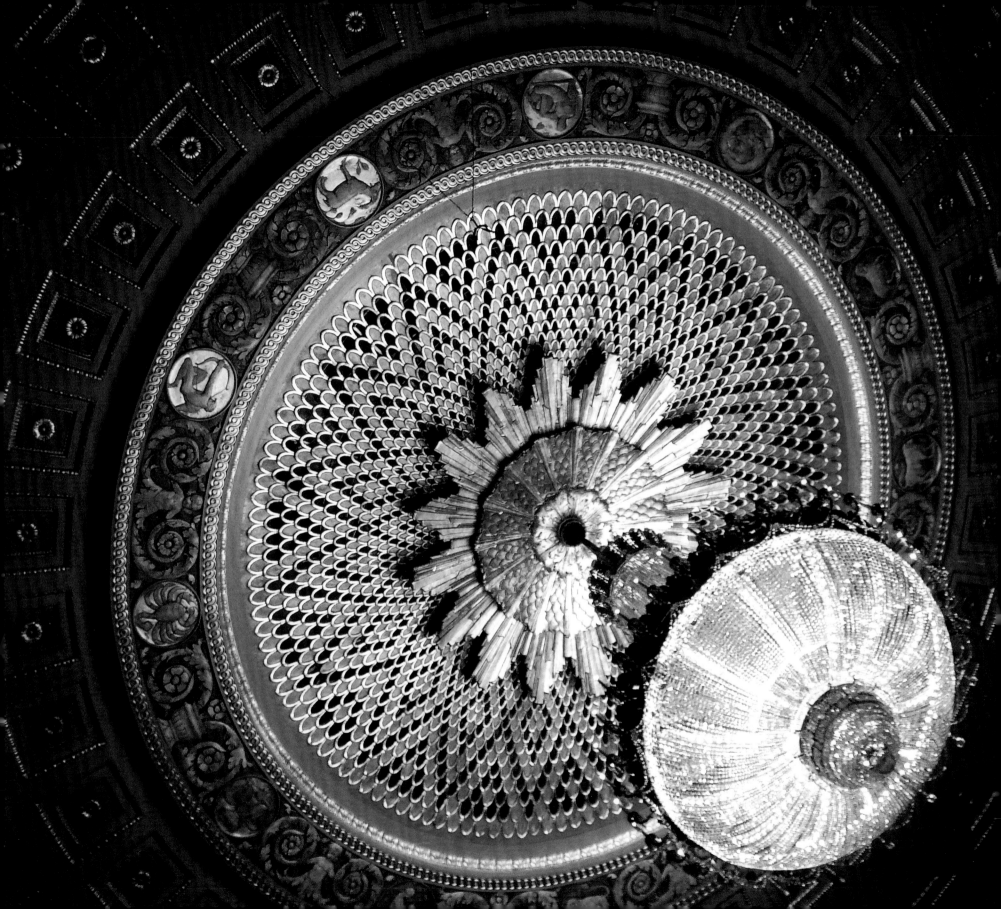

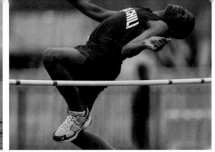
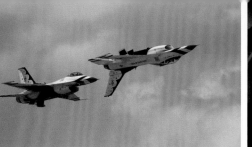

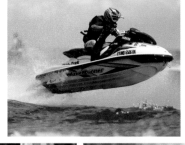

Sports & Recreation

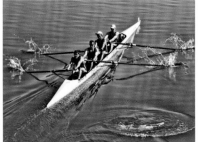
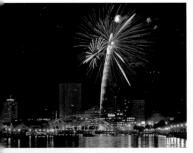
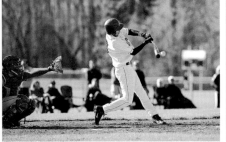

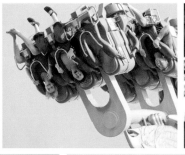
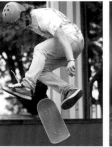
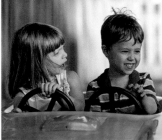

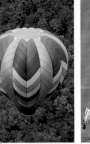
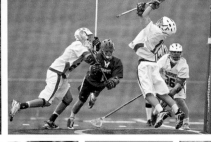
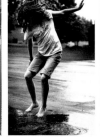
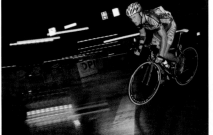
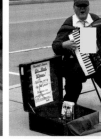
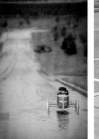

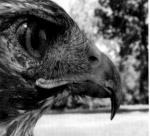
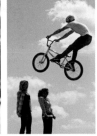
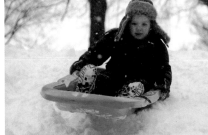
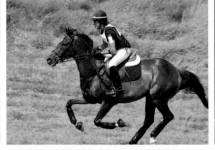
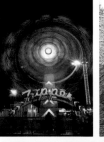
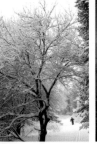
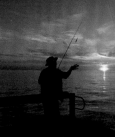

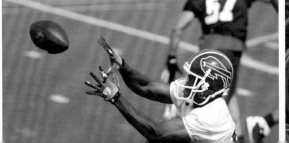

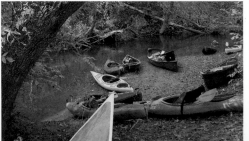
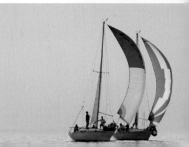

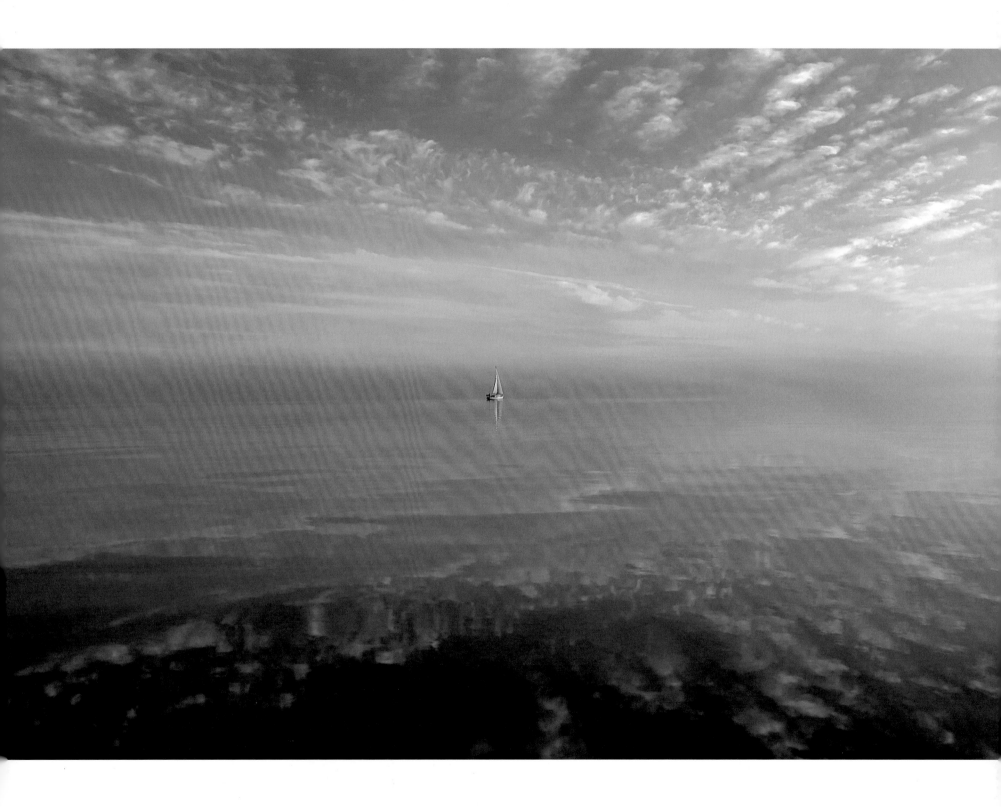

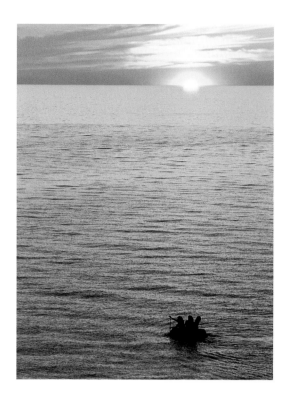

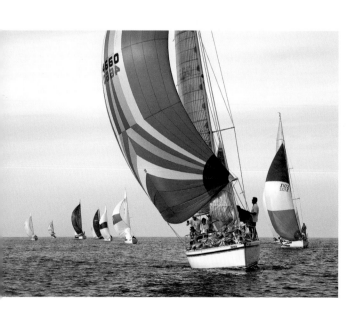

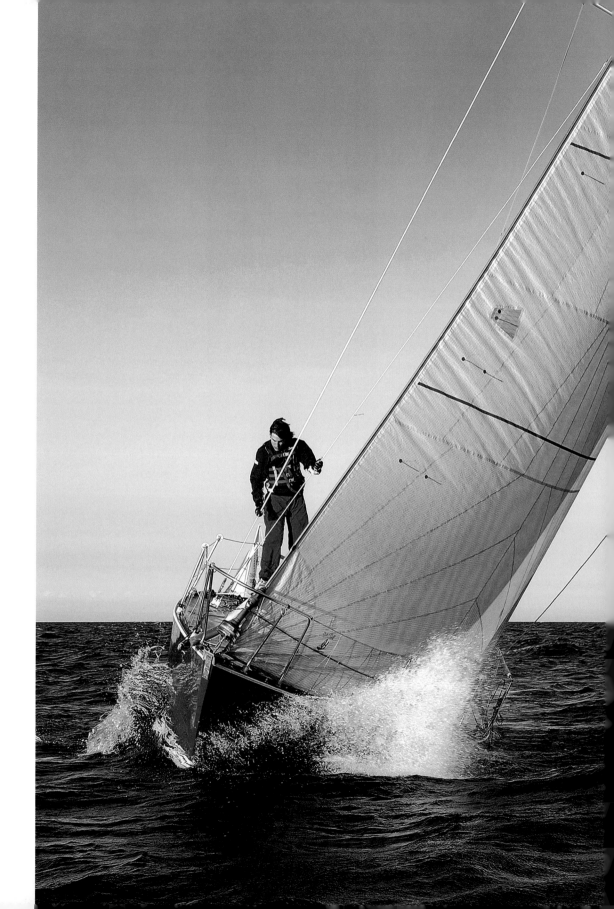

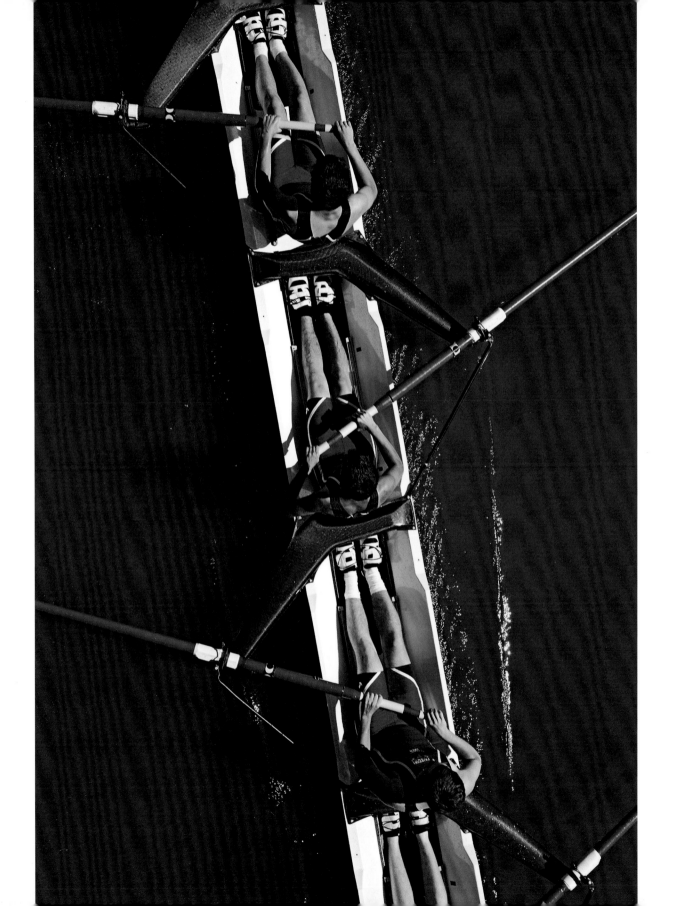

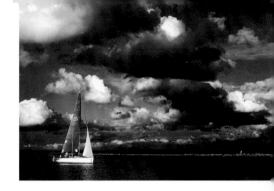

BOATING UNDER A THREATENING SKY (above)
Ontario Beach Park
This lone yacht was coming in to the Port of Rochester when the sun suddenly peeked out and lit it. 📷 **PRAMODH SENEVIRATNE**

WORKING TOGETHER (left)
The Fairport crew going under a bridge in Pittsford. 📷 **CHRISTOPHER COVE**

★ **RACE TO CANADA** (previous)
Dawn breaks in the middle of a calm Lake Ontario. The Scotch Bonnet race is an annual sailboat race from Rochester to Canada and back. 📷 **MATTHIAS BOETTRICH**

DRIFTING TOWARDS THE SUN
(opposite top)
Chimney Bluffs, Lake Ontario
Three kids push their raft towards the sun setting over Lake Ontario. 📷 **BRIAN CONHEADY**

SPINNAKERS UP (opposite bottom)
Lake Ontario
Lake Ontario lights up with color — when spinnakers fly, as the sailboats run with the wind. 📷 **MATTHIAS BOETTRICH**

WIND POWER (opposite right)
Lake Ontario
A crew member checks equipment on the foredeck. The sails are perfectly set and the boat slices through the water with great speed and power. 📷 **MATTHIAS BOETTRICH**

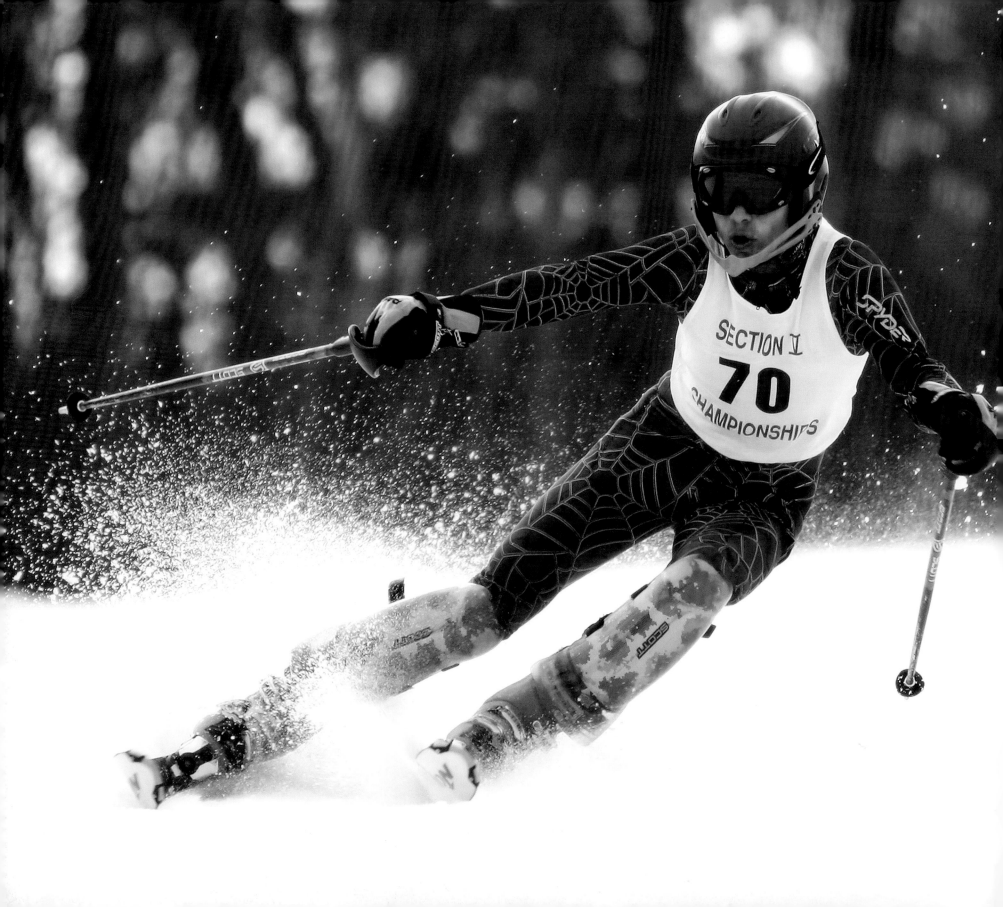

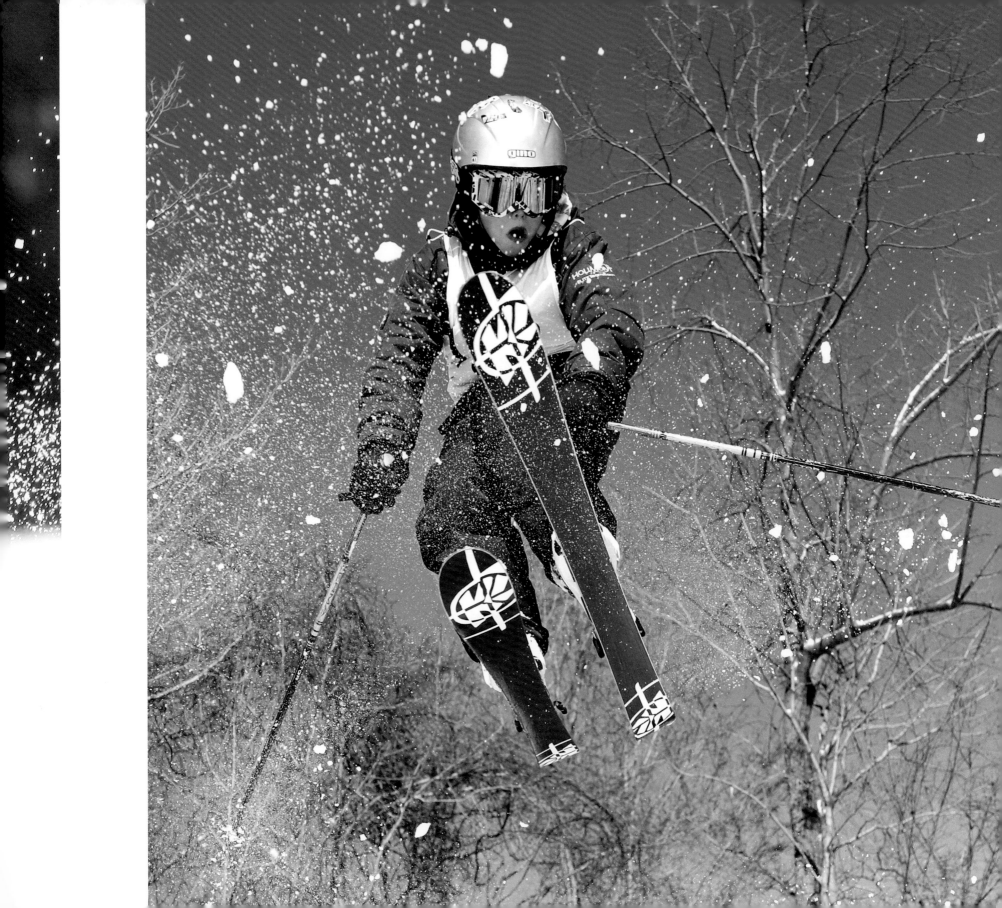

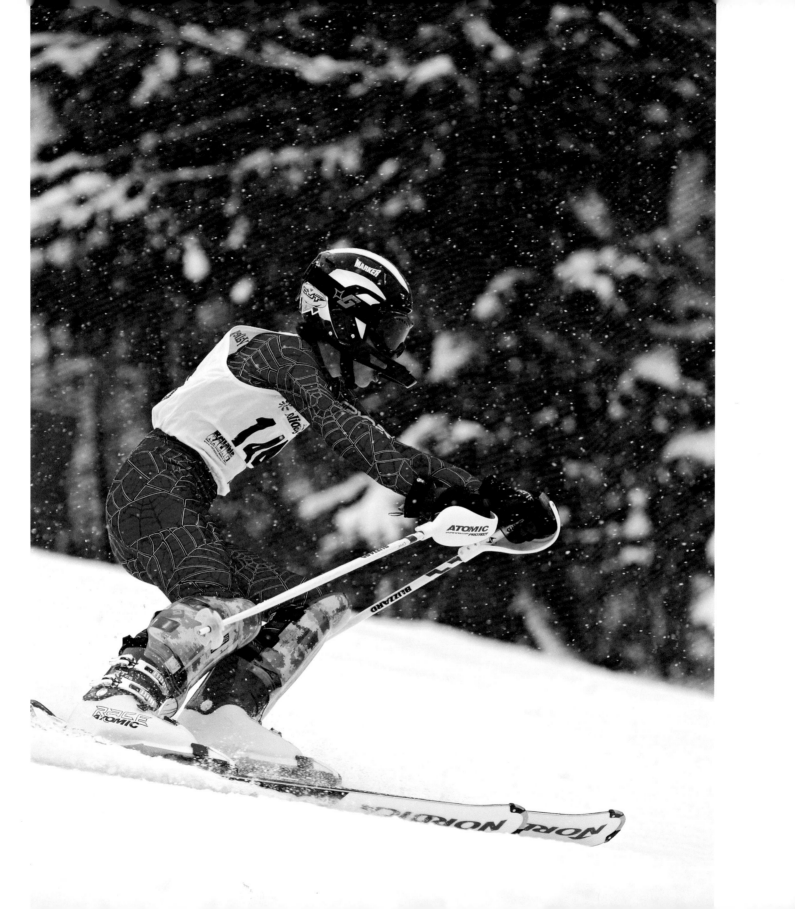

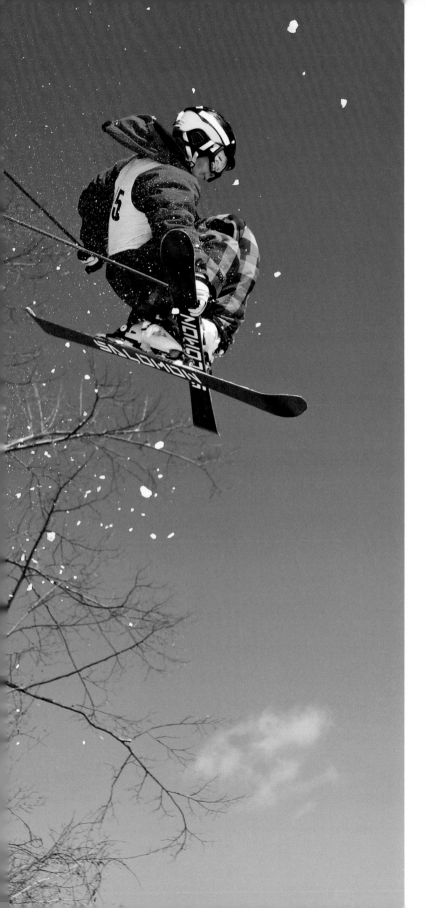

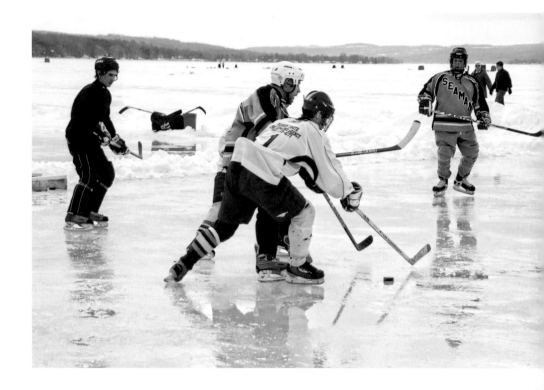

**CONESUS LAKE
ICE HOCKEY** *(above)*
The First Annual Finger Lakes Pond Hockey
Festival on Conesus Lake, held next to Vitale
Park in February. 📷 **DICK BENNETT**

THE GRAB *(left)*
A competitor from Bristol Mountain freestyle
team competing in a free air competition.
📷 **CHRISTOPHER COVE**

ZACH'S TURN *(opposite)*
Pittsford resident competes in a local ski race.
📷 **CHRISTOPHER COVE**

★ **DOWNHILL** *(previous left)*
A Fairport Red Raider participates in Section V
Varsity boys Slalom Sectionals at Bristol Moun-
tain in Bristol, NY. 📷 **CHRISTOPHER CECERE**

IN YOUR FACE *(previous right)*
360 by competitor in a free air competition.
📷 **CHRISTOPHER COVE**

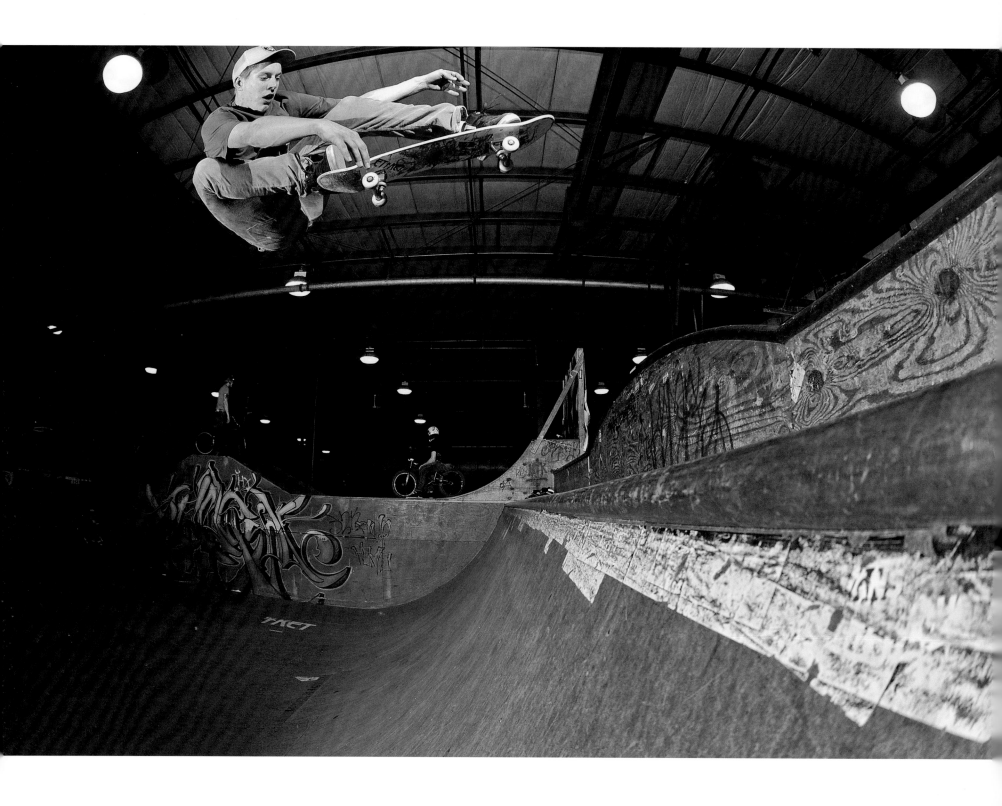

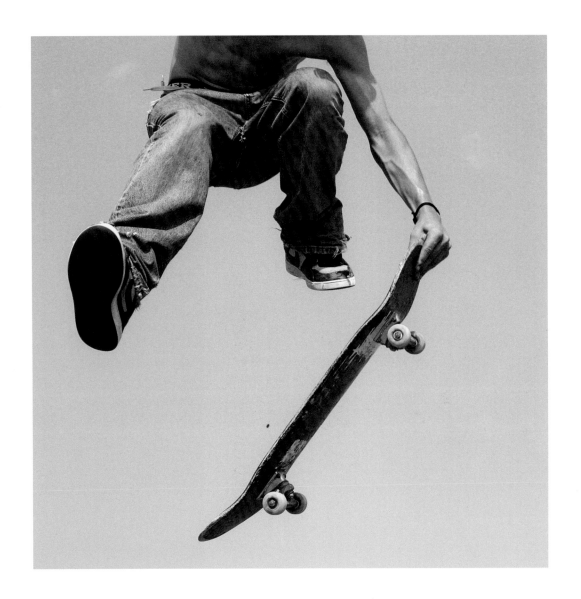

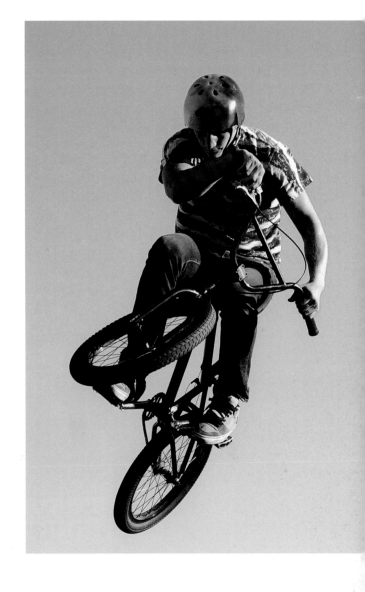

EVAN-TWEAKER *(opposite)*
X Dreams Skatepark. 📷 **TYLER LEPAGE**

AIRBORNE *(above)*
Gates
I photographed this skateboarder in mid flight at the skatepark in
Westgate Park. 📷 **TRENT RASCOE**

IN FLIGHT *(above)*
Chili
A member of the X-Dreams team doing a trick from a box ramp at the
Chil-E Festival on July 4th, 2009 📷 Jeff Gerew

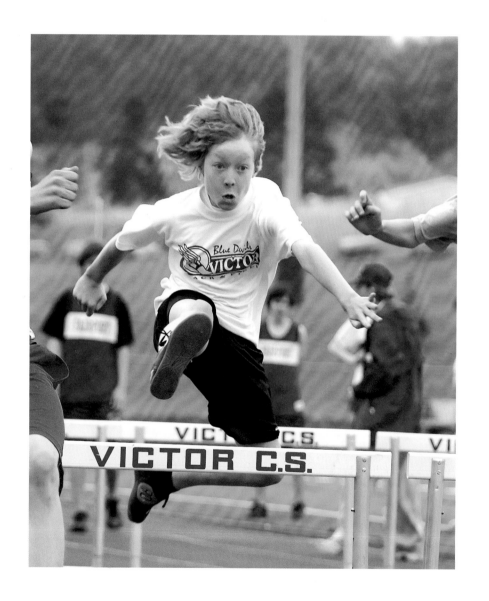

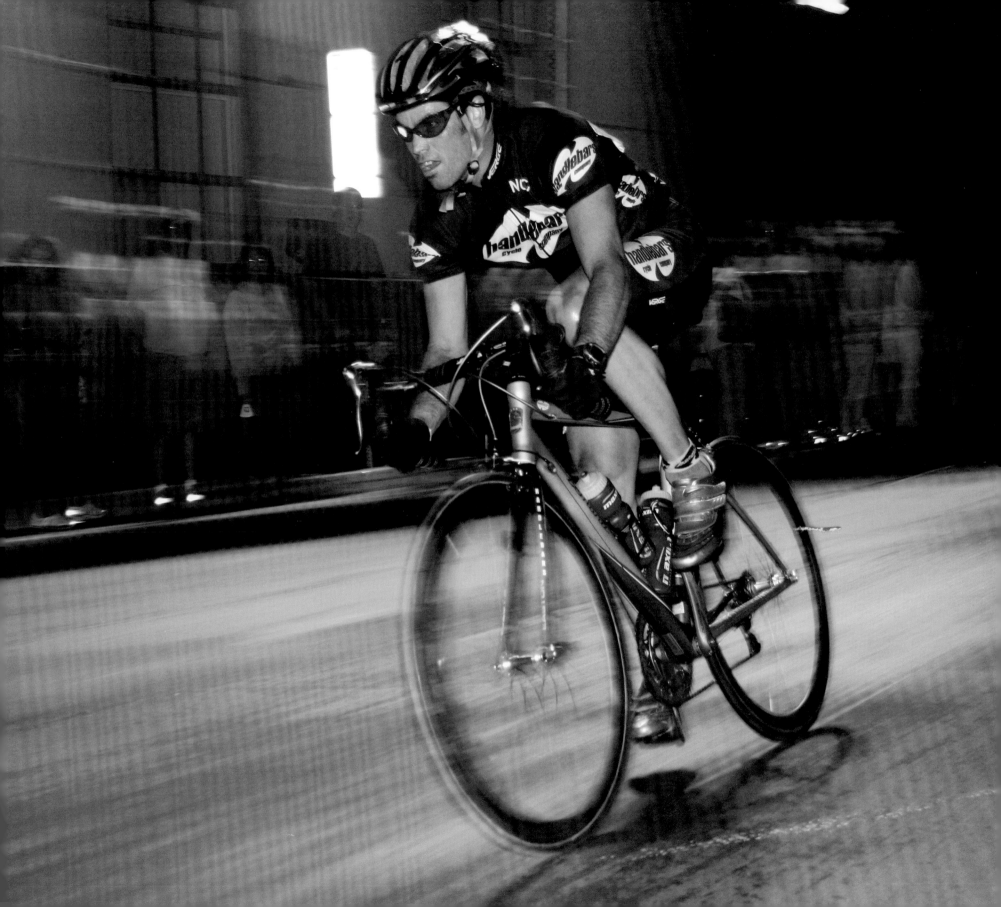

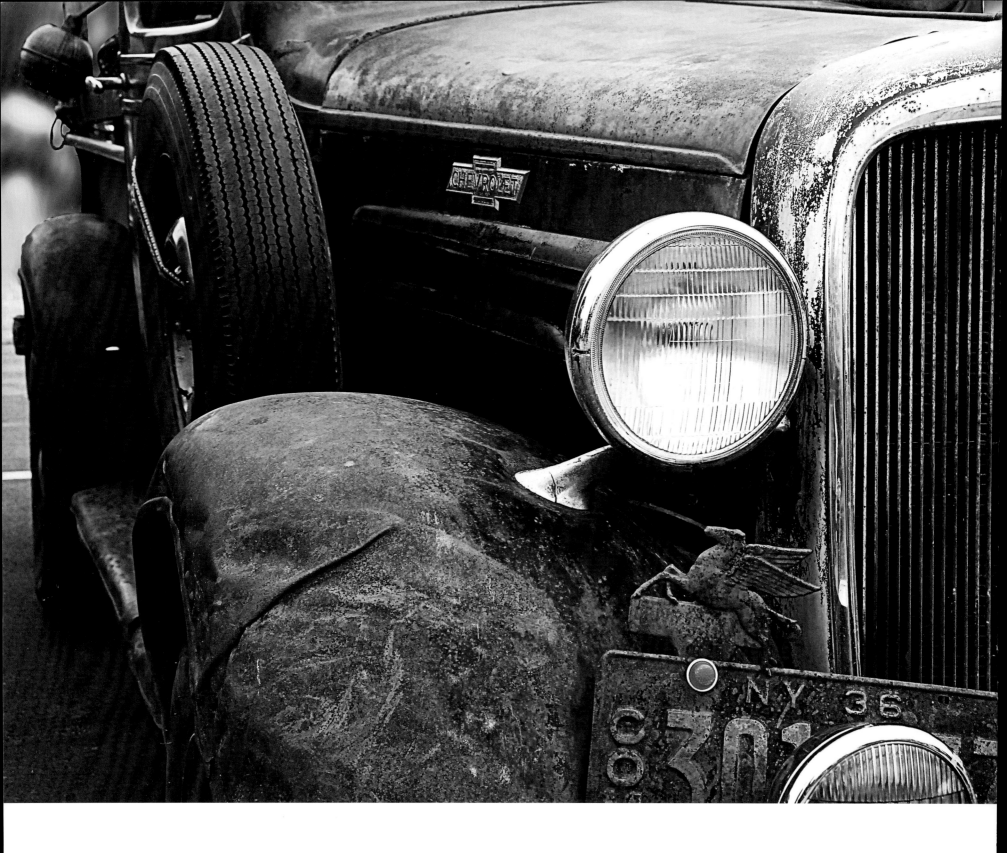

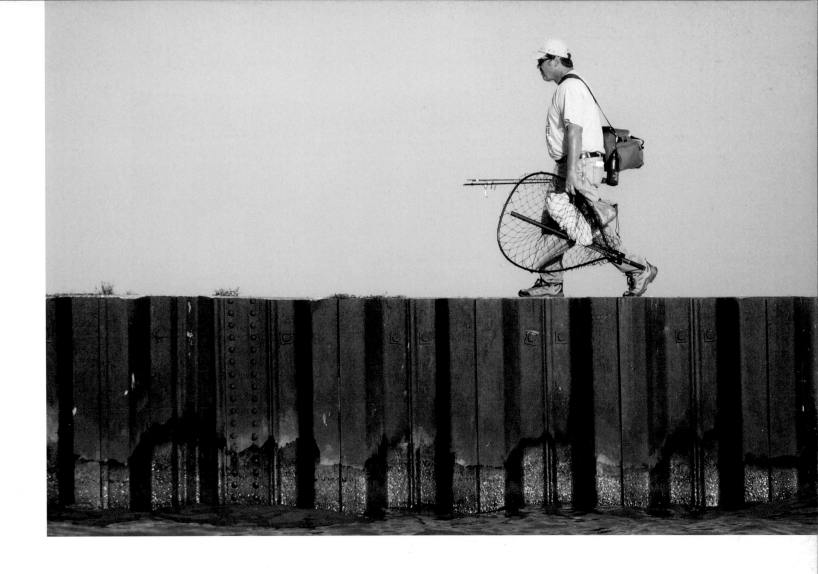

> "It was a beautiful day for an apple festival. The car show had many entries but this one caught my attention.
> — JUDY KNESEL/ON THE ROAD AGAIN

GONE FISHIN' *(above)*
Rochester
A fisherman strides
out the east river
pier to claim his spot
and to "reel 'em in!"
📷 **VALERIE WEYAND**

ON THE ROAD AGAIN *(left)*
Hilton Apple
Festival 📷 **JUDY KNESEL**

UP AND OVER *(previous left)*
Nate Bellerose of Victor Junior High School
clears the bar in the 55 meter hurdles
📷 **ROBERT KILMER**

ROCHESTER TWILIGHT CRITERIUM *(previous right)*
Rochester
With few barriers along the course, spectators stood on the sidewalk only inches
away from the riders as they twisted and
turned throughout downtown Rochester.
📷 **BENJAMIN GAJEWSKI**

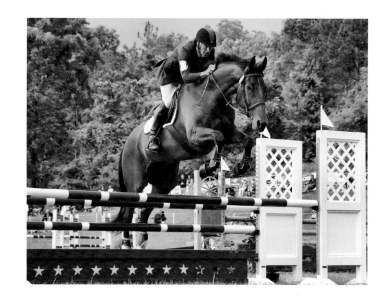

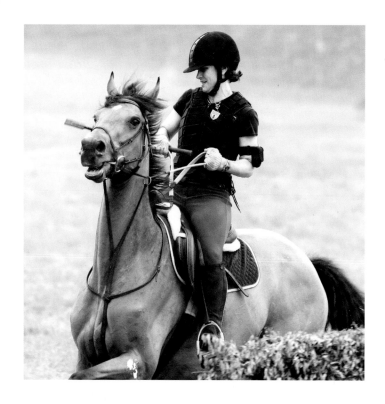

"There's a saying among horse owners, 'When you ask a gelding to do something you get a response. When you ask a mare you get a discussion.' A sense of surrealism is captured as Mela and her owner 'discuss' an obstacle at the cross-country course at Stuart Farms.
— KYM POCIUS/THE FEMALE WILL

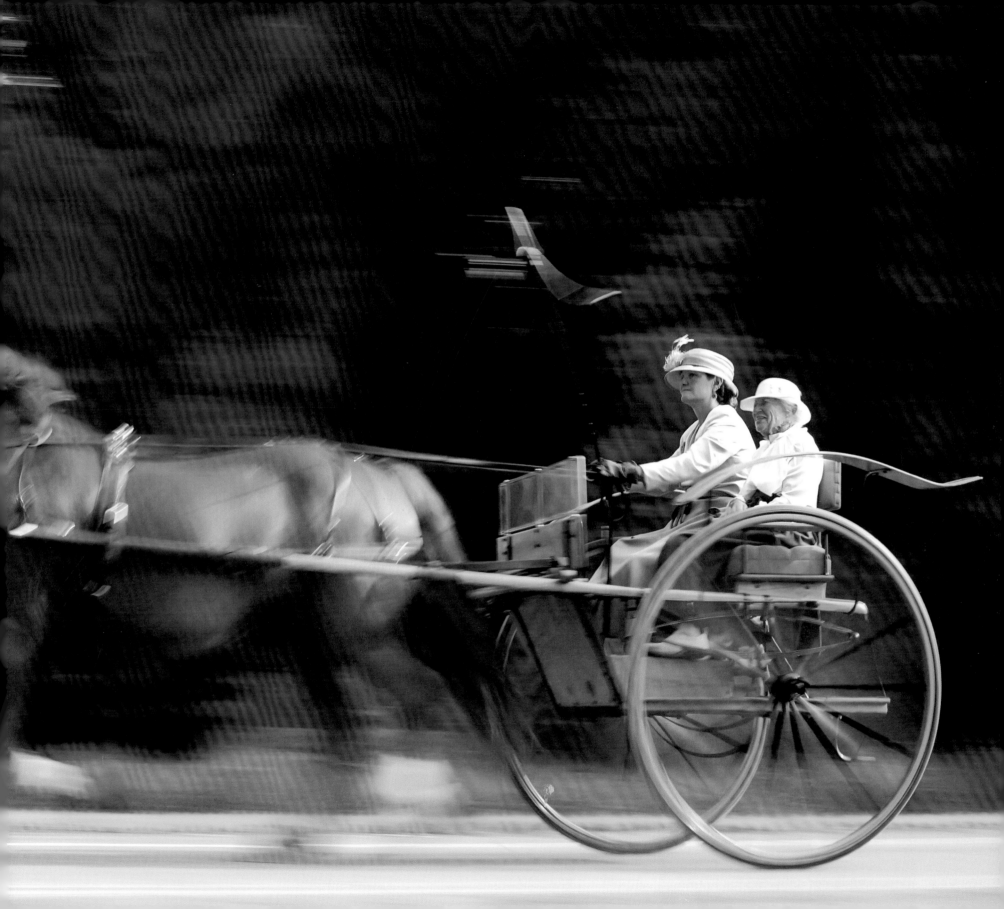

FINALE OF 4TH *(right)*
Meridian Centre Park in Brighton
Independence Day fireworks, 2009. The finale portion of the display
provided plenty of light to the foreground elements in this composition.
📷 **ROB HICKEY**

FIREWORKS OVER ROCHESTER *(opposite)*
Rochester
A couple watch the 4th of July fireworks display over the Genesee
River. 📷 **JEFF HAMSON**

GRACE & POWER *(previous top)*
Dick Bayly, from Kingston, Ontario, Canada, riding Sifton in Open
Preliminary Stadium Jumping at the Cosequin Stuart Horse Trials in
Victor. 📷 **CHARLES VAUGHN**

THE FEMALE WILL *(previous bottom)*
Stuart Farms, Victor 📷 **KYM POCIUS**

★ **HIGH SPEED**
CARRIAGE RACE *(previous right)*
Mendon Ponds Park
This photo was captured during the annual Walnut Hill Farms Vintage
Driving Competition. 📷 **PRAMODH SENEVIRATNE**

REDWINGS FIREWORKS *(below)*
The Kodak tower watches over fireworks at a Red Wings game.
📷 **CARL SMITH**

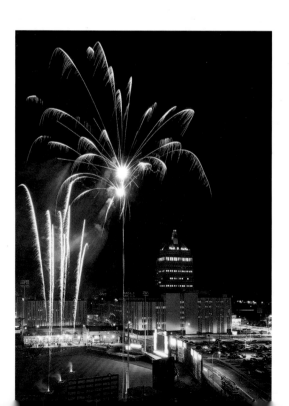

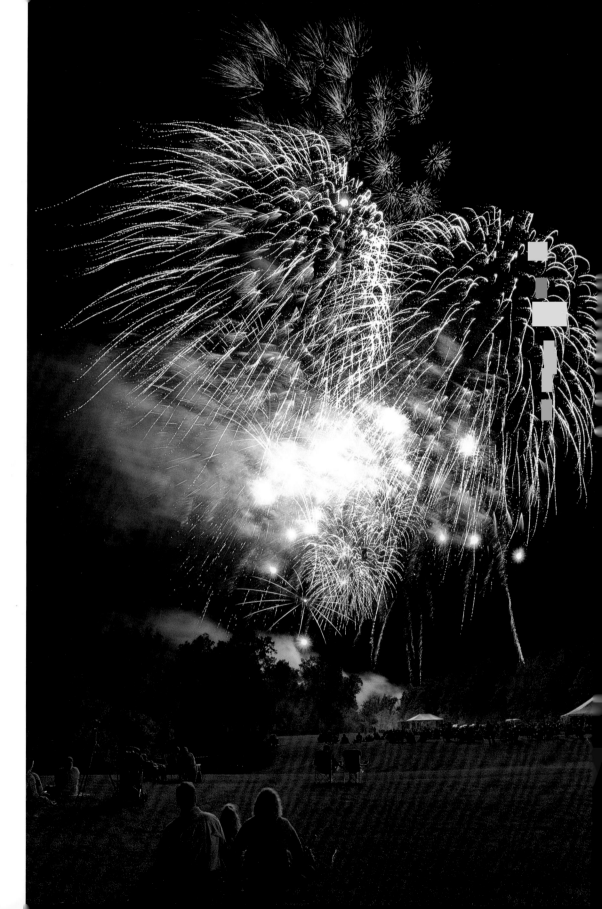

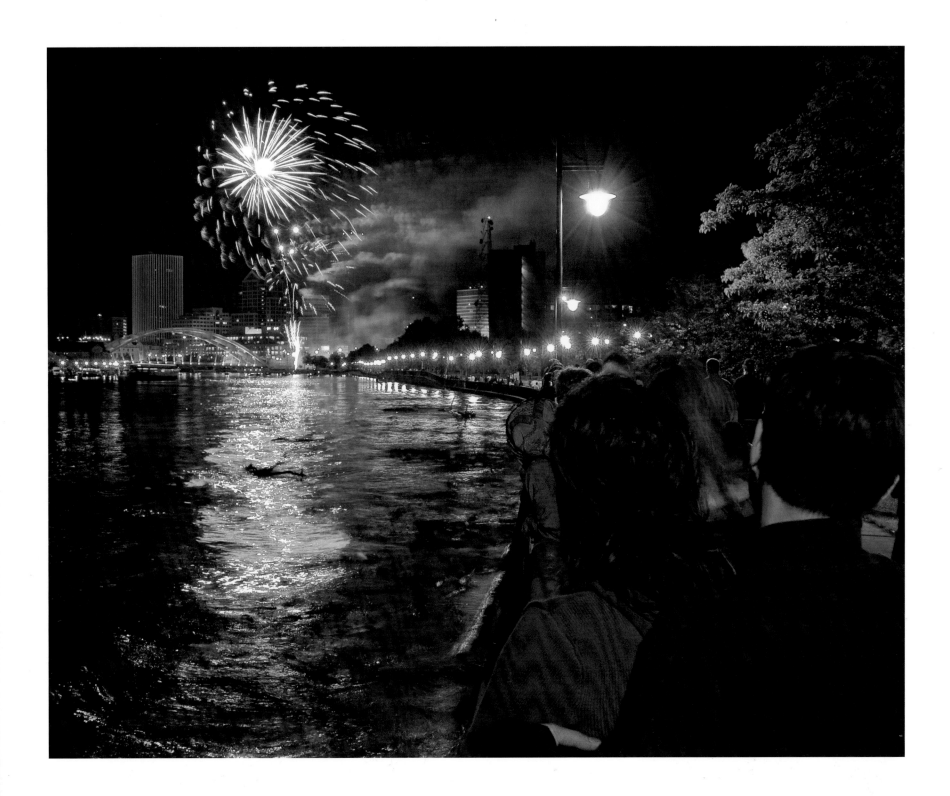

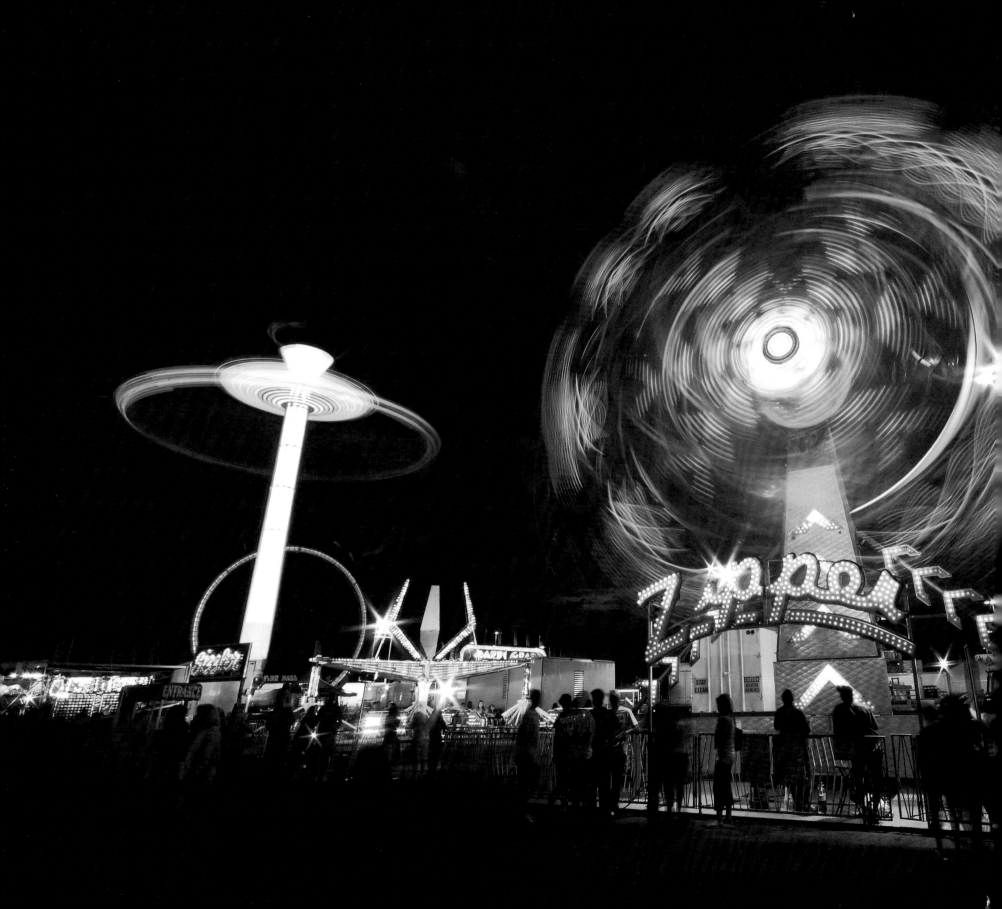

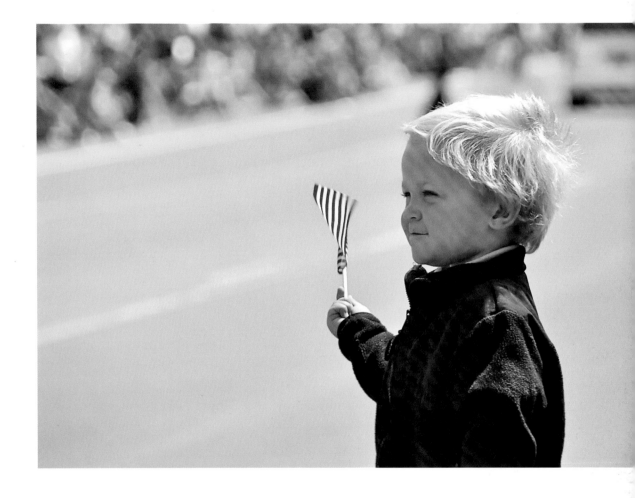

I LOVE A PARADE *(above)*
Irondequoit Parade
A young boy shows his patriotism along Titus
Avenue during the Fourth of July parade in
Irondequoit. 📷 **GLENN PECK**

MONROE COUNTY FAIR *(left)*
Rochester
The midway lights up on opening night of the
Monroe County Fair. 📷 **PAUL BAKER**

THE SCALE OF IT *(following left)*
Dansville
This sure gives you a sense of perspective 📷 **ANDREW BLOOM**

FIRED UP *(following middle)*
Dansville
One of the pilots participating in the New York State Festival of
Balloons. fires up his balloon just after take off to gain some quick
altitude. 📷 **ROB HICKEY**

SUNDAY MASS *(following right)*
Dansville
Balloons launch en masse at the New York State Festival of Balloons
📷 **ROBERT KILMER**

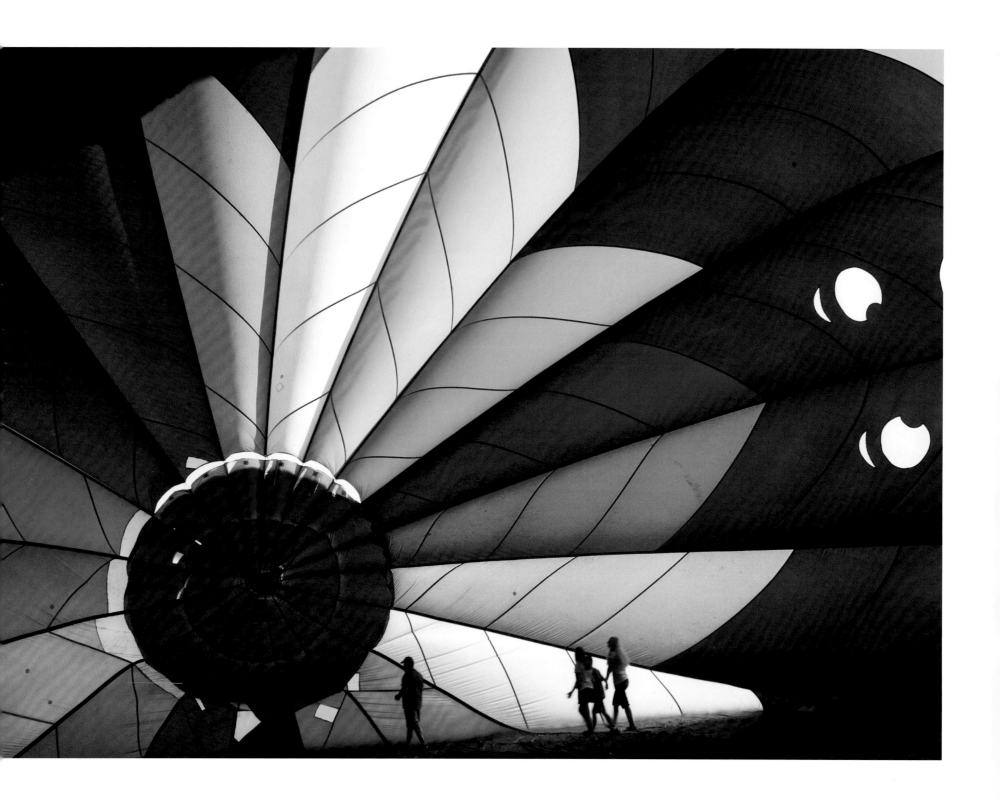

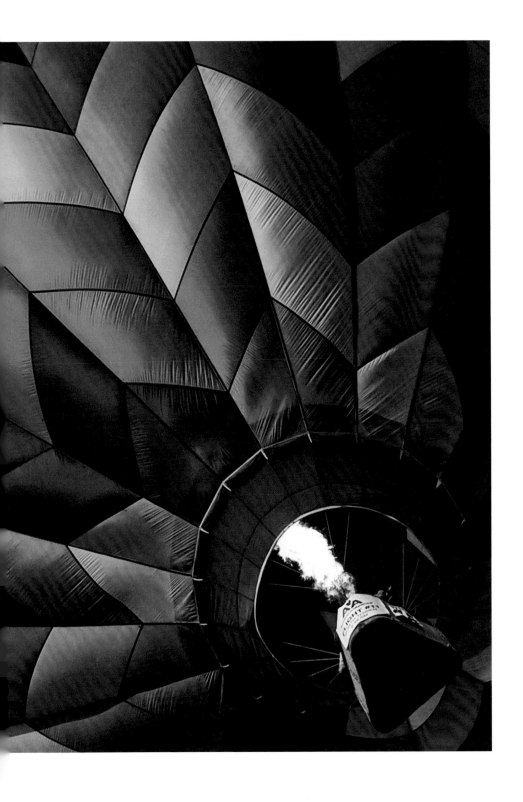

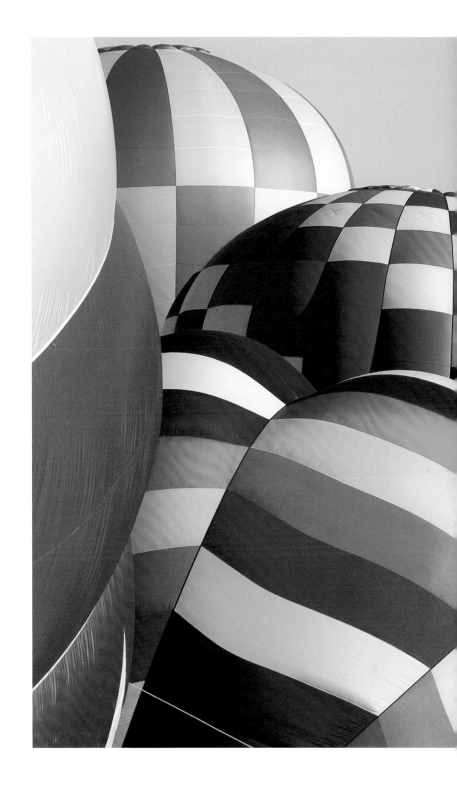

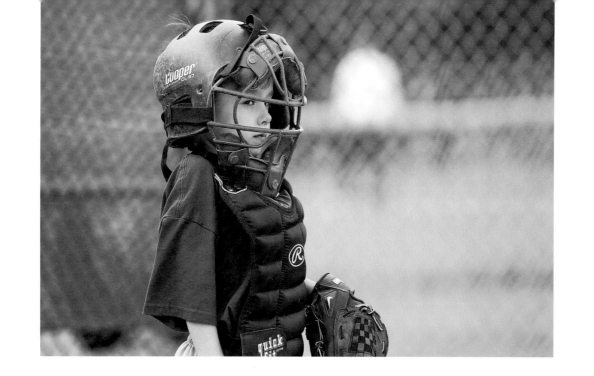

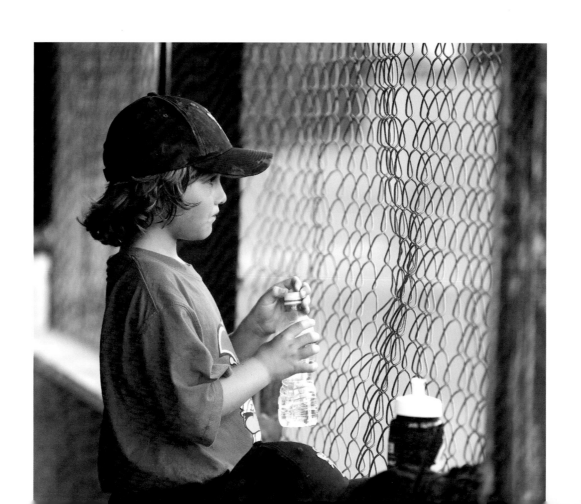

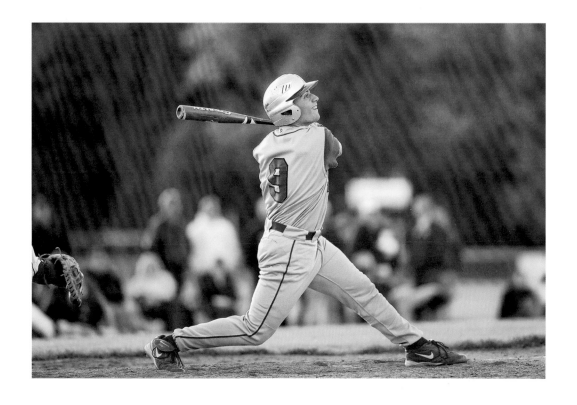

THE FOLLOW-THROUGH *(above)*
Penfield Town Hall Field
Penfield/Fairport boys varsity baseball. 2009
Penfield Section Five Champs. 📷 **JIM PETRILLO**

YOU GONNA RUN ON ME? *(opposite top)*
Penfield Town Hall
My son at tee-ball in full catcher's gear. However, they do not actually catch the pitch in tee-ball. 📷 **JIM PETRILLO**

TAKING A DRINK *(opposite bottom)*
Webster
Seven-year-old baseball player TJ Leverett takes a drink during a Webster Summer League game at Empire Park in Webster on a hot August night. 📷 **TIM LEVERETT**

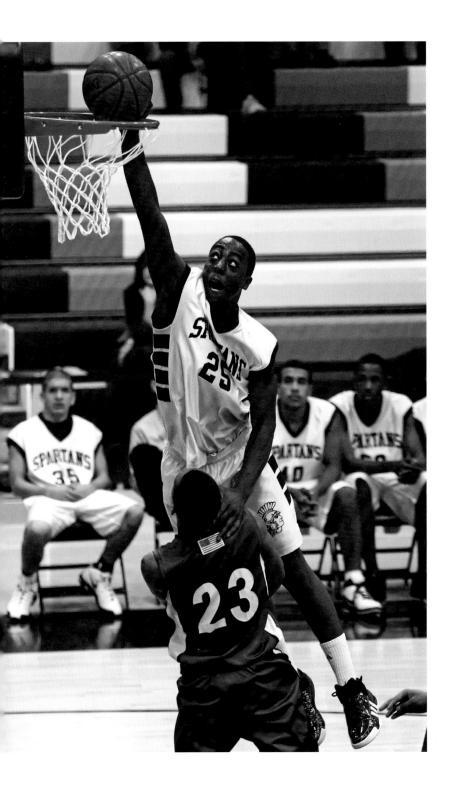

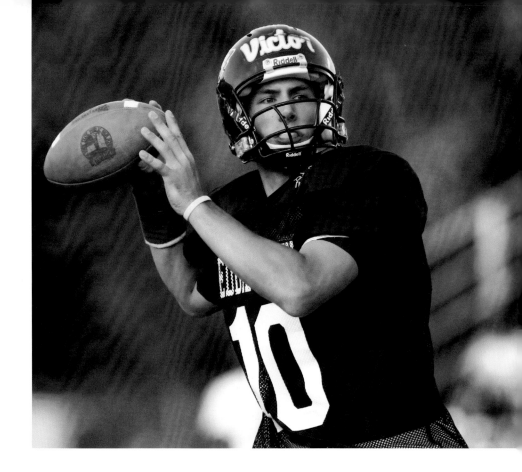

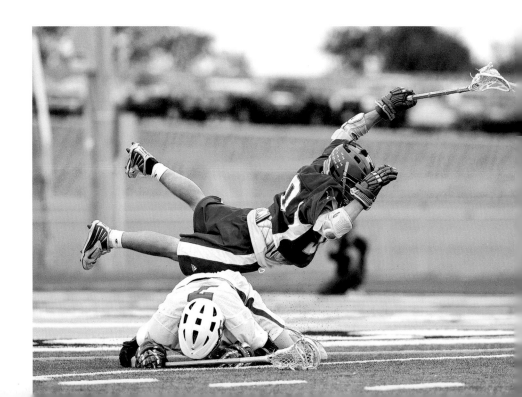

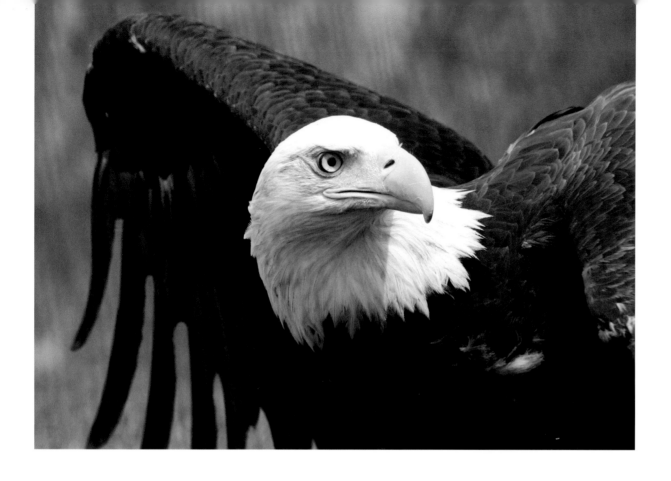

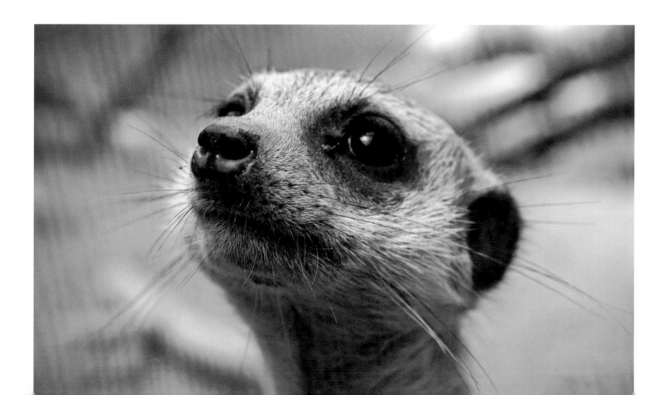

LIBERTY *(top)*
This is Liberty, a Bald Eagle, photographed during the Birds of Prey Days held at Braddock Bay Park. The event is held each spring and is a fantastic place to learn about birds of prey, their migration and conservation efforts on their behalf. ◙ **JOEL PAIGE**

BABY MEERKAT *(bottom)*
One of the baby meerkats at Seneca Park Zoo ◙ **WILLIAM KERR**

LOOK OUT BELOW *(opposite left)*
Spartan CJ Russell dunks over an opposing player in a section V boys basketball game between the Gates-Chili Spartans and Elmira Southside Green Hornets at Gates-Chili High School's new gym in Rochester.
◙ **CHRISTOPHER CECERE**

QUARTERBACK POSE *(opposite top)*
Rochester
Victor High School Senior quarterback Chris Rose prepares to throw in the 27th Annual Eddie Meath All-Star Football Game on Sunday, July 5, 2009 at Growney Stadium at St. John Fisher College. Chris and the East All Stars beat the West 27-0. ◙ **CHRISTOPHER CECERE**

I'M FLYING *(opposite bottom)*
Webster Schroeder and Fairport lacrosse.
◙ **JIM PETRILLO**

CLOUD SURFING *(following top)*
Ontario Beach Park
A skydiver appears to be surfing across a cloud at the 2009 ESL Air and Water Show.
◙ **WILLIAM KERR**

ESL 2009 AIR SHOW *(following bottom)*
Ontario Beach Park
The Snowbirds in flight over Lake Ontario during the 2009 ESL Air Show. ◙ **WILLIAM KERR**

SPLITTING SNOWBIRDS *(following middle)*
2009 Rochester Air Show ◙ **CARL SMITH**

AT-6 *(following right)*
An AT-6 Texan doing aerobatics in Geneseo, NY. This plane was a trainer for the pilots during WWII. ◙ **BOB BURDEN**

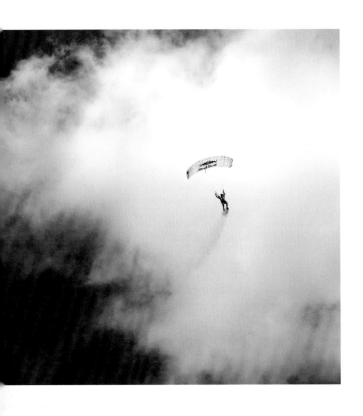

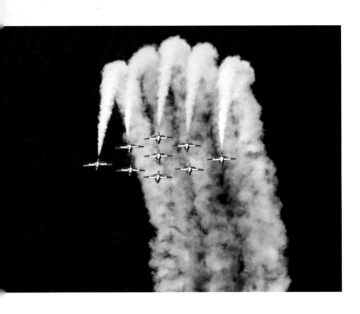

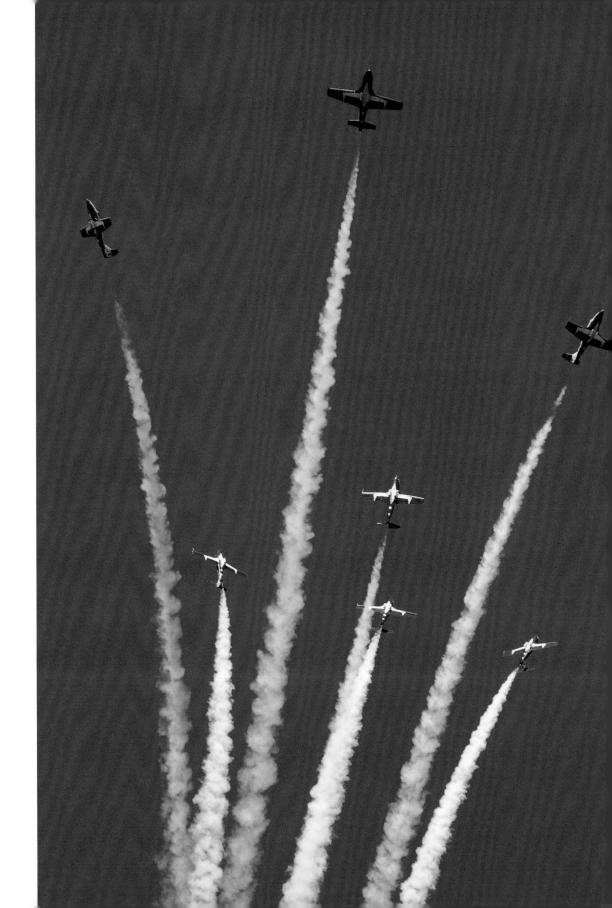

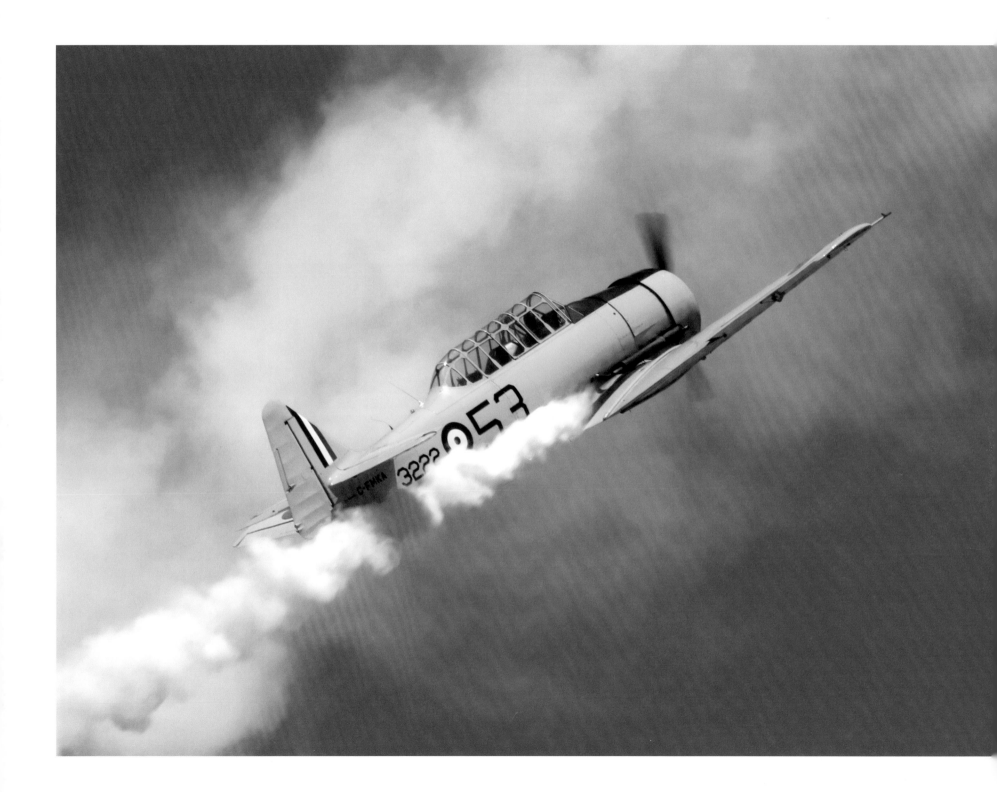

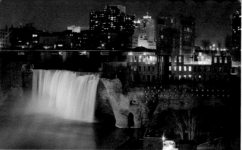
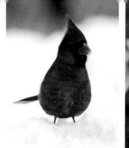
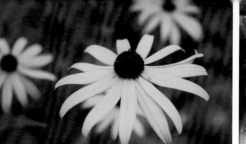
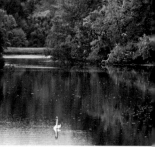

Scapes of All Sorts

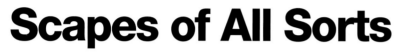
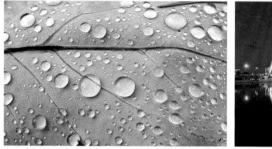

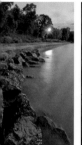
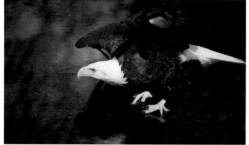
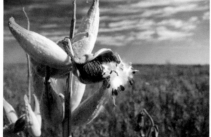
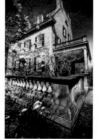
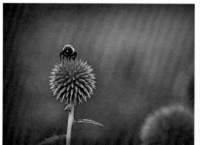
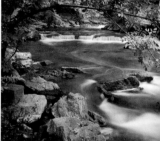

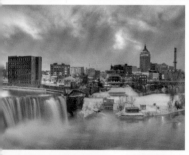
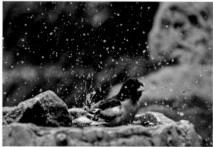

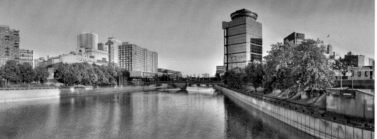
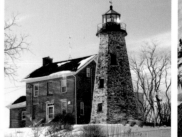

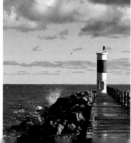
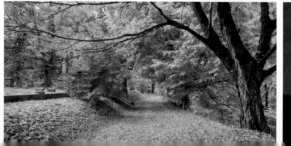
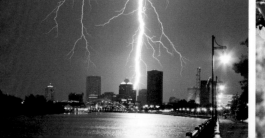
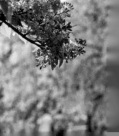

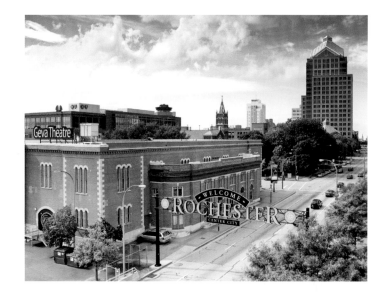

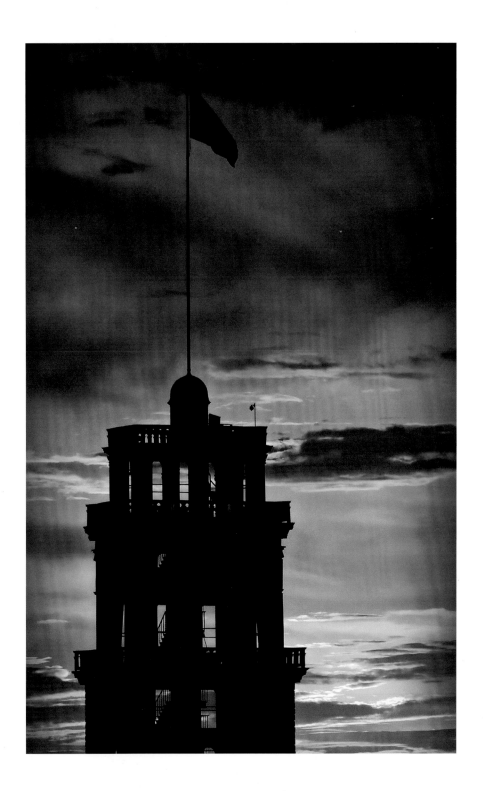

GATEWAY TO ROCHESTER *(above)*
Rochester
The gateway to downtown Rochester on Clinton Avenue. View includes Geva Theater in the foreground, the Blue Cross Blue Shield Building, old revolving restaurant, Hyatt Hotel, and iconic Bausch & Lomb building in the background. 📷 **TIM LEVERETT**

TOWER OF POWERS *(left)*
Corner of Main and State
The tower on the old Powers Building at sunset — a beautiful structure 📷 **AARON WINTERS**

STEEPLE *(following left)*
Rochester
The steeple of St. Joseph's Church.
📷 **JEFF HAMSON**

VERTIGO *(following right)*
Powers Building Rochester
The courtyard of the Powers Building is lit nicely by a skylight several stories high.
📷 **DON MENGES**

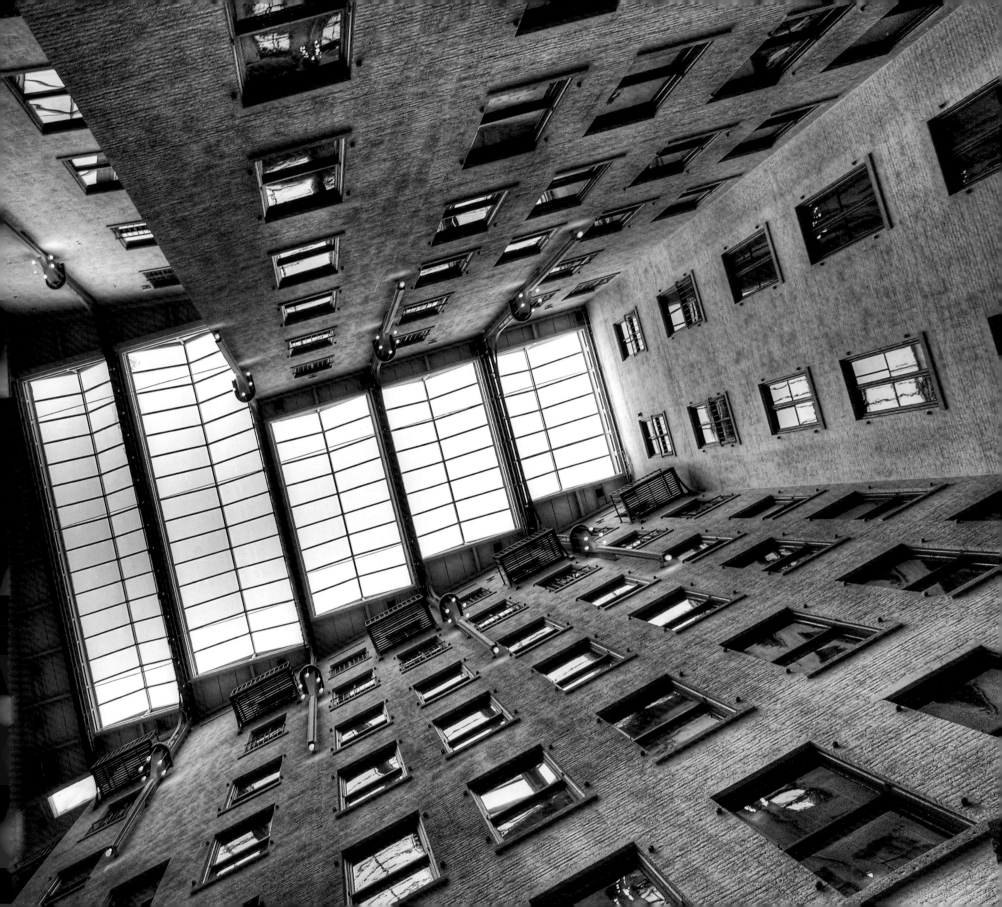

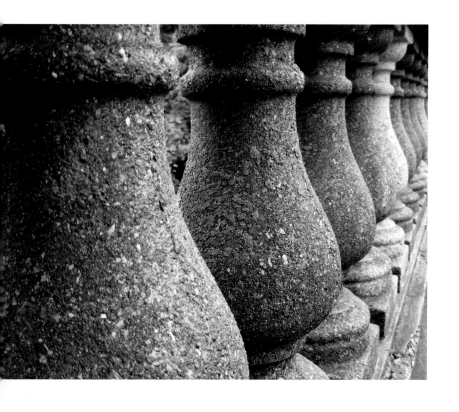

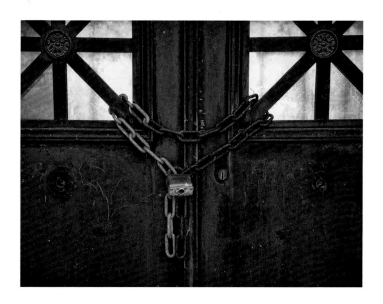

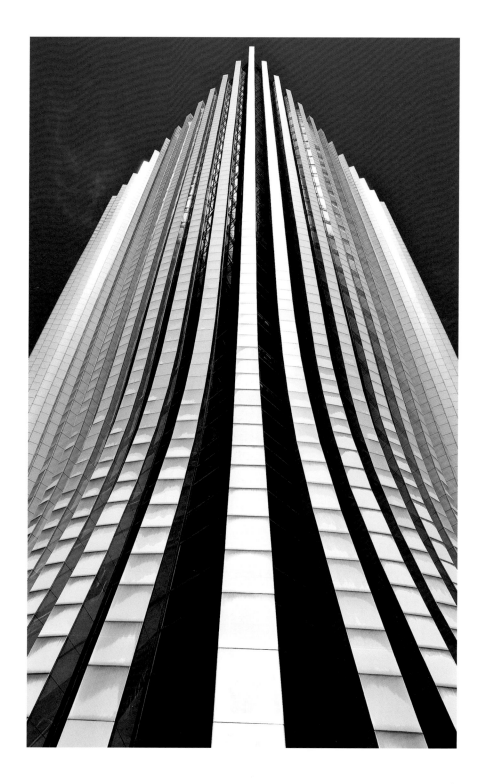

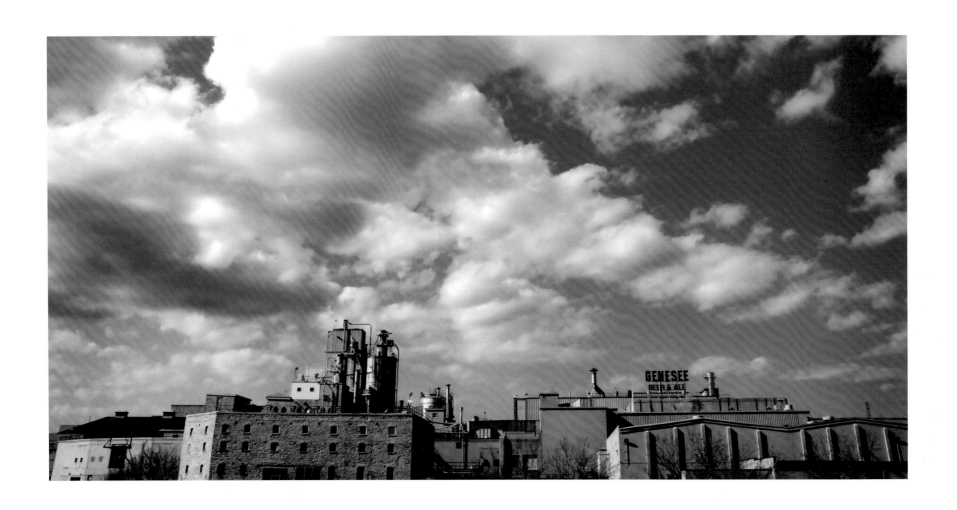

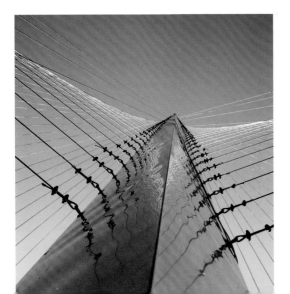

BEER AND BLUE SKY *(above)*
Rochester's own High Falls Brewing Company.
📷 **SEAN MCGINNIS SCANLON**

LIBERTY POLE *(left)*
The Liberty Pole at the intersections of East Avenue, East Main Street and Franklin Street, Rochester, NY. 📷 **JOSEPH MOROZ**

ALL IN A ROW *(opposite top)*
Famous for designing New York City's Central Park, Frederick Law Olmsted also designed many other urban parks, including Rochester's Genesee Valley Park along the banks of the Genesee River. This beautiful stonework is part of one of the bridges in the park that crosses over Red Creek. 📷 **KELLY LUCERO**

CHAINED *(opposite bottom)*
Mt. Hope Cemetery
I'm not sure why they have doors on mausoleums anyway, but chains on the doors make you wonder who they are barring.
📷 **JUDY KNESEL**

CHASE TOWER *(opposite right)*
Rochester, NY
Looking up from the base of Chase Tower in downtown Rochester. 📷 **JEFF HAMSON**

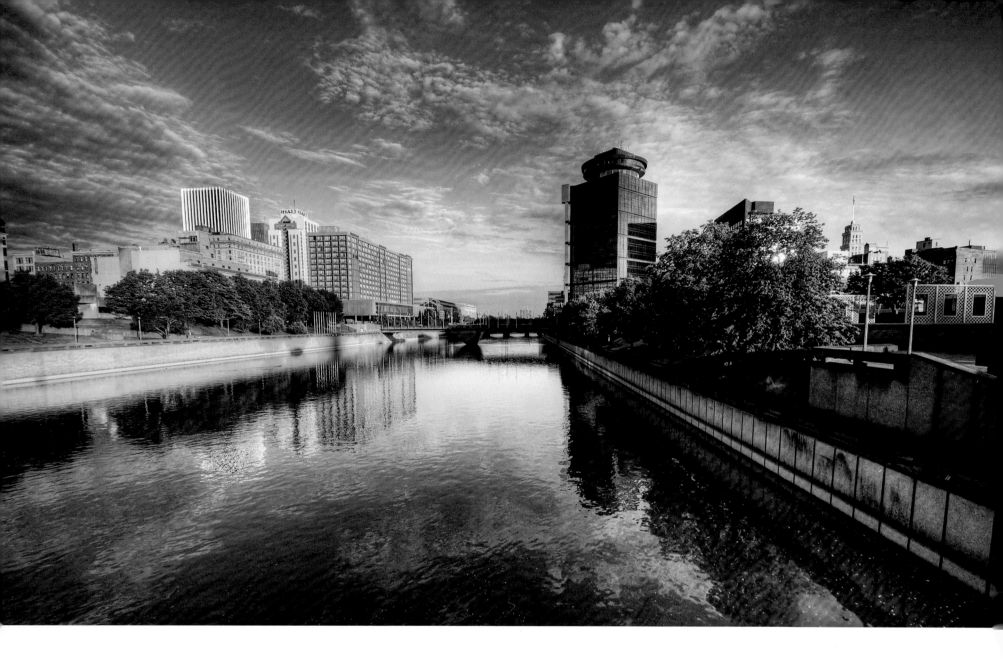

RIVER VIEW *(above)*
Downtown Rochester
A view of the city from the Andrews Street
Bridge, June 2009. 📷 **KIM PRICE**

CORNER OFFICE *(opposite left)*
Downtown Rochester
The Powers building was originally built in
1869. These three floors were added later
because the owner, Daniel Powers, wanted
to have the tallest building in Rochester.
📷 **JUDY KNESEL**

GOING GOING GONE *(opposite right)*
Chestnut Street
Some days, you just feel directionaly chal-
lenged. 📷 **AARON WINTERS**

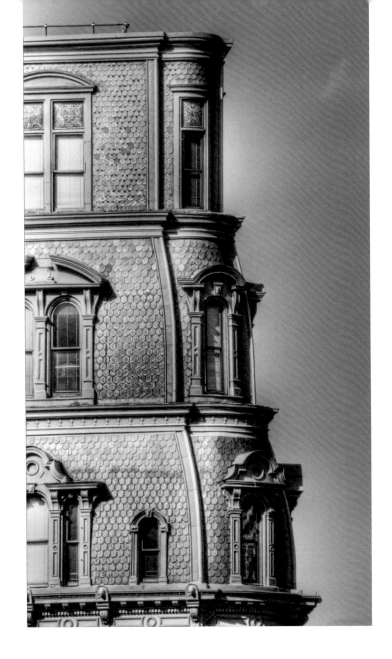

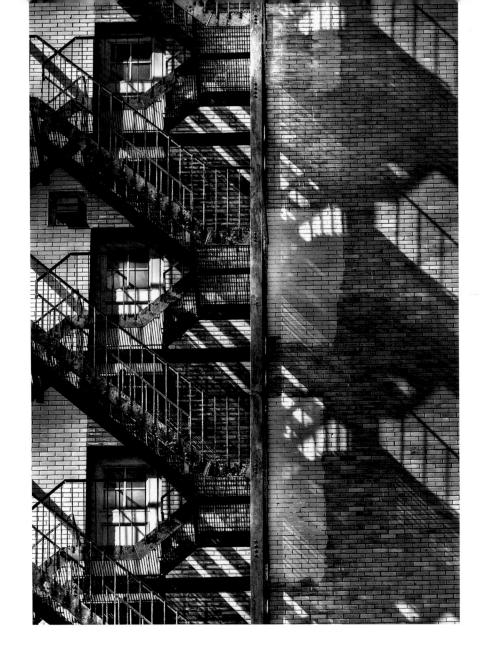

COURT STREET GARAGE *(following left)*
Rochester
A view of the Court Street Garage outside of
the Bausch & Lomb Building. 📷 **JEFF HAMSON**

★ **LIGHTHOUSE STAIRS** *(following right)*
The stairs near the top of the Charlotte
Lighthouse, looking down. The rope on the
left is what you hold on to as you climb.
📷 **DICK BENNETT**

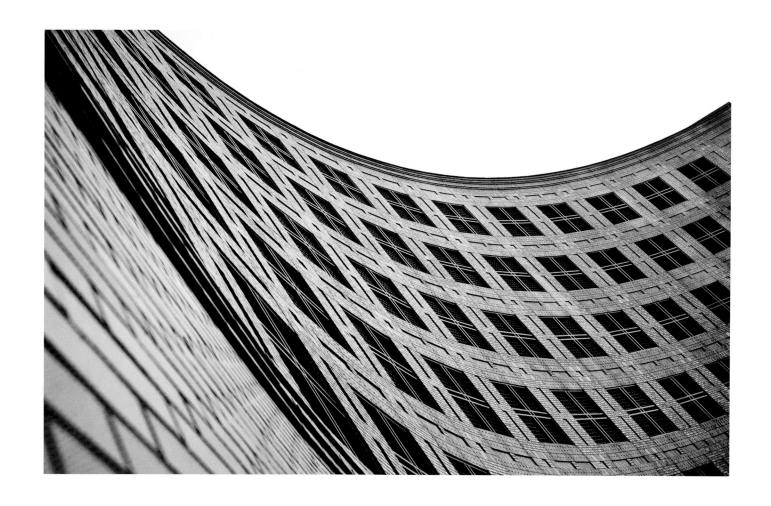

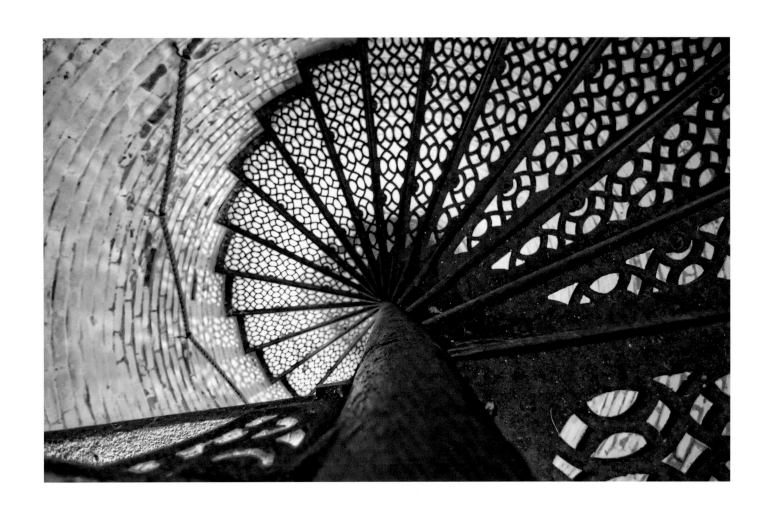

"It's a beautiful view from the top.
— DICK BENNETT/ LIGHTHOUSE STAIRS

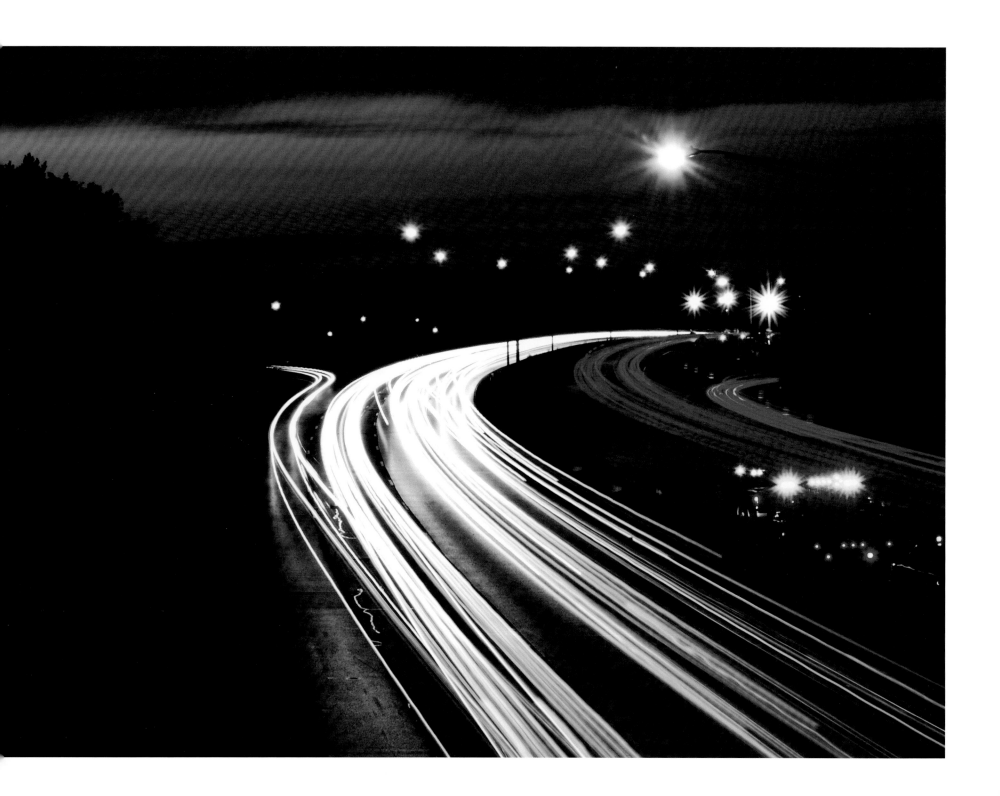

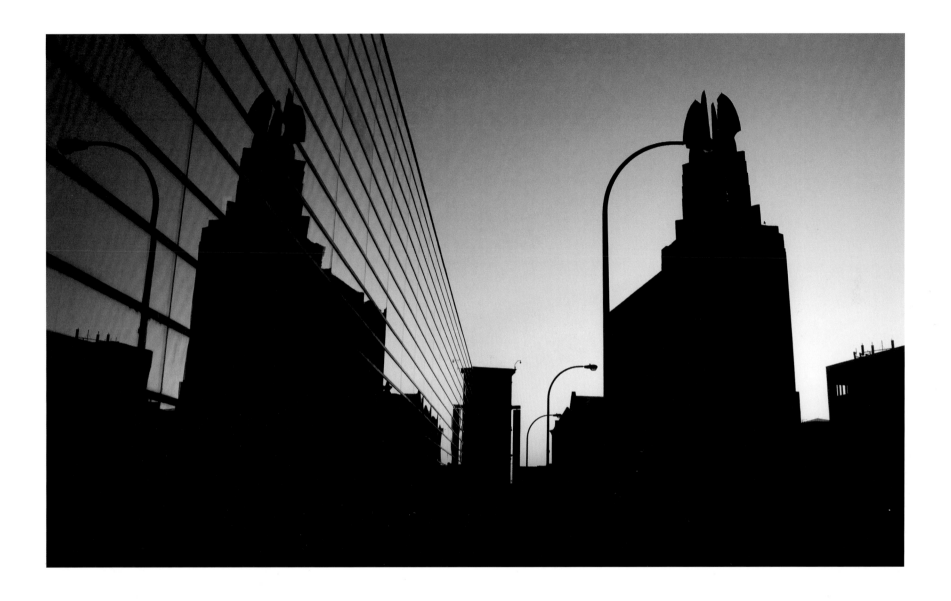

TWICE AS NICE *(above)*
Thanks to my husband for noticing the reflection of the Wings of Progress in the Blue Cross Arena. Our local icon is twice as nice!
📷 **ANGELA POSSEMATO**

SUNSET ON 590 NORTH *(opposite)*
Rochester
This was one of the shots I took recently using my tripod and a long shutter time. I love the look of the car lights and the sunset.
📷 **DEBRA ERPENBECK**

FAST TRACKS TO NOWHERE *(following left)*
I took this while walking down the railroad tracks on a hazy day in East Rochester, near the old train depot. 📷 **BRIAN SCIARABBA**

WESTBOUND TRAIN *(following right)*
A westbound CSX train rolls through the last rays of sunlight, leaving Rochester behind.
📷 **NICK WILSON**

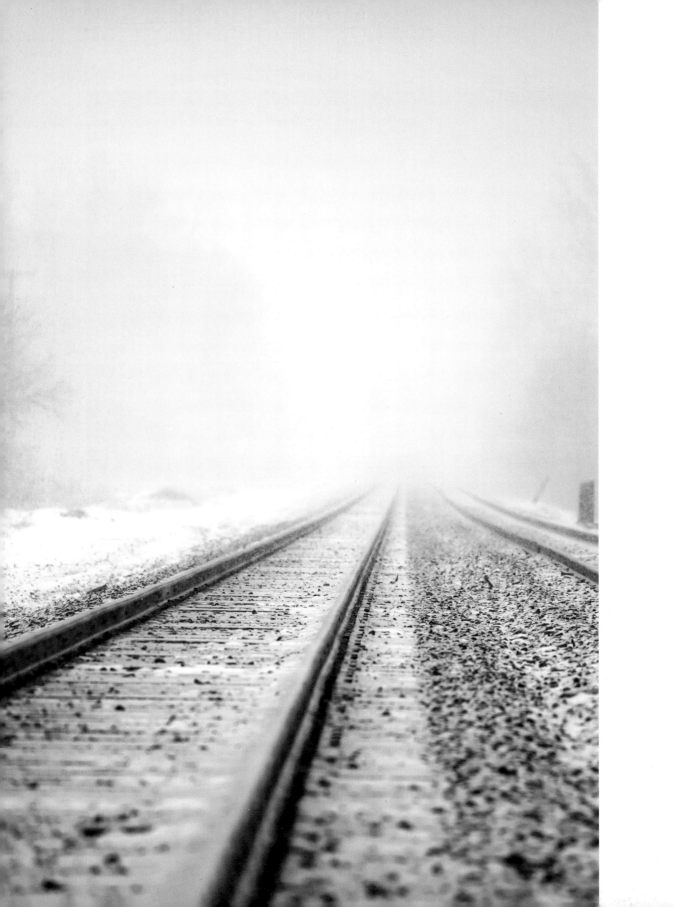
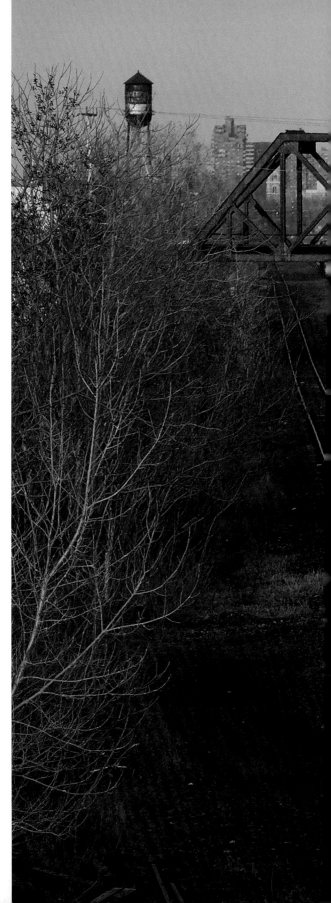

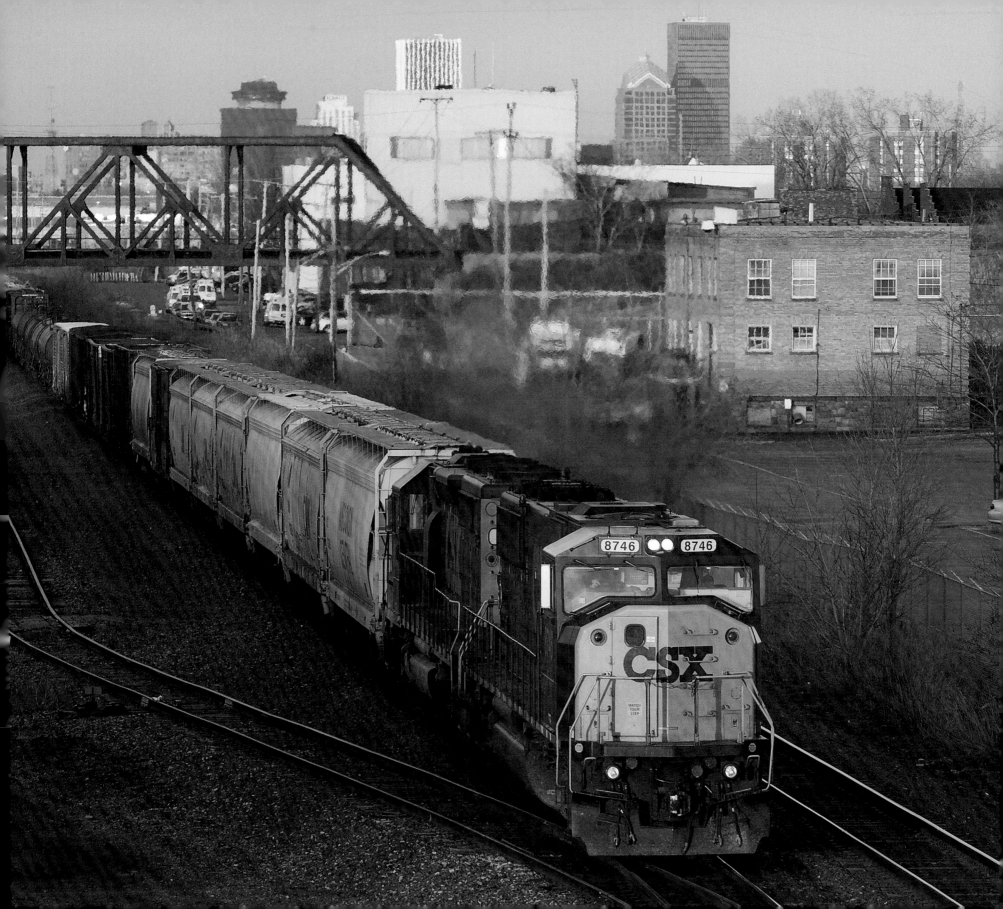

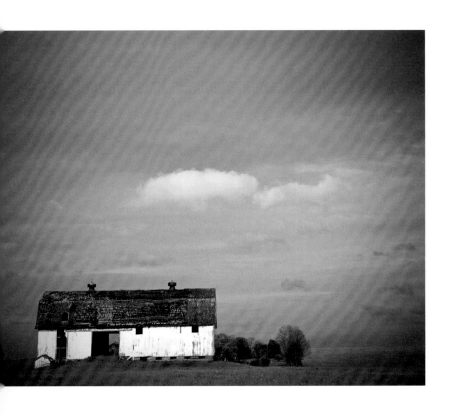

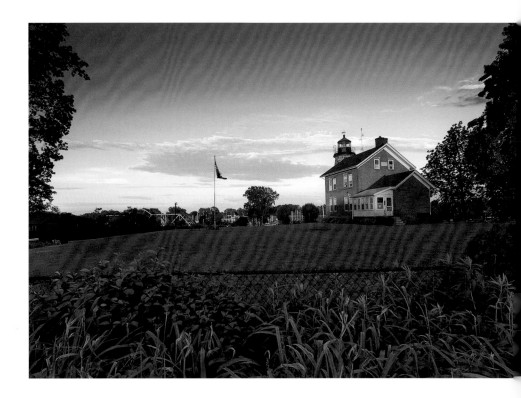

"It has always intrigued me how the open doorway of this barn perfectly frames the red barn just a few hundred feet up the road. — KELLY LUCERO/APPROACHING STORM

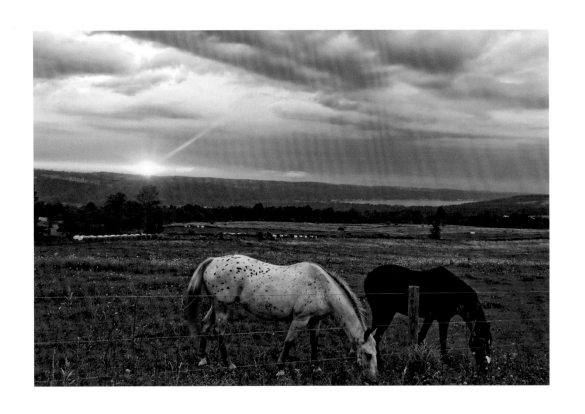

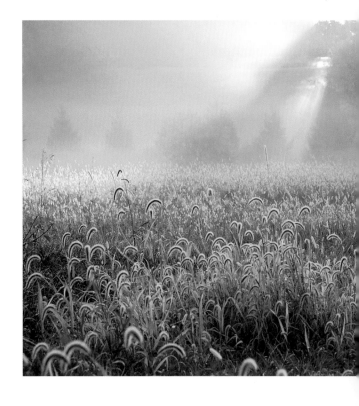

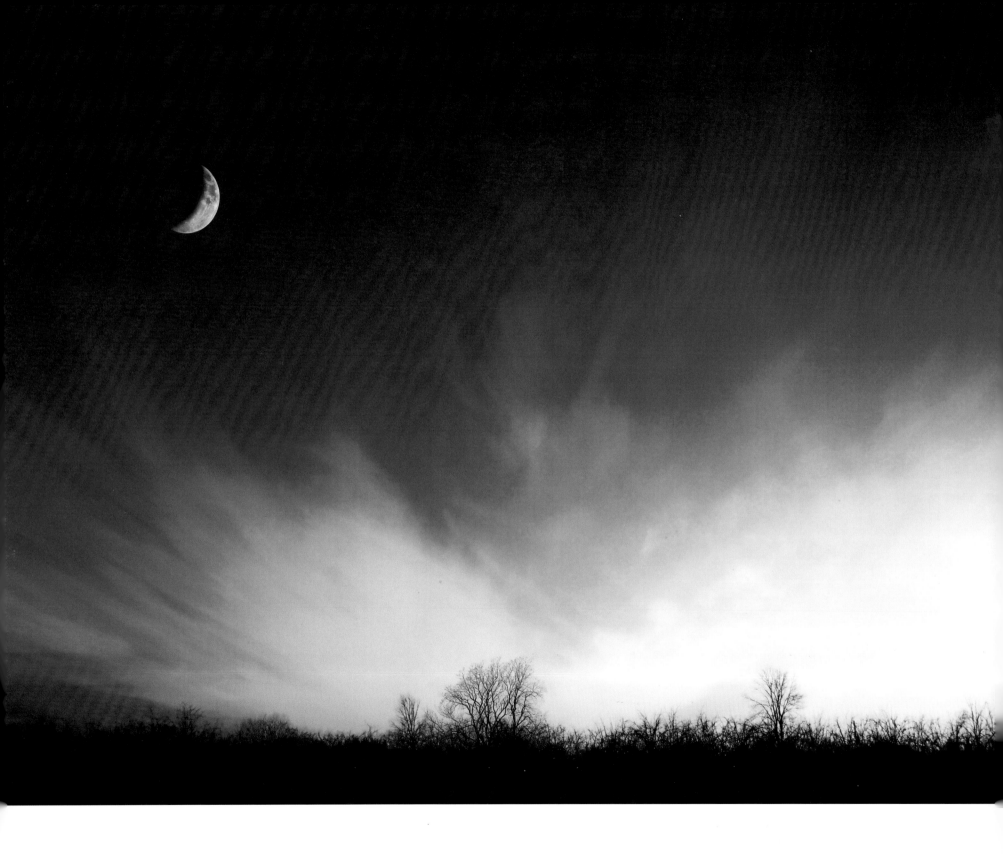

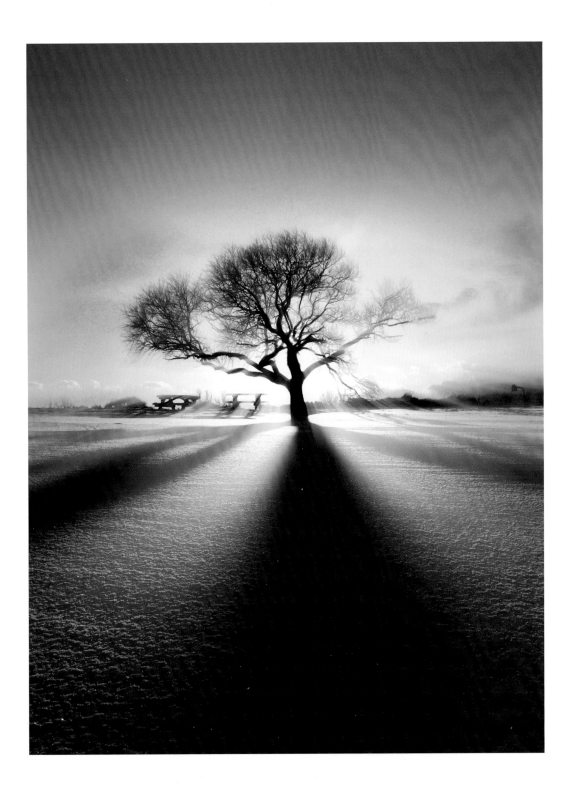

TREECLIPSE (left)
Hamlin Beach State Park
This is my personal "tree of life" because this photo inspired my photography career and provided me with the confidence I needed to turn a hobby into a passion. 📷 CHRISTOPHER WILLIAMS

★ **VALENTINE'S SUNSET** (opposite)
Black Creek Park, North Chili 📷 CHRISTOPHER WILLIAMS

APPROACHING STORM (previous far left)
Wheatland 📷 KELLY LUCERO

EVENING LIGHT ON LIGHTHOUSE (previous left)
The last rays of summer hitting the old Charlotte Lighthouse.
📷 PRAMODH SENEVIRATNE

CONESUS LAKE SUNSET (previous right)
Conesus Lake
Horses grazing at the southern end of Conesus Lake as the sun sets behind them. 📷 DICK BENNETT

SUNBEAMS (previous far right)
Looking east at dawn from a field on Clover Street in Mendon.
📷 JULES ZYSMAN

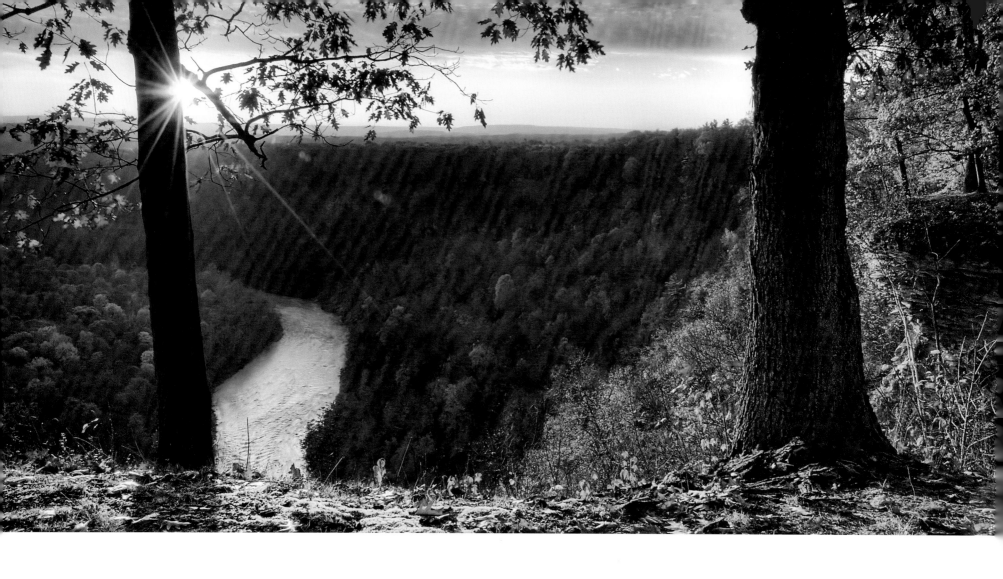

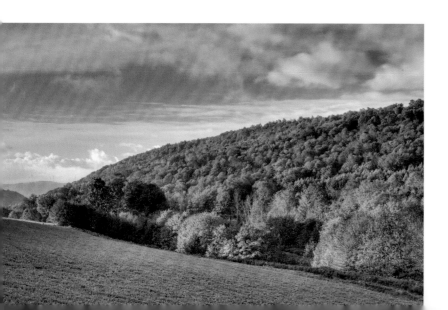

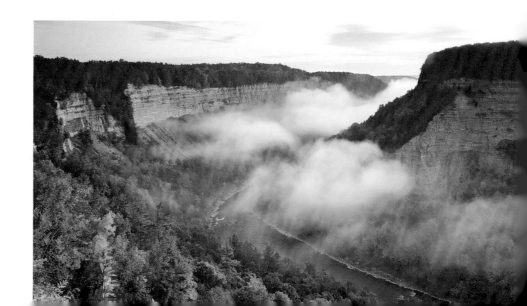

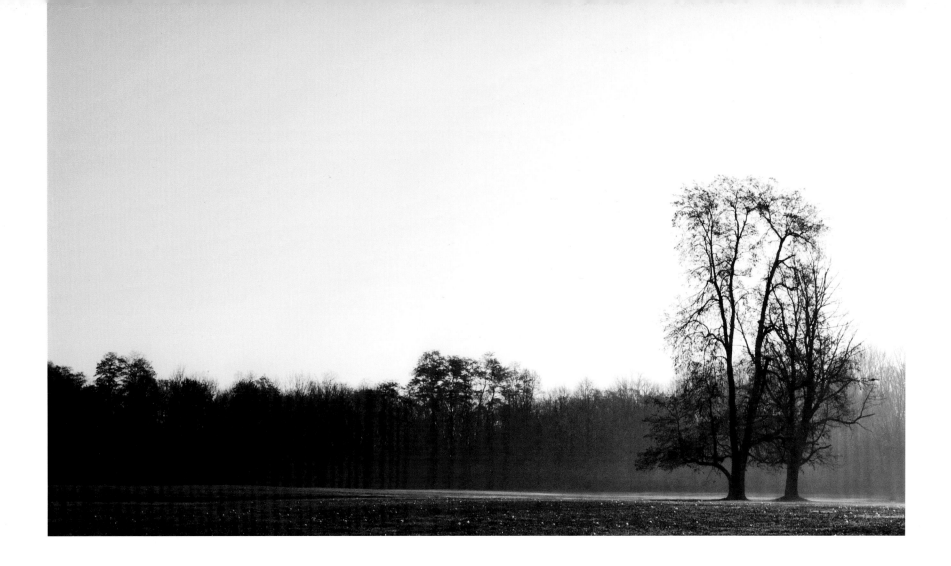

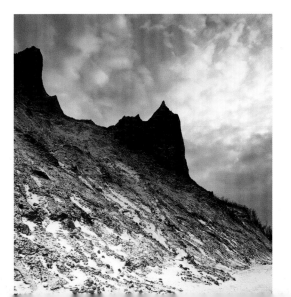

FOGGY MORNING *(above)*
Webster Park
A foggy morning in Webster Park, November 2008. 📷 **KIM PRICE**

CHIMNEY BLUFFS *(left)*
The long winter provides a firm but slippery walkway at the base of the bluffs, and the setting sun provides the dramatic and brilliant colors in the clouds. 📷 **CARL SMITH**

SUNBURST AT LETCHWORTH *(opposite top)*
A sunrise at Letchworth State Park in the fall is worth the short trip from Rochester. 📷 **CHARLES VAUGHN**

OH CANADICE *(opposite left)*
Canadice
When the sun broke through the clouds, the colors exploded on the hillsides just south of Harriet Hollister Spencer State Recreation Area. 📷 **ED WELCH**

GREAT BEND *(opposite right)*
Letchworth State Park
Letchworth in the fall is amazing! 📷 **CHRISTOPHER COVE**

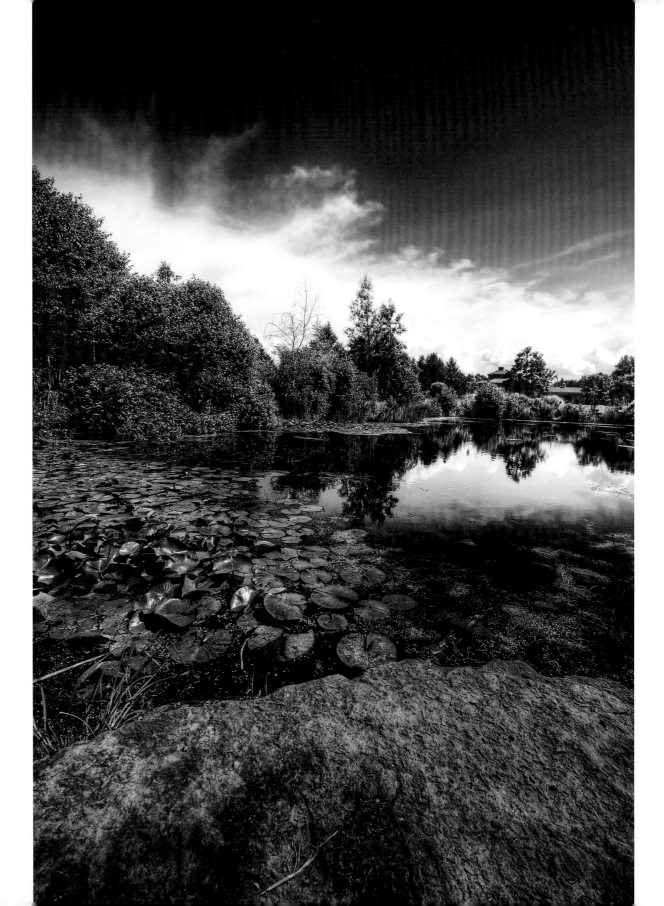

> "It's a little hidden gem of a spot ... hope it stays that way! — KIM PRICE/KENT PARK

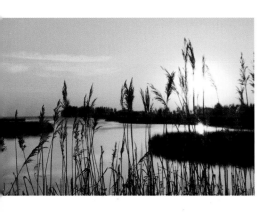

86

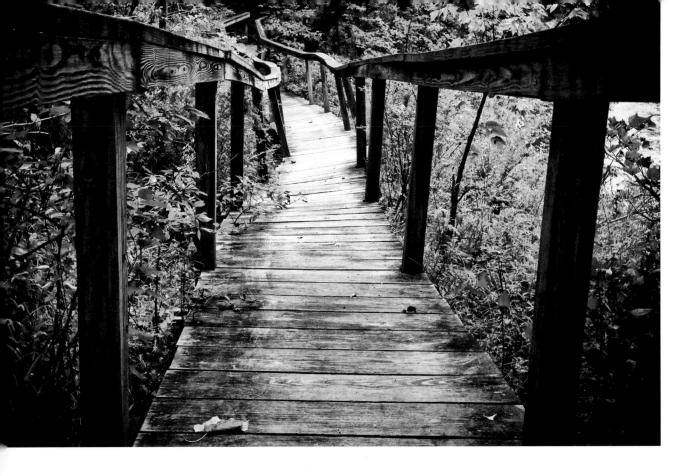

BEHIND THE WEEDS! *(opposite left)*
Greece
Braddock's Bay sunrise through the weeds.
📷 ROGER WELCH SR.

KENT PARK *(opposite right)*
Webster Arboretum
I spent some time with friends walking
through Kent Park in Webster, August 2009.
📷 KIM PRICE

TWISTED BIDGE *(left)*
Linear Park, Penfield
Do you wonder what's on the other side?
📷 ANDREW BLOOM

FALL CARPETING *(bottom left)*
Autumn on the Gorge Trail at Letchworth State
Park. 📷 MATTHEW CONHEADY

ALLEY *(bottom right)*
Rochester
A pathway between seasons. 📷 ANNE MEAGHER

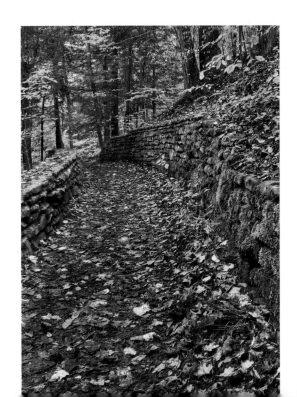

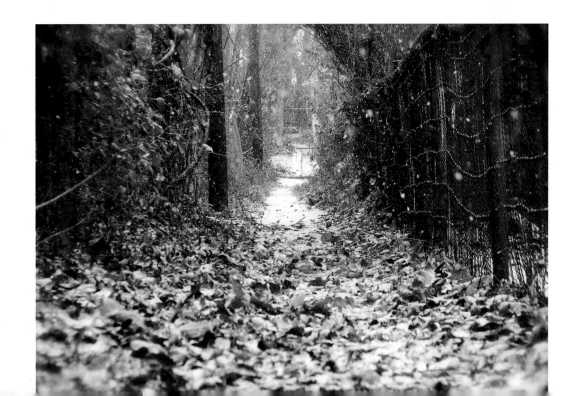

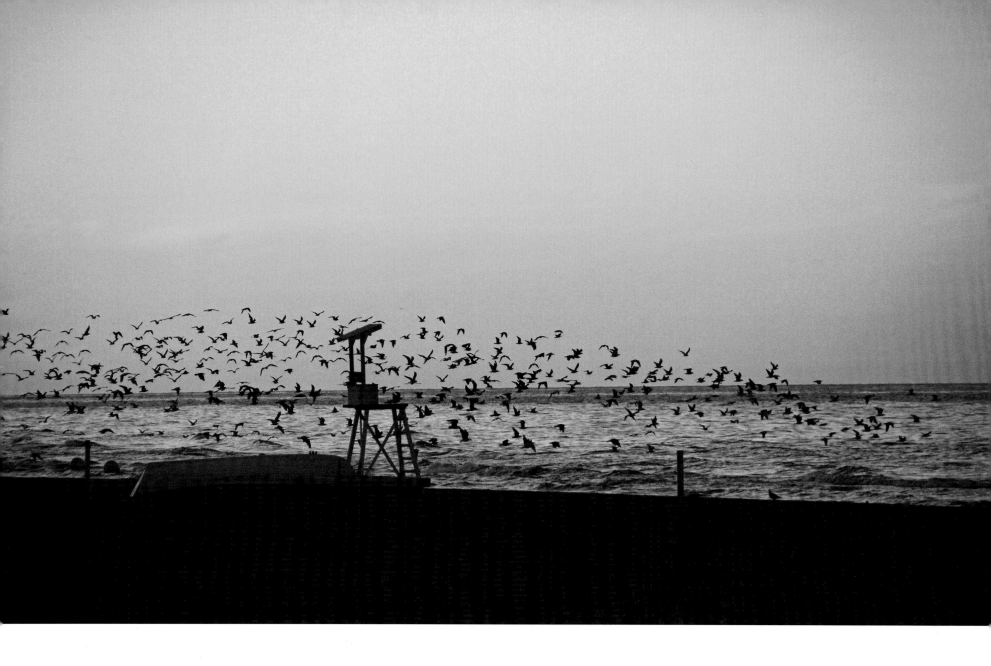

**LAKE ONTARIO
BEACH SUNSET** (above)
Charlotte
Rochester sunset from Lake Ontario Beach
Park. 📷 **MIKE PARK**

NORTON'S FALLS (opposite)
Genesee River, Rochester
Norton's Falls lies along the historic Carthage Trail, which was once
used as a point of access to the Genesee River by the Iroquois. White
settlers expanded the trail and founded the village of Carthage here in
1817. 📷 **MATTHEW CONHEADY**

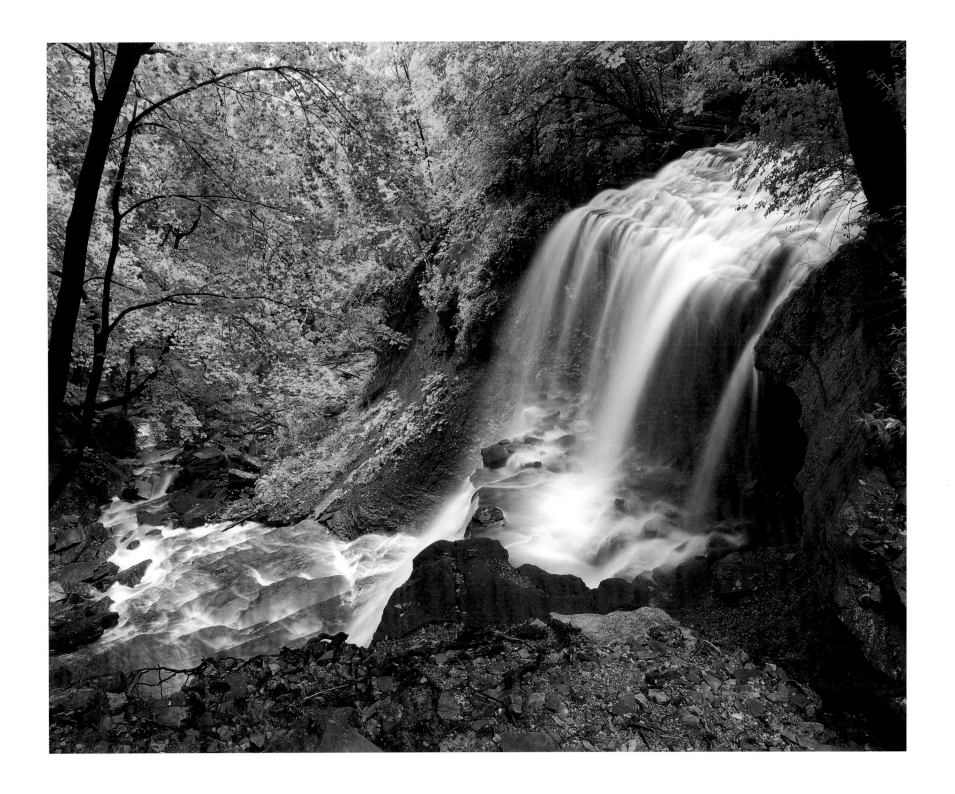

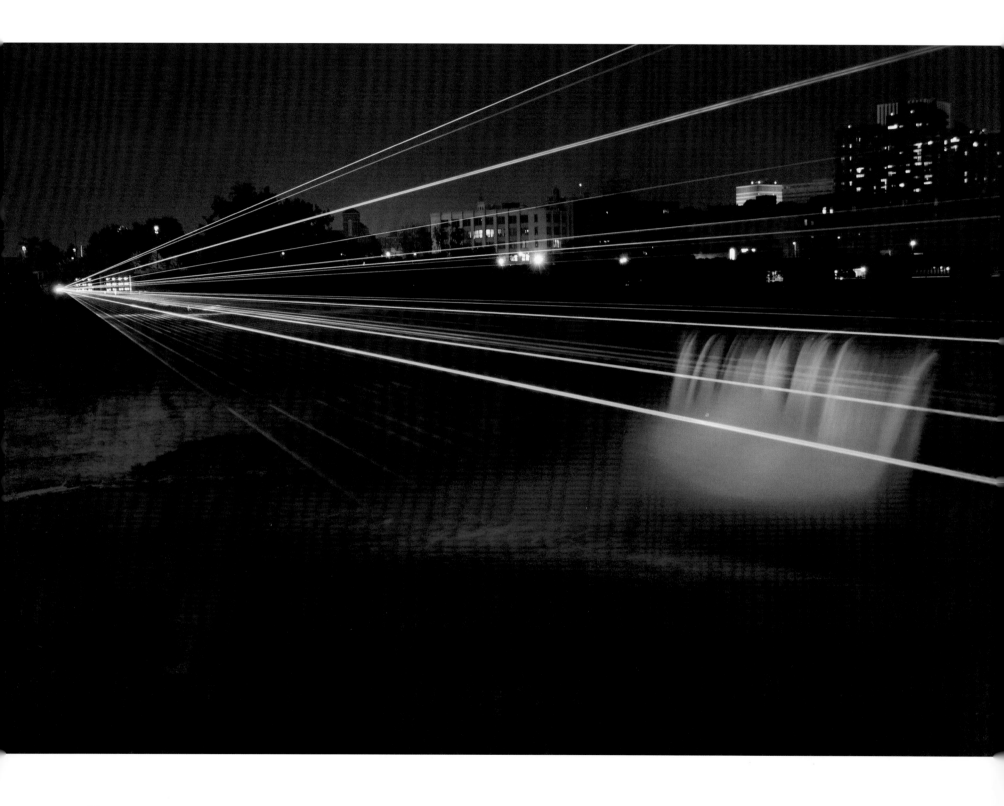

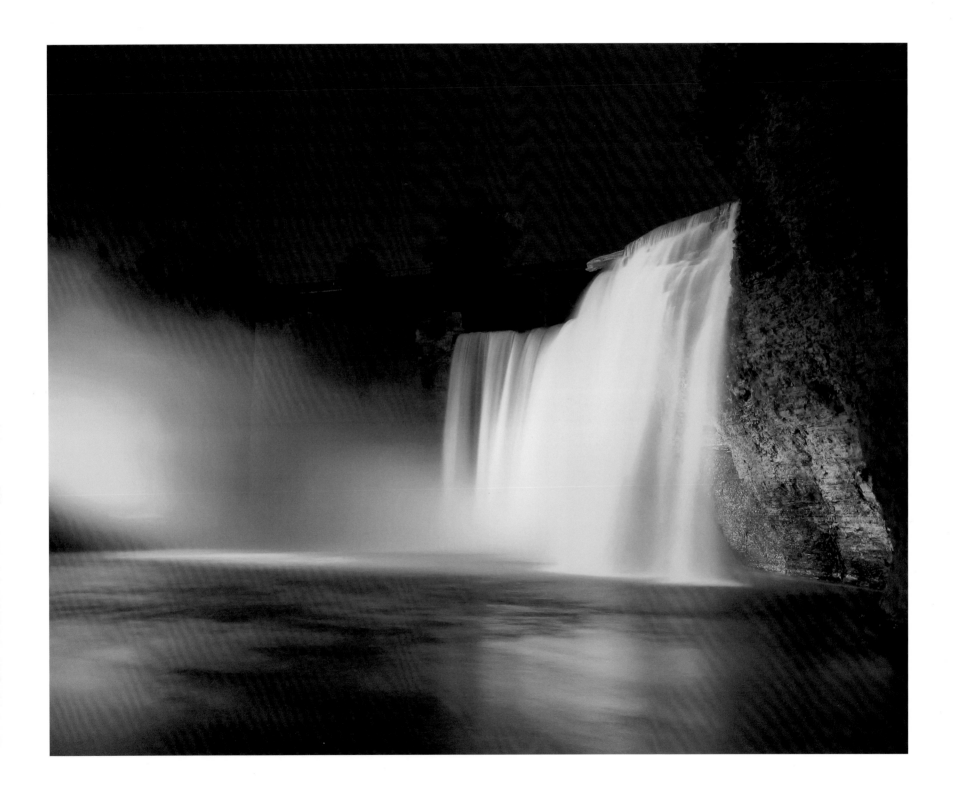

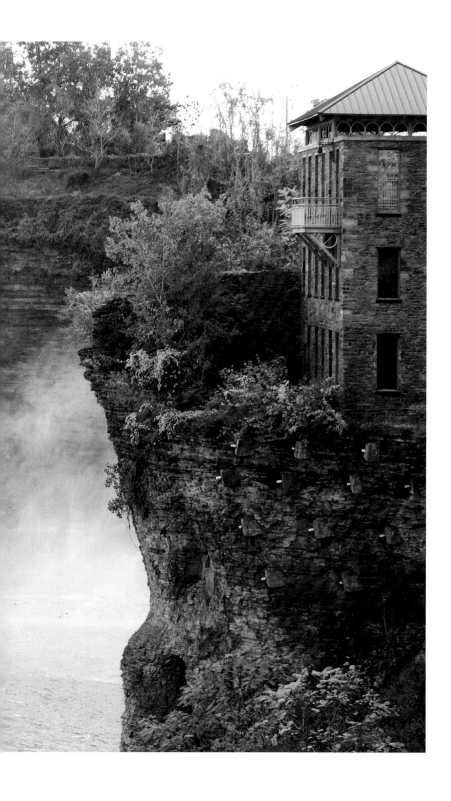

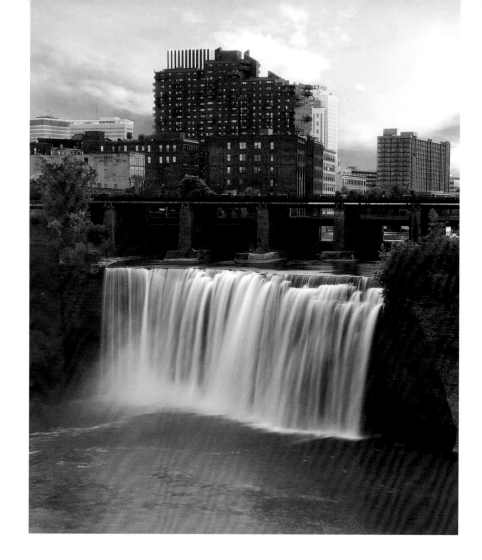

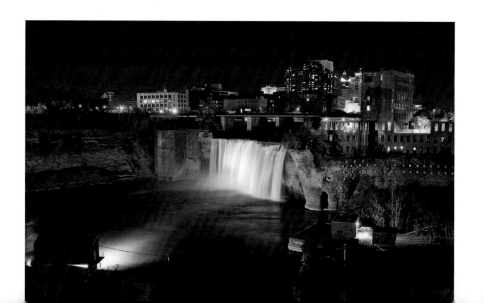

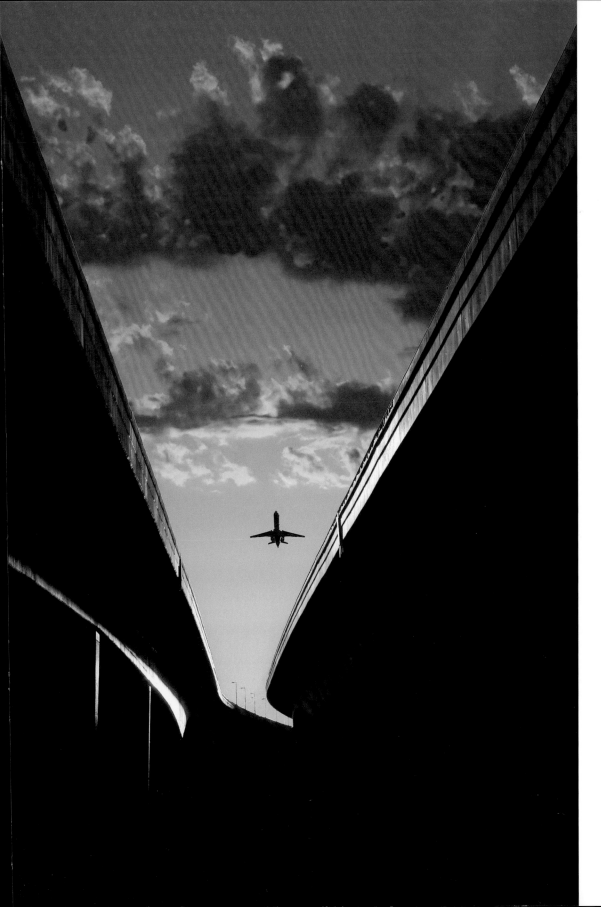

PLANE LEAVING AT SUNSET *(left)*
Greater Rochester International Airport
This was a difficult image to capture. I had to go back to this location many times to get the light right. At close to the summer solstice the sun would move across the opening of Rt. 390 that passes over the Genesee River. But I wanted the sun to light up the right side of the over pass and then the left side. So, I photographed the right side and waited for the sun to pass by the opening and light up the other side. Then I put the two images together. While I was waiting numerous airplanes would go by, but the sun was in the way. So, I waited and waited until almost sundown for a plane to go through. By the way, the engineers that built this bridge received a design award. The plaque is under the bridge. 📷 **DAVE VALVO**

CLIFF SIDE *(opposite left)*
High Falls on a beautiful fall day in Rochester. 📷 **APRIL MCEVOY**

HIGH FALLS SUMMER *(opposite top)*
High Falls, Downtown Rochester 📷 **MATTHEW CONHEADY**

HIGH FALLS AT NIGHT *(opposite bottom)*
Rochester's High Falls seen at night. 📷 **JEFF HAMSON**

HIGH FALLS LASER SHOW *(previous left)*
A laser show at High Falls. 📷 **CHRISTOPHER LAROSA**

BLUE FALLS *(previous right)*
Rochester's High Falls are bathed in blue light before the laser show, August 2009. 📷 **JOE RICCI**

SYMMETRY *(following left)*
Rochester, NY
The Douglass-Anthony Bridge is an engineering marvel from any viewpoint. 📷 **ED WELCH**

FREDDY SUE BRIDGE *(following right)*
The "Freddy Sue" Bridge, formally known as the Frederick Douglas – Susan B. Anthony Memorial Bridge.. 📷 **ELIUD RODRIGUEZ**

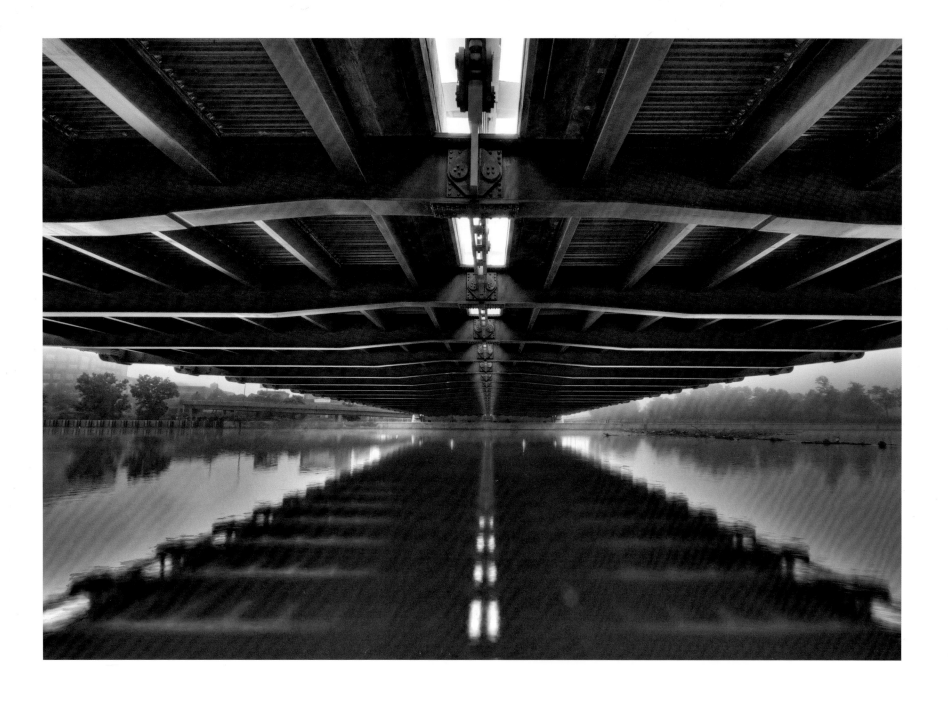

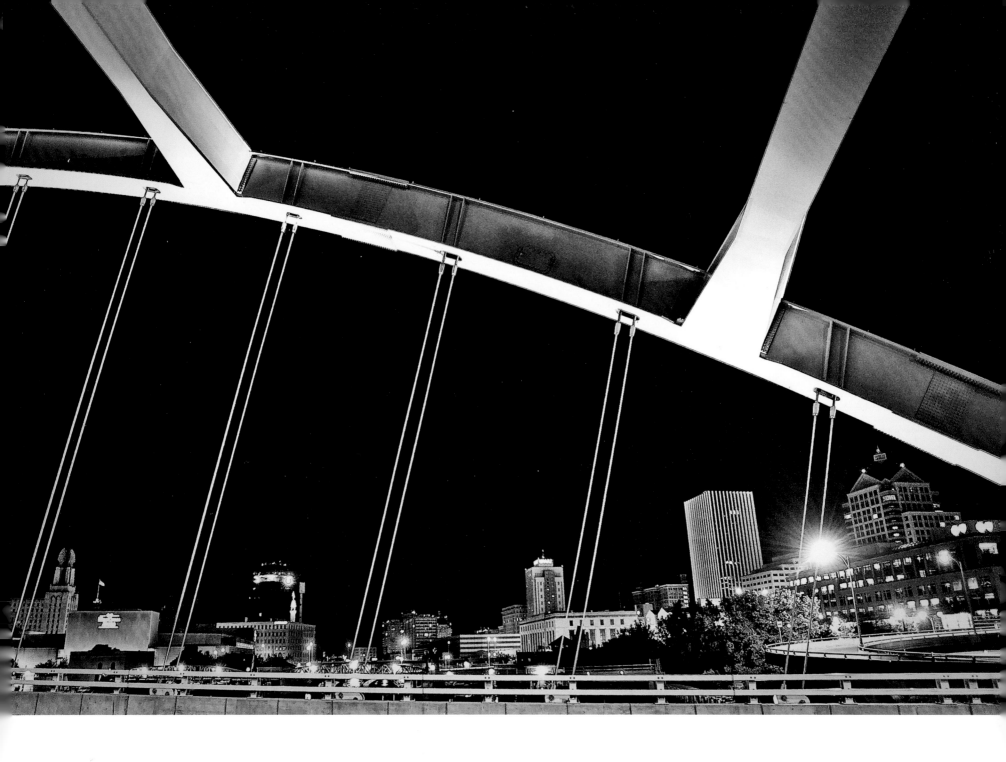

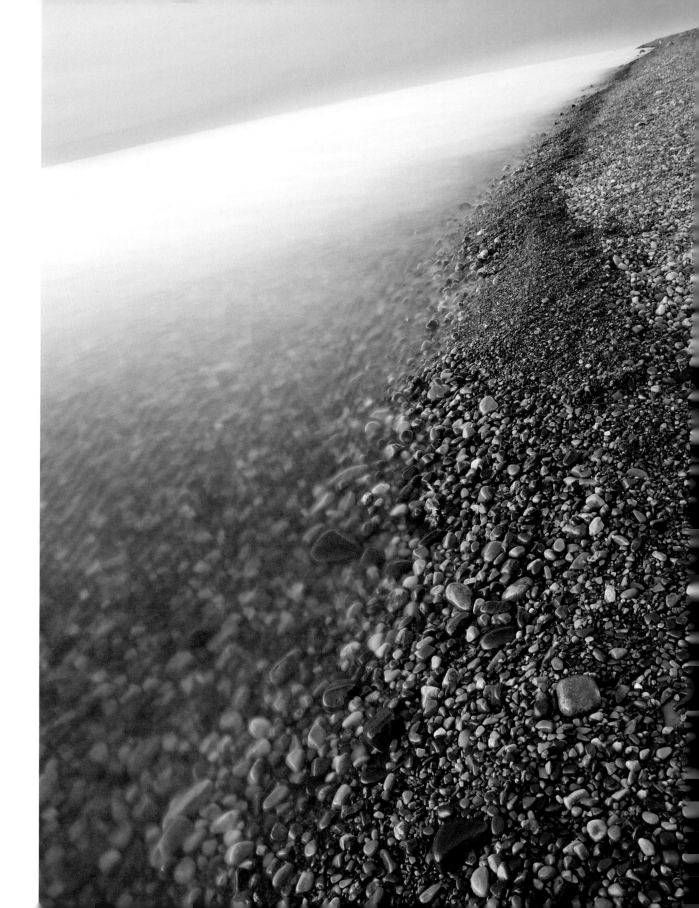

★ ONTARIO PEBBLE BEACH *(right)*
Lake Ontario shore, Wayne County
Glacial activity rounded and polished the various stones found along the shores of Lake Ontario. 📷 **MATTHEW CONHEADY**

FANNING THE SUN *(opposite left)*
Genesee River
We need to be quick when we see an interesting cloud formation in Rochester because it can dissipate so quickly, especially with a setting sun and its reflections. This photo is looking back on the Court Street Dam. 📷 **SHERIDAN VINCENT**

REFLECTIONS *(opposite top)*
Charlotte Pier
High waves and bright skies bring a magical gloss to the beat up pier. 📷 **MATTHEW CONHEADY**

DRIFTWOOD STUMP *(opposite bottom)*
Webster
Driftwood piles up along this jetty in Webster Park, along the shores of Lake Ontario. The wood is from trees that fall and wash into the Genesee River, which are then expelled into the lake from the river. The flow of the lake takes most of them east and many wash up on shore and get caught on the stone jetties.
📷 **TIM LEVERETT**

**GLOOMY
CHARLOTTE BEACH** *(following)*
The weather was intense. Walking the icy pier was difficult with the wind blowing freezing cold water across it. 📷 **CARL SMITH**

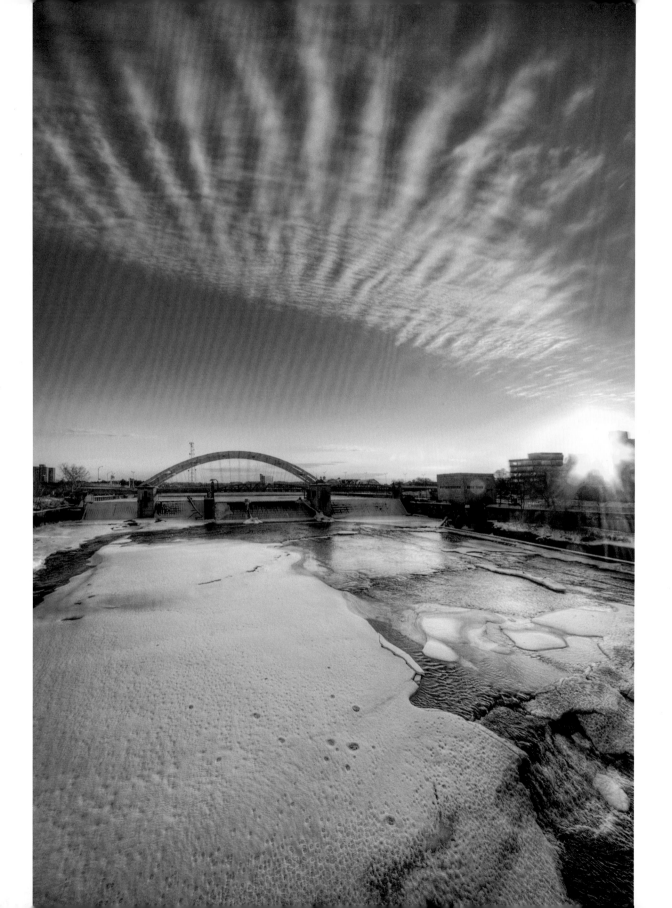

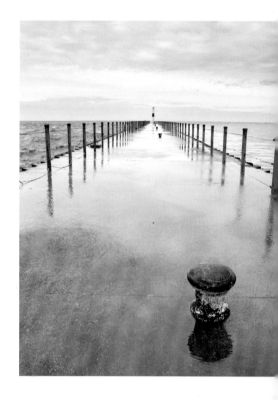

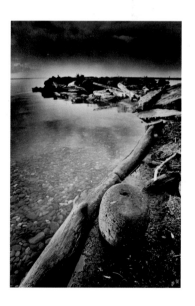

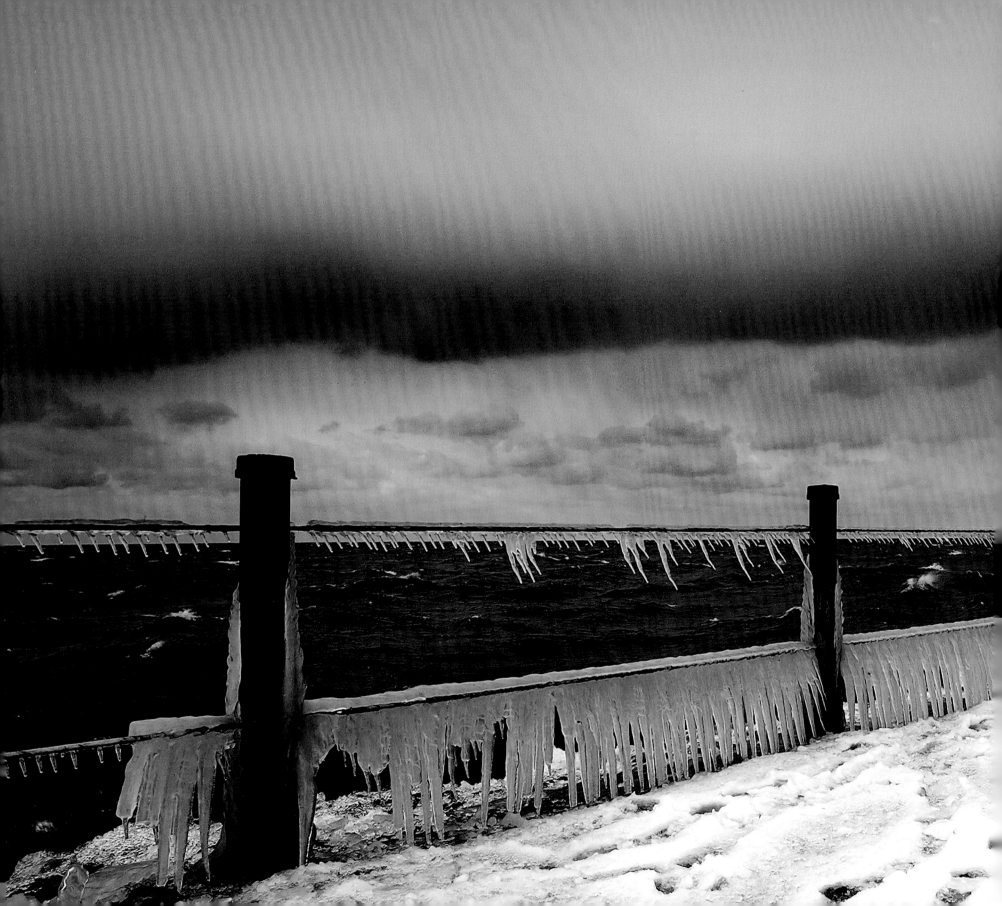

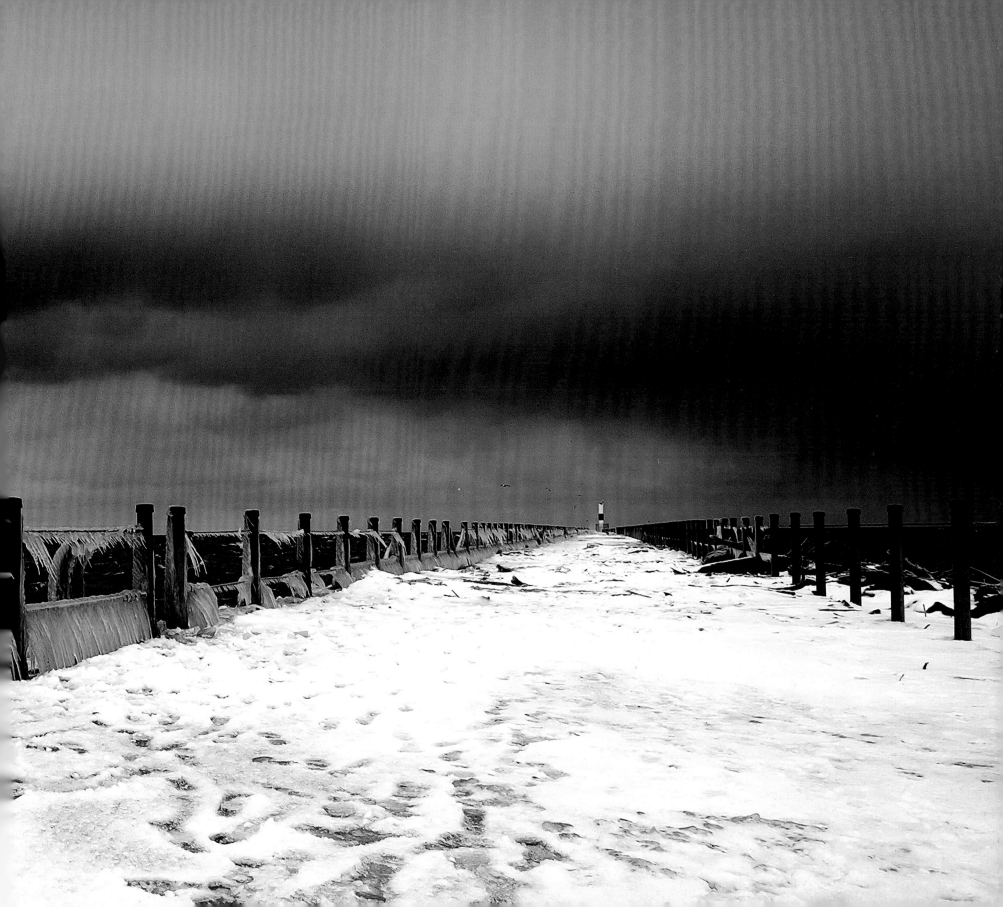

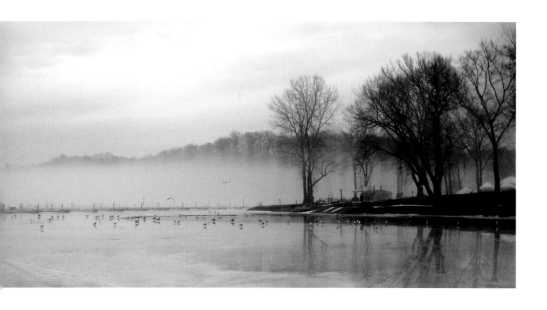

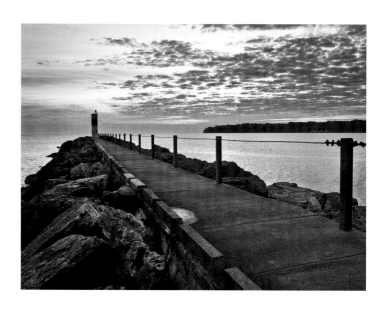

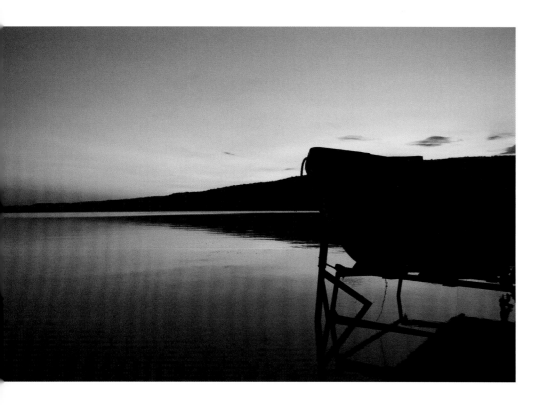

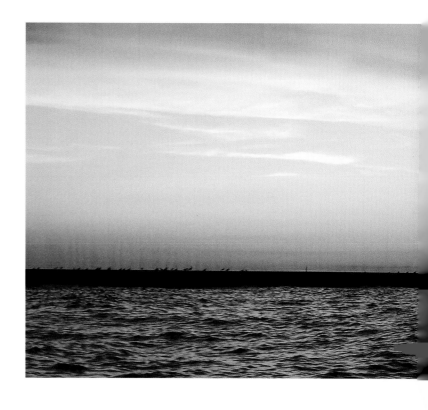

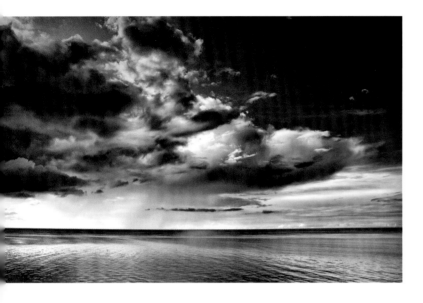

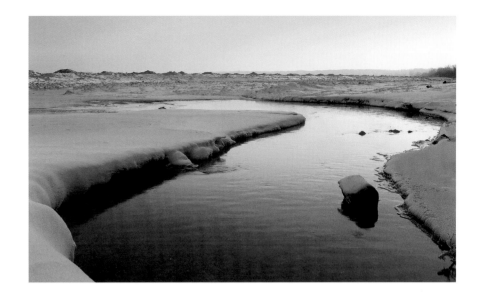

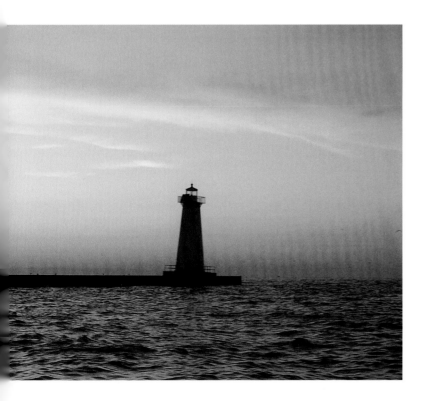

FIRE AND ICE *(top right)*
Lake Ontario is an amazing place to visit in the winter. 📷 **CHRISTOPHER COVE**

PASSING STORM *(top left)*
Webster
Storm clouds pass over Lake Ontario. Photo taken from a cliff edge in the Webster area.
📷 **TIM LEVERETT**

JULY 4TH WEEKEND *(left)*
Calm at Sodus Outer (Pierhead) Lighthouse, waiting for dark to see the 4th of July fireworks at Sodus Point. 📷 **AMY O'KEEFE-HYSER**

ICE AND FOG *(opposite top left)*
I was driving down Empire Boulevard and I looked over at Irondequoit Bay. I could not believe how beautiful the ice and fog looked. I had to stop and take photos. 📷 **SHERRY GRIFFO**

PIER AT SUNRISE *(opposite top right)*
A view along the Irondequoit Inlet Pier at sunrise. 📷 **STEVE LIGUORI**

DAWN ON THE LAKE *(opposite bottom left)*
Honeoye Lake
This photo was taken on a very still and quiet morning. The only moving things were bats returning from their night out. They seemed to just materialize out of the darkness and I could hear their wings beat as they swooped in from all directions around me. 📷 **KOREEN APPLEBY**

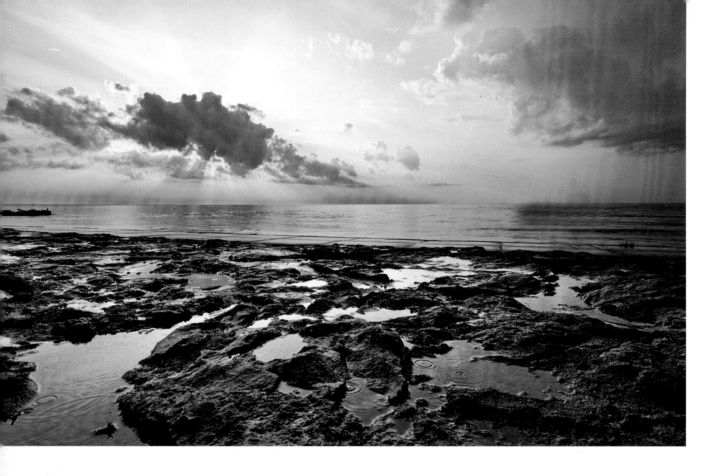

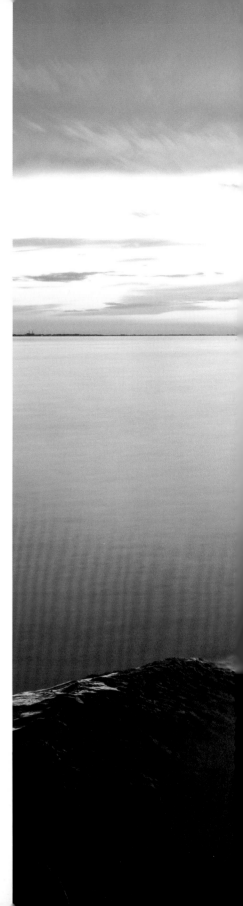

AFTER THE STORM (above)
The remains of a passing storm over Lake
Ontario at Webster Park. 📷 **STEVE LIGUORI**

TUESDAY'S CURTAIN CALL (right)
The light after the sun had set over Lake
Ontario at Webster Park. 📷 **TIM LEVERETT**

**CARDINAL STEALING
A SNACK** (following left top)
Mendon Ponds Park
This female cardinal wouldn't go away and
kept coming back for more bird seed — finally
allowing me to get close enough for this shot.
📷 **PRAMODH SENEVIRATNE**

**ANNUAL AUGUST
TREAT** (following left bottom)
Every August anticipation rises as the
sunflower fields in the Clover/Calkins Rd. area
approaches the blooming period. 📷 **ED WELCH**

SUNFLOWER (following middle)
Last summer I discovered a sunflower patch
on Shoecraft Road in Webster. I think they
are beautiful, and a lot of fun to photograph.
📷 **KIM PRICE**

SAW-WHET OWL (following right)
A Northern Saw-whet Owl roosting at Braddock
Bay. 📷 **MATTHEW CONHEADY**

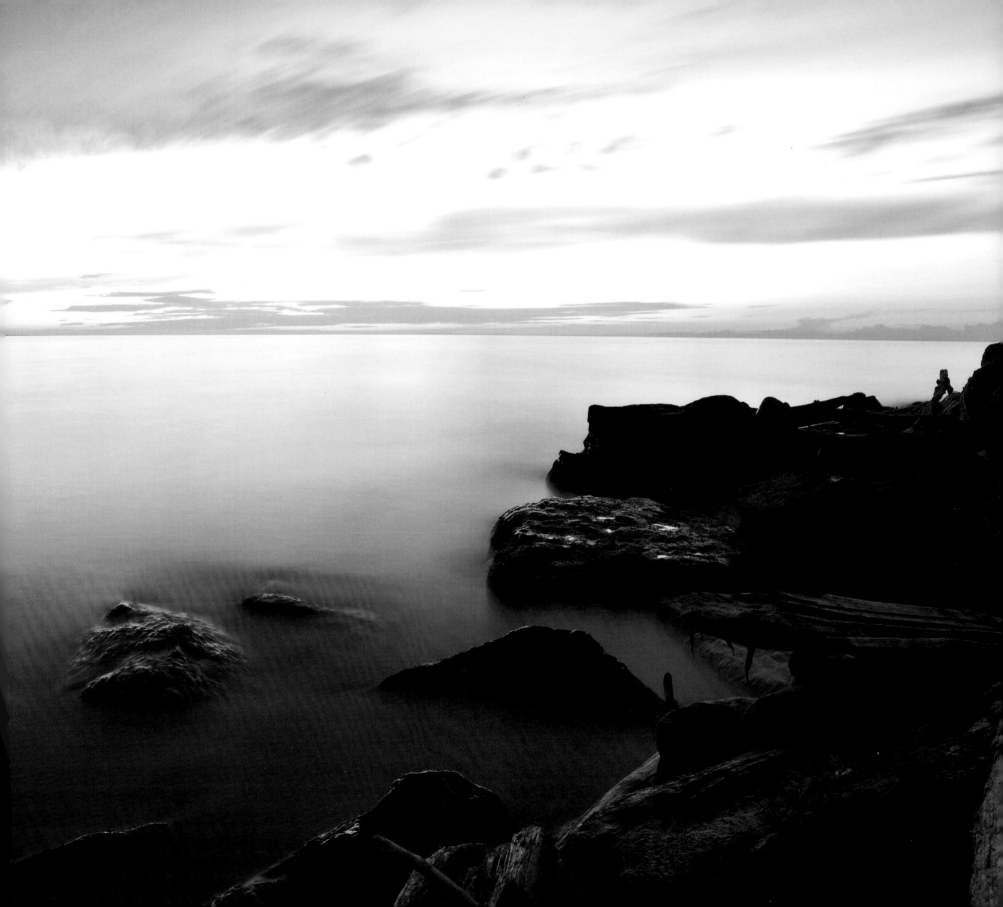

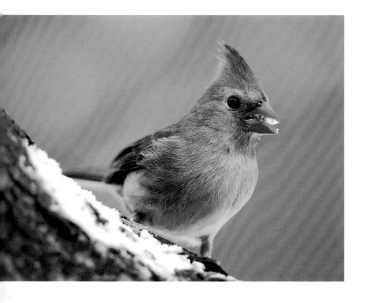

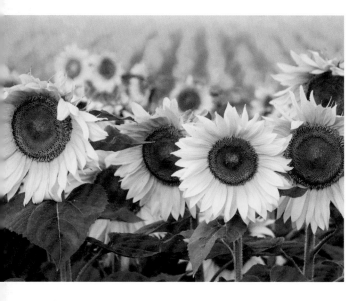

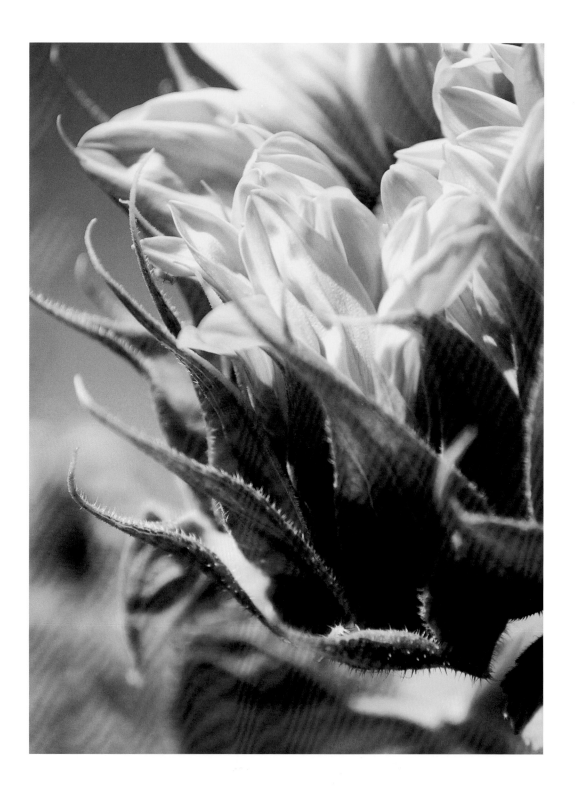

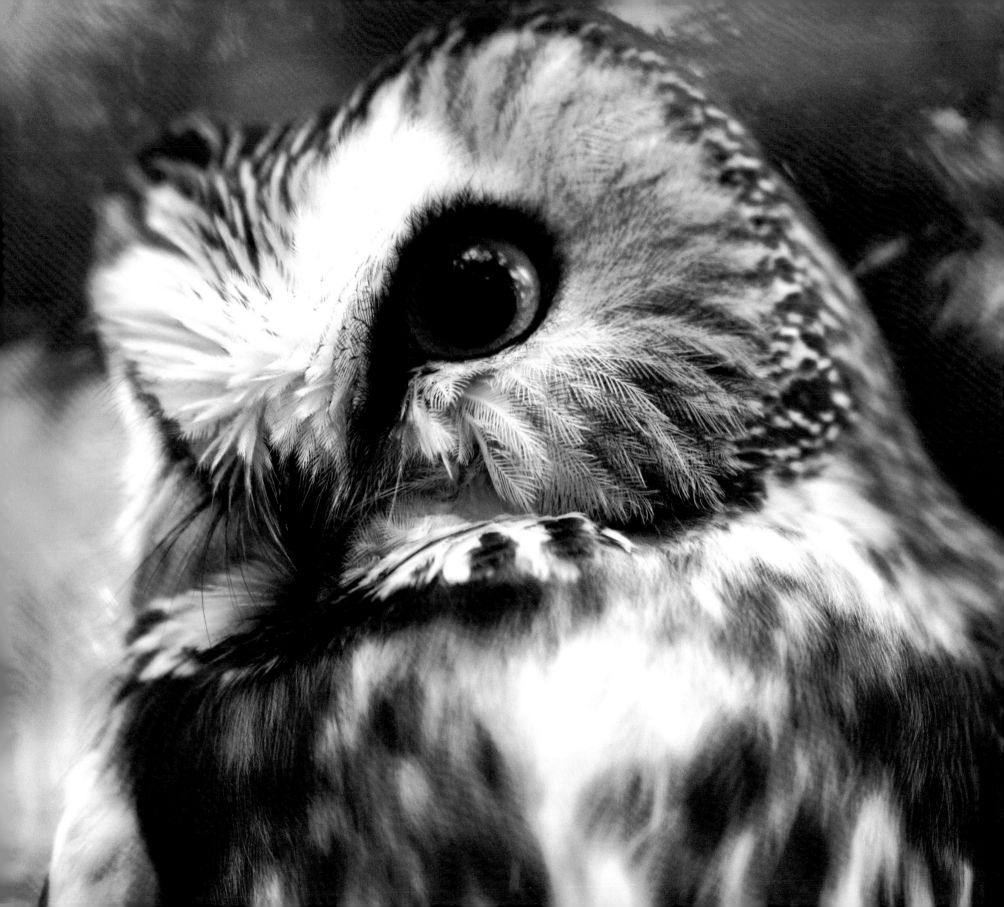

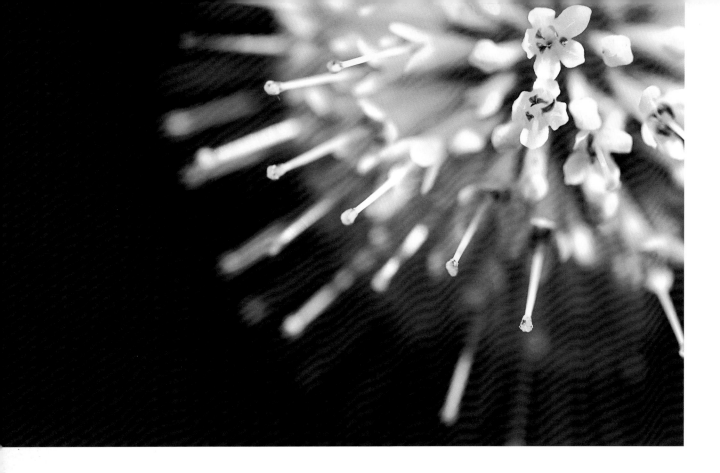

UNTITLED *(above)*
Kent Park, Webster Arboretum
I came across the coolest looking bush during my walk through Kent Park. This is a closeup of one of the flowers. It reminded me of a blow fish. 📷 **KIM PRICE**

DEW COVERED WEB *(right)*
I was really glad to have a macro lens on hand when I came across this dew covered spider web on an early morning trek through the woods. 📷 **ROBERT LANGEN**

ANGEL PAINTING *(following left)*
Greece
These designs were on my bedroom window when I woke up one morning last February. Temperature outside was 5 degrees. I have never seen anything so intricate like it before. When the sun came up they were gone. I'm sure my guardian angel painted them while I was asleep. Actually, they are hoarfrost designs on window glass. 📷 **DAVE VALVO**

NICE HAIR DO! *(following top)*
A male Red-breast Merganser with the wind blown look on Lake Ontario. 📷 **CHRISTOPHER COVE**

WHAAAAA? *(following bottom)*
Tinker Nature Park, Henrietta
Salt Does What? Nooo! I'm too young to die! Mr. Snail rather surprised about our eye-opening conversation. 📷 **LISA FAUBER**

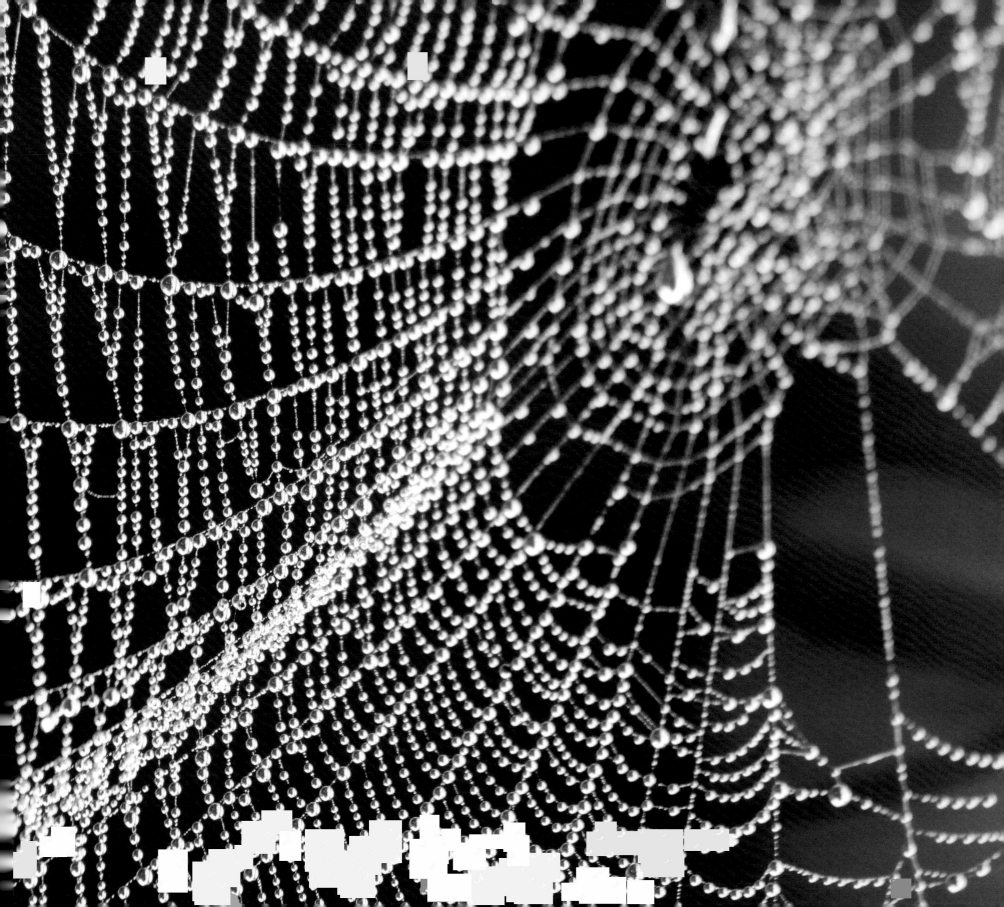

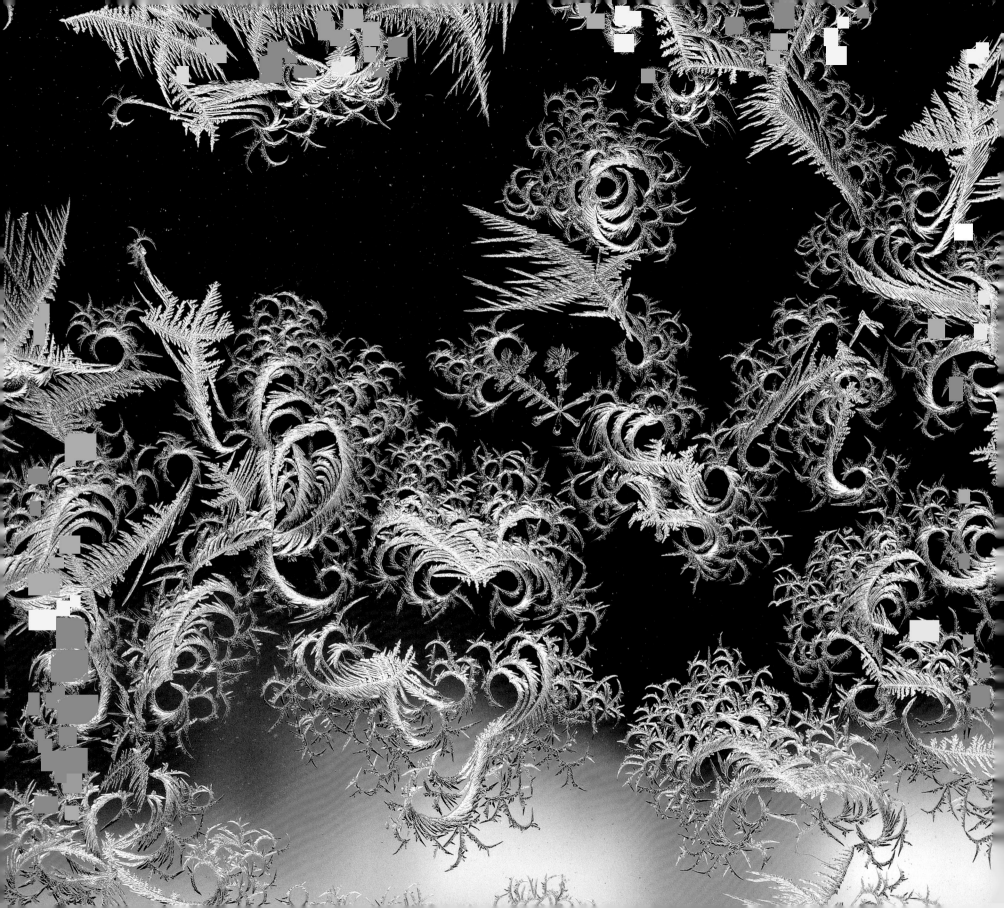

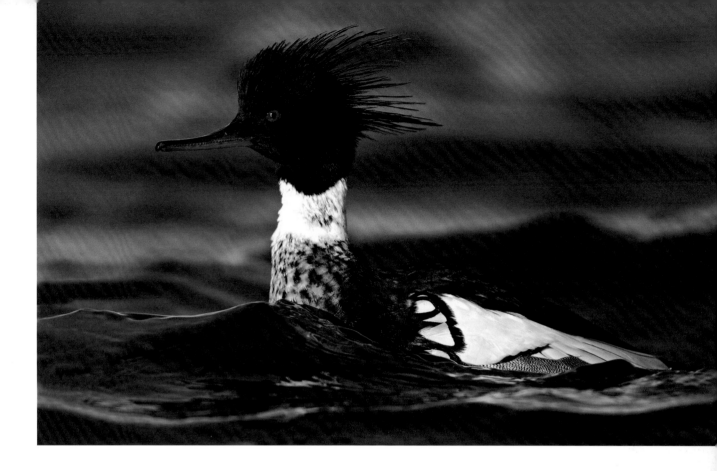
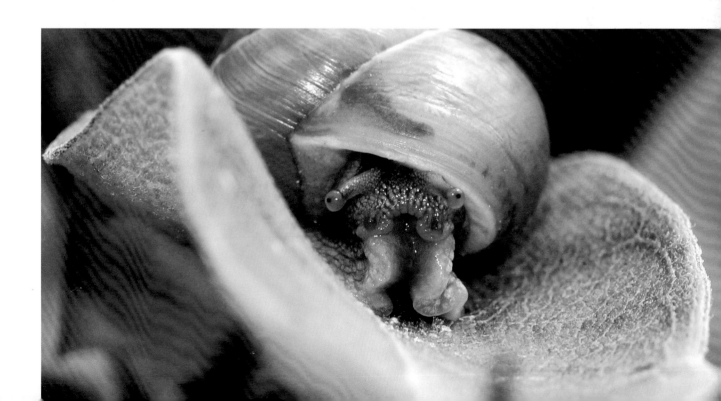

Pets

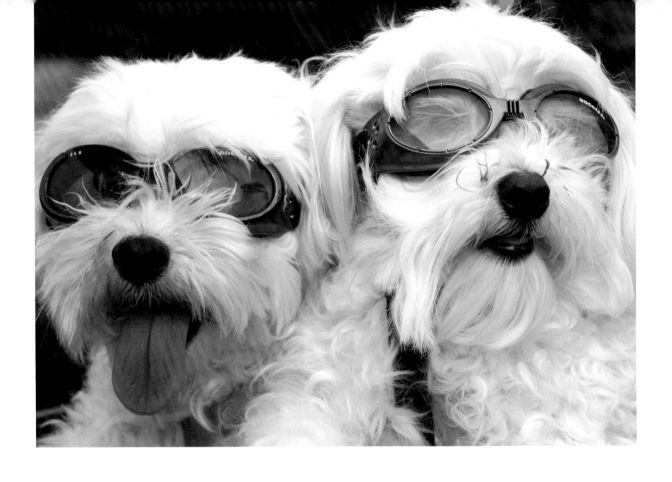

> "Enzo wants to drive, but Bubba thinks he is in charge... I think I'll drive. — **BOB BURDEN**

THE BOYS ARE READY TO GO! (top)
This is Bubba and his little brother, Enzo, ready for their ride in the car. 📷 **BOB BURDEN**

ROXY THE ENGLISH BULLDOG (bottom left)
Are you kidding me right now? Really?
📷 **TRACIE CANTIE**

MINI SCHNAUZERING (bottom right)
Penfield
Two miniature schnauzers playing together.
📷 **DAVID SELBY**

★ **SMILING SCHNAUZER** (following left)
Penfield
A miniature schnauzer puppy. 📷 **DAVID SELBY**

OUT ON THE TILES (following right)
West Irondequoit
My weimaraner, Marty, concentrating on the treat in my hand. 📷 **JEFF GEREW**

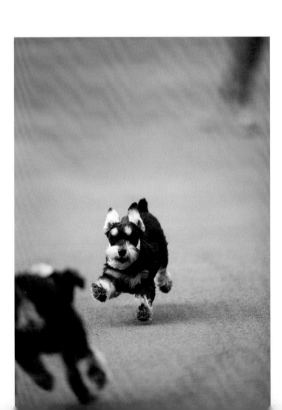

111

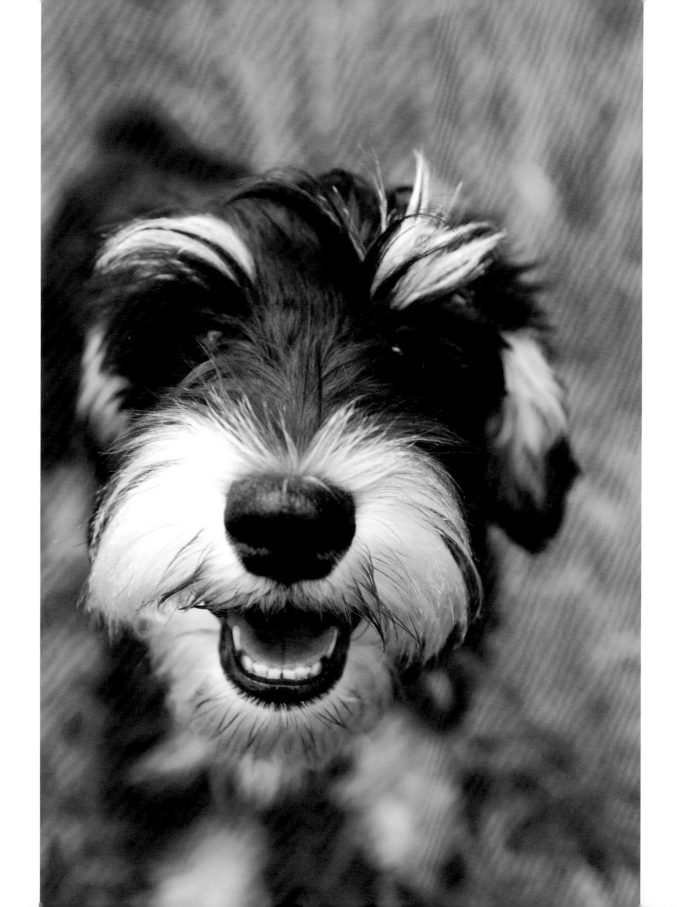

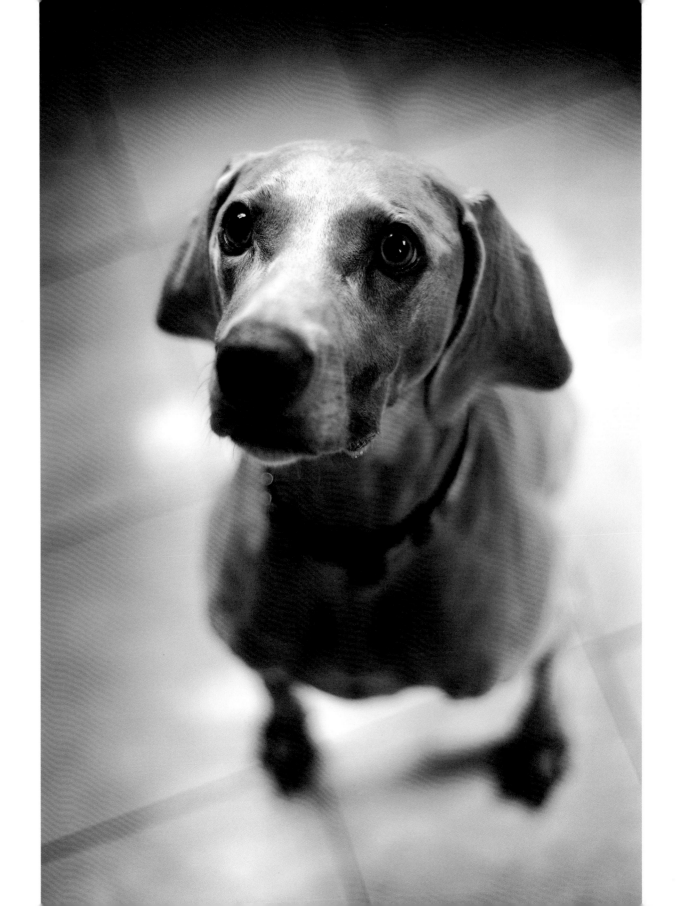

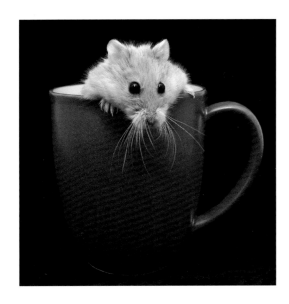

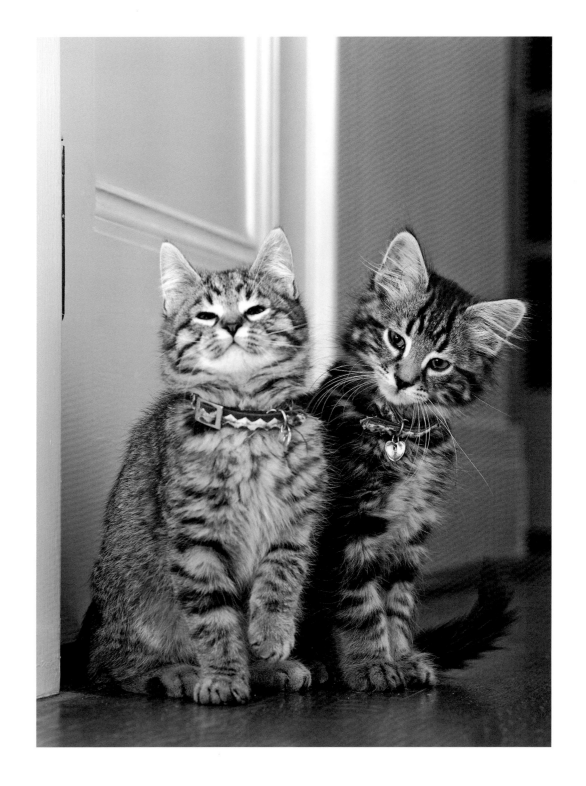

MIMI THE HAMSTER. *(above)*
Chili
Mimi the fancy dwarf hamster. 📷 **MATTHEW CONHEADY**

POSE FOR THE CAMERA *(right)*
Rochester
Tiger and his brother, Stripes, as kittens! 📷 **CHRISTOPHER COVE**

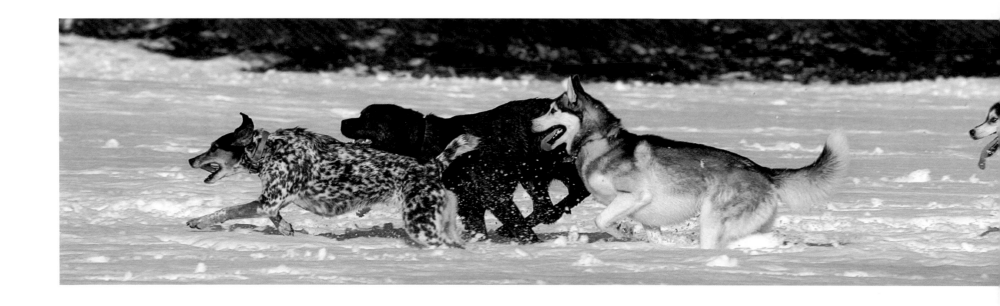

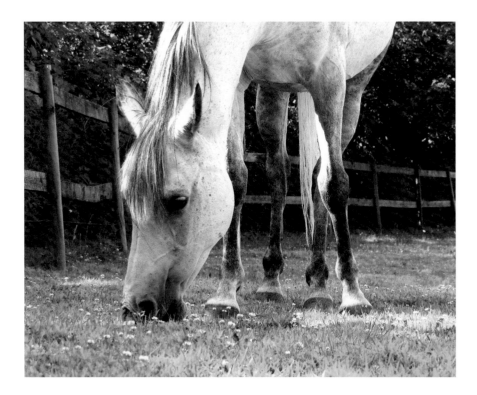

LEADER OF THE PACK *(above)*
East Rochester
The lead dog has some spectacular markings. I think this shows the sheer joy of running free 📷 **RICH ENGELBRECHT**

GRAZE OF GLORY *(left)*
My Arabian mare Khallera could not be more content. For what else is there in life but grazing? 📷 **LAURIE DIRKX**

TOOTIE *(following left top)*
My boy, Tootie. 📷 **CATHY HANDT**

TAKING SHELTER *(following bottom left)*
Just weeks old, this warmblood colt took shelter under his mother while I admired him. 📷 **AJ SHARLOW**

IGUANA SALUTATIONS *(following bottom middle)*
Henrietta
Baby green iguana, waiting to strike a pose. 📷 **LISA FAUBER**

★ **FENCED IN BEAUTY** *(following right)*
Shoemaker Road, Webster
I drive by this guy just about every day and this was the first time I thought to stop and take his picture. 📷 **KIM PRICE**

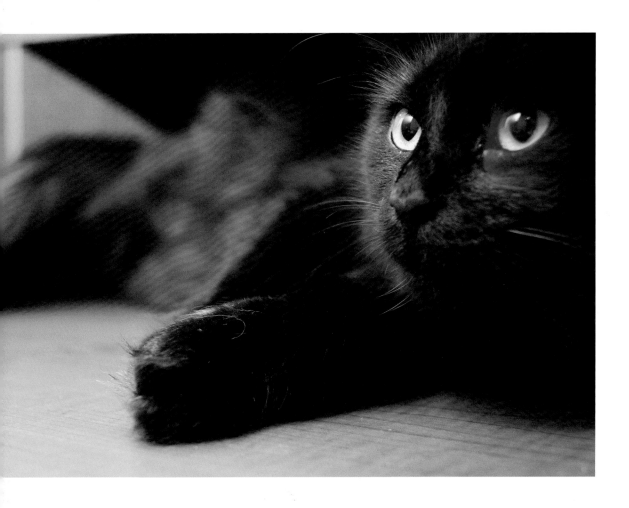

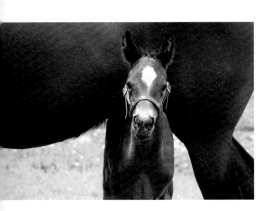

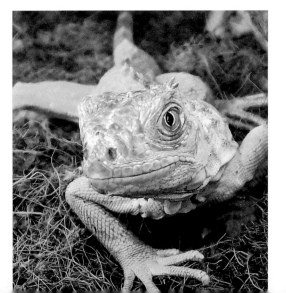

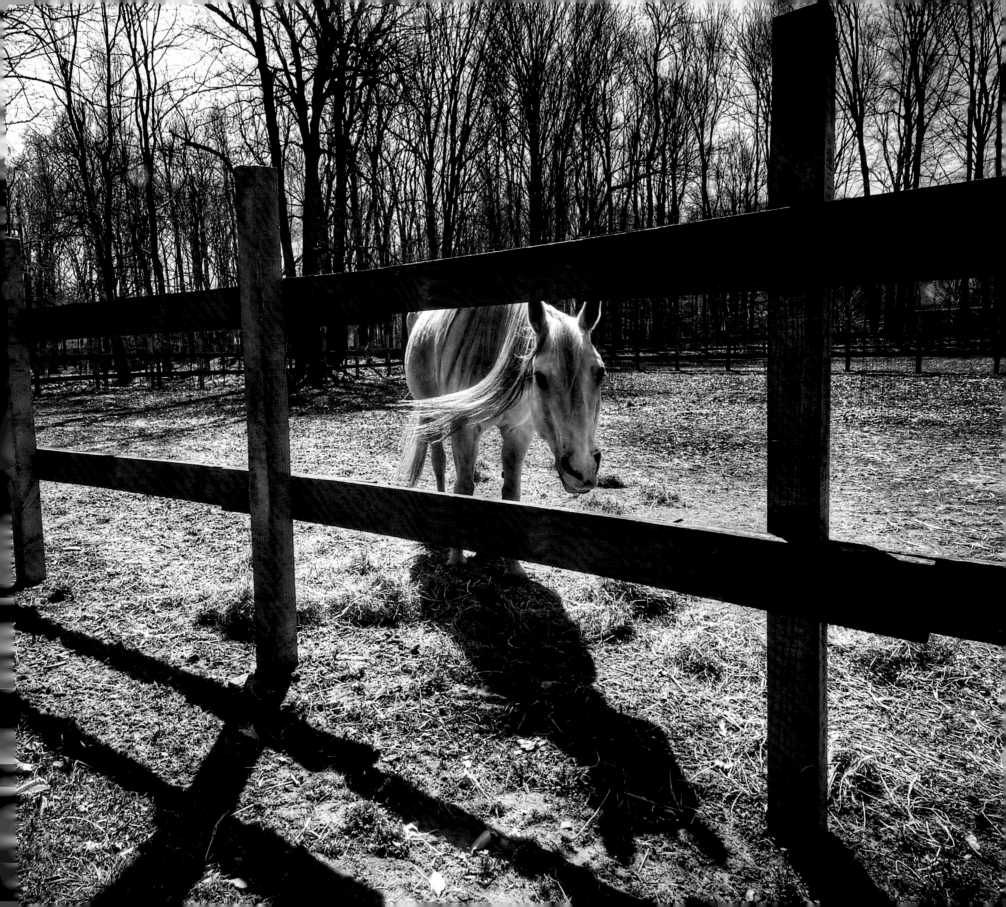

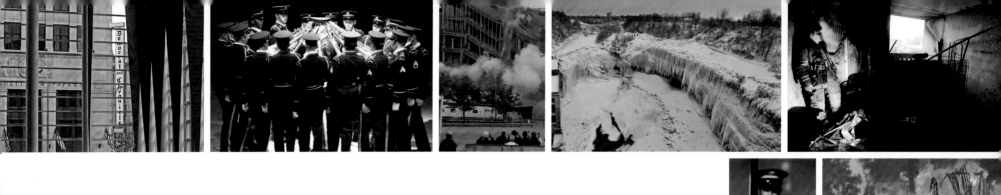

Newsworthy

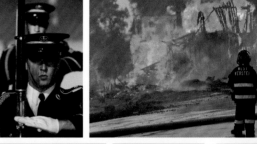

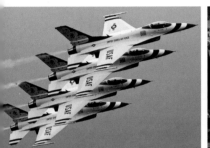

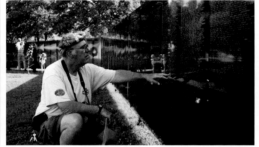

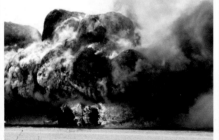

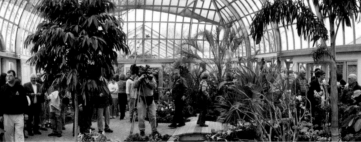

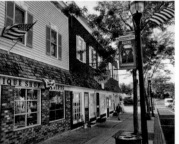

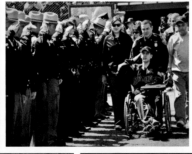

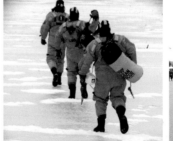

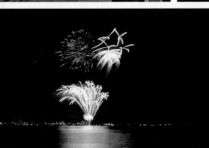

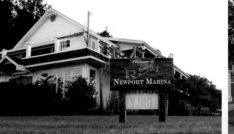

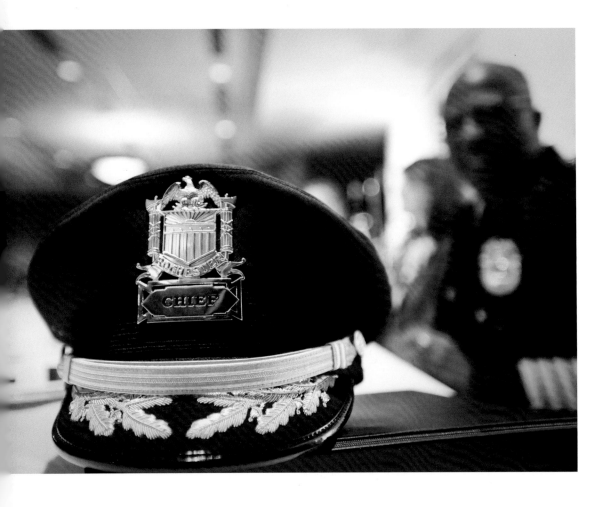

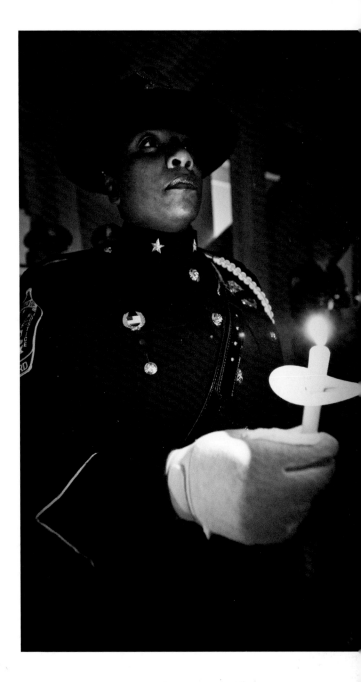

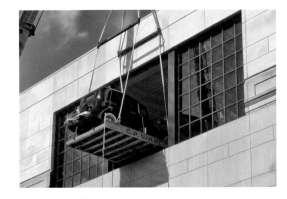

★ **CHIEF** (above)
David T. Moore, Chief of Police in Rochester.
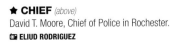 **ELIUD RODRIGUEZ**

DRIVE-THROUGH WINDOW (right)
A 1936 Cunningham-Ford town car is loaded
into a third floor window of the Rochester
Museum & Science Center. A part of the mu-
seum's collection, this car was custom-made
for Rochester socialite Charlotte Whitney Allen
and is being readied for display. 📷 **JOE RICCI**

VIGIL (far right)
Candle-light vigil honoring all local depart-
ments. 📷 **ELIUD RODRIGUEZ**

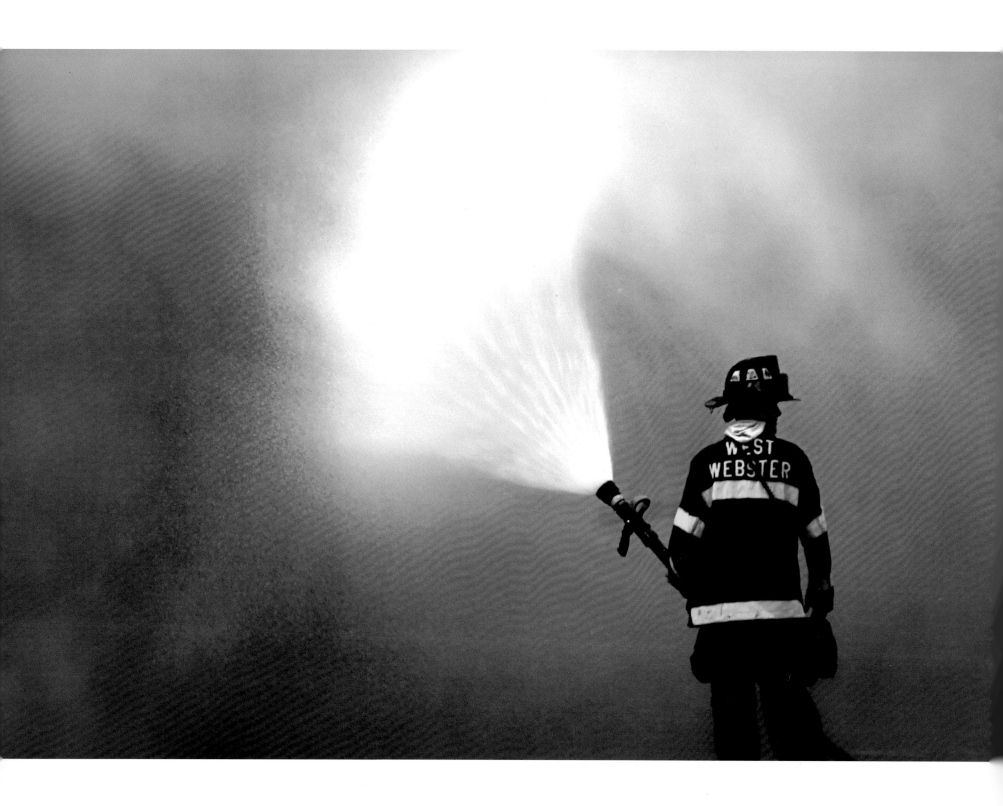

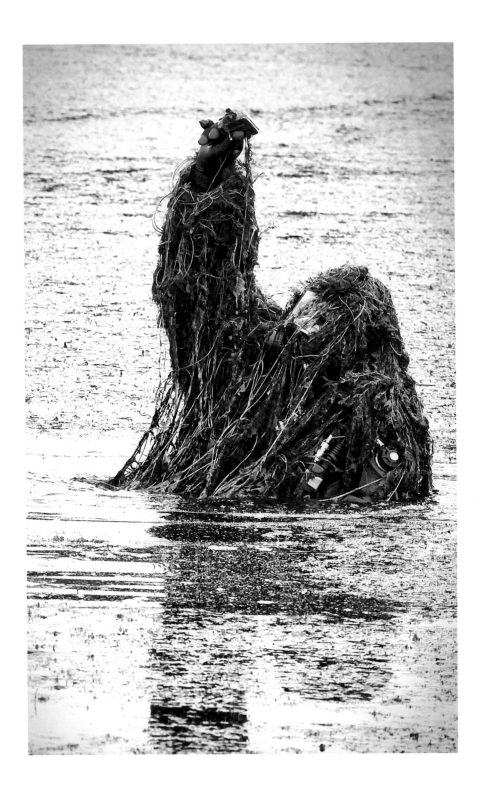

★ WATERED DOWN (opposite)
Webster
Taking out the fire. 📷 TOM GRIFFO

POLICE SCUBA DIVER (left)
Police scuba diver demonstrates locating evidence in a difficult water environment.
📷 ELIUD RODRIGUEZ

REFLECTIONS OF AN ACCIDENT SCENE (below)
390 Northbound at the 590 Split
This tractor trailer crashed and jumped the barriers. I saw the aftermath and pulled around to the Brighton Town Park park and ran through the trails in the rain to capture this scene.
📷 DAN DANGLER

SPONTANEOUS COMBUSTION (bottom)
East Groveland Road, Groveland
I was following this tractor down the road when the hay suddenly burst into flames. The driver is attempting to separate the tractor from the wagon before it too catches fire. 📷 JESSICA BRICK

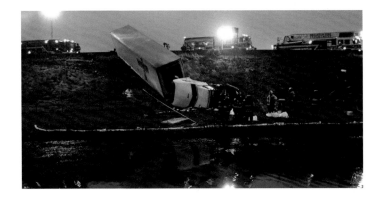

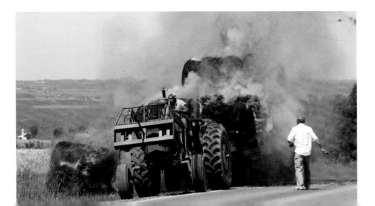

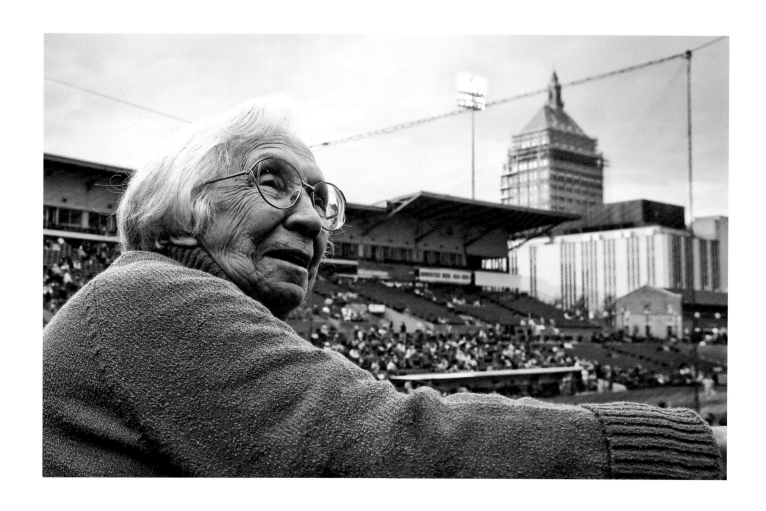

DORIS FOX *(above)*
First female Knot Hole Gang member, Doris
Fox, passed away this year. She was honored
on July 6 and threw out the first pitch. She was
90 years old. 📷 **ELIUD RODRIGUEZ**

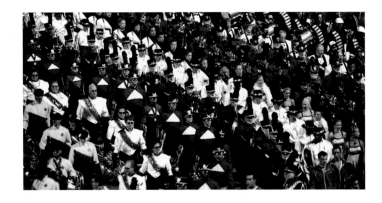

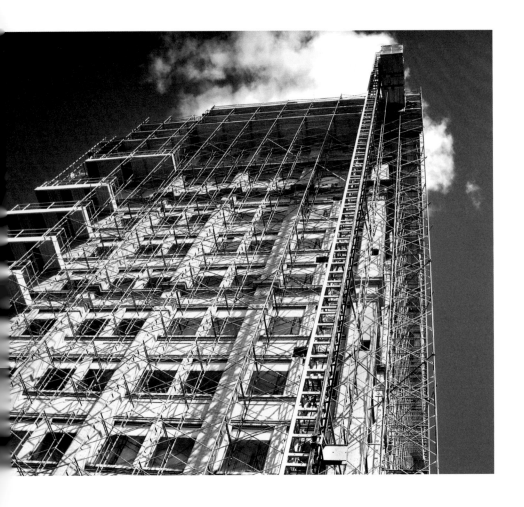

PARADE OF CHAMPIONS *(above)*
Rochester
Members of various drum corps march into Rhinos Stadium for the awards ceremony following the final day of competition at this year's DCA Championships. 📷 **SEAN MCGINNIS SCANLON**

REBUILDING A GIANT *(left)*
Downtown Rochester
Scaffolding and work elevators cover Eastman Kodak Company's 19-story corporate headquarters for a reported two-year, multi-million dollar repair project. Fracturing terra cotta on the upper floors is being repaired and replaced. 📷 **JIM FORGER**

Arts, Culture & Food

SPONSORED BY VISITROCHESTER

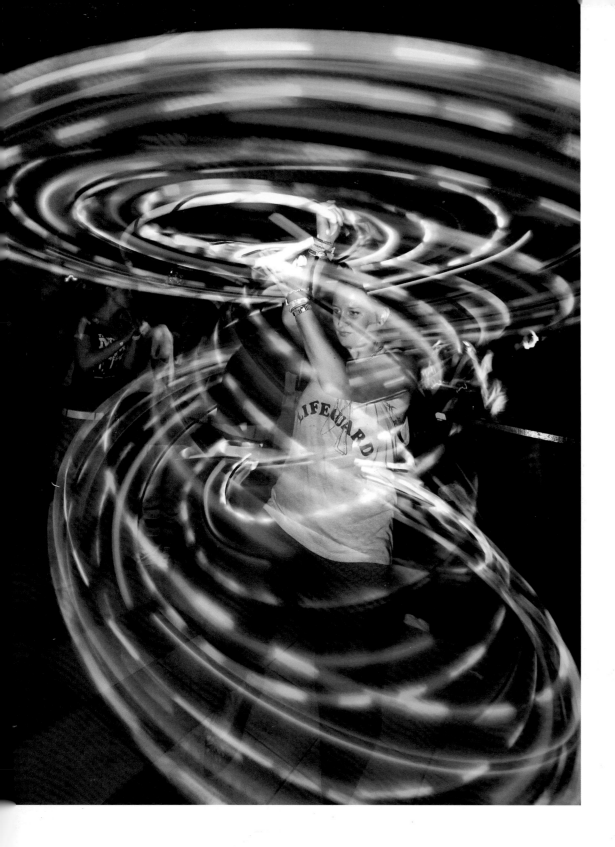

HOOPIN IT *(left)*
Holly Rutkowski twirls a hula-hoop at Dubland Underground.
📷 **RICH PAPROCKI**

DANCING LOCAL CELEBS *(following left)*
Inn On The Lake, Canandaigua
Rochester grocery king Danny Wegman dances the night away with wife Stency at the Rochester City Ballet benefit called Motown at the Inn On The Lake in Canandaigua. 📷 **TIM LEVERETT**

★ **ROCHESTER CITY BALLET** *(following right)*
Rochester City Ballet Studios, Rochester
Rochester has a world class ballet and contemporary dance company in Rochester City Ballet. Along with the classic Nutcracker performed yearly with the Rochester Philharmonic Orchestra, Rochester City Ballet provides a diverse repertoire of contemporary dance set to music from contemporary and popular music artists. This is not the old "stuffy" ballet you thought you knew from the past. It is live performances filled with fiery emotion, intense concepts and artistic vision, great live musicians of all styles, and a comfortable accessibility for even those who have never seen a dance performance before. Be sure to check them out in their newly remodeled home theater at Nazareth Performing Arts Center. 📷 **TIM LEVERETT**

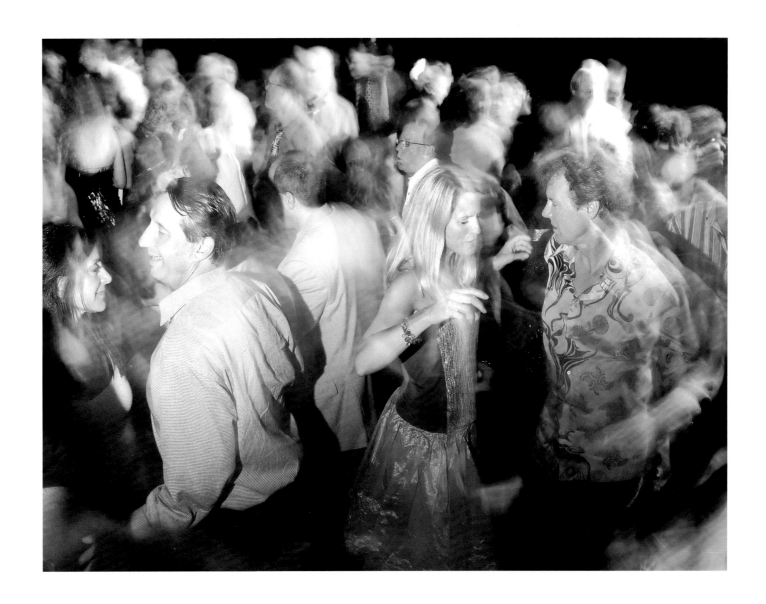

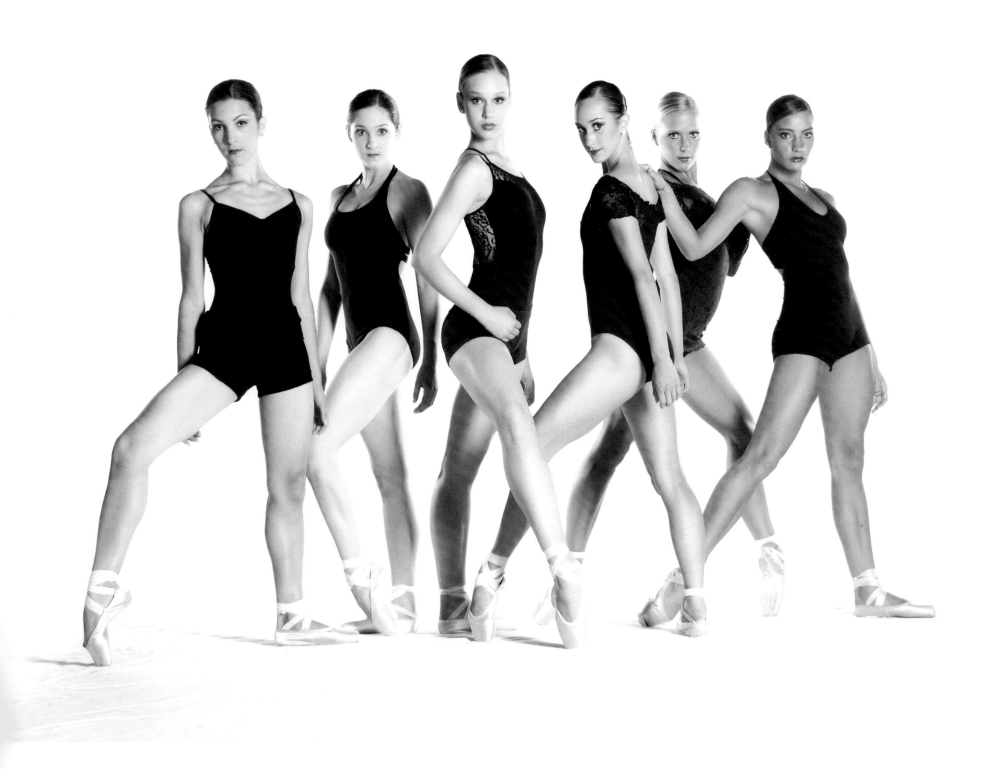

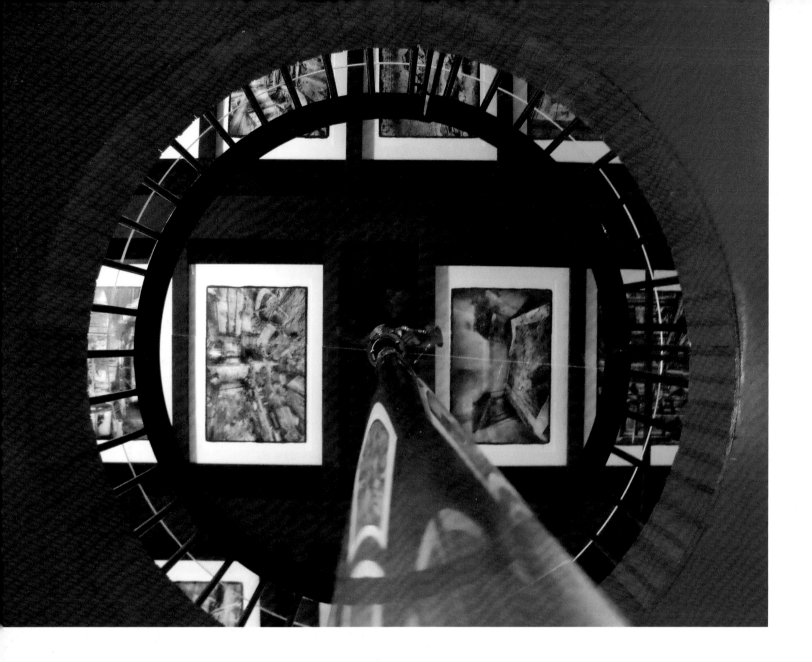

**SECOND FLOOR
CEILING ART** (above)
Second floor, fire station ceiling art at Artisan
Works, Rochester. 📷 **DAVID SCHROEDER**

LITTLE THEATRE HORROR MOVIE? (right)
I take photos for my college's magazine, this is one I took at the
Little Theatre on East Avenue. The models for this picture did great!
📷 **SCOTT SULLIVAN**

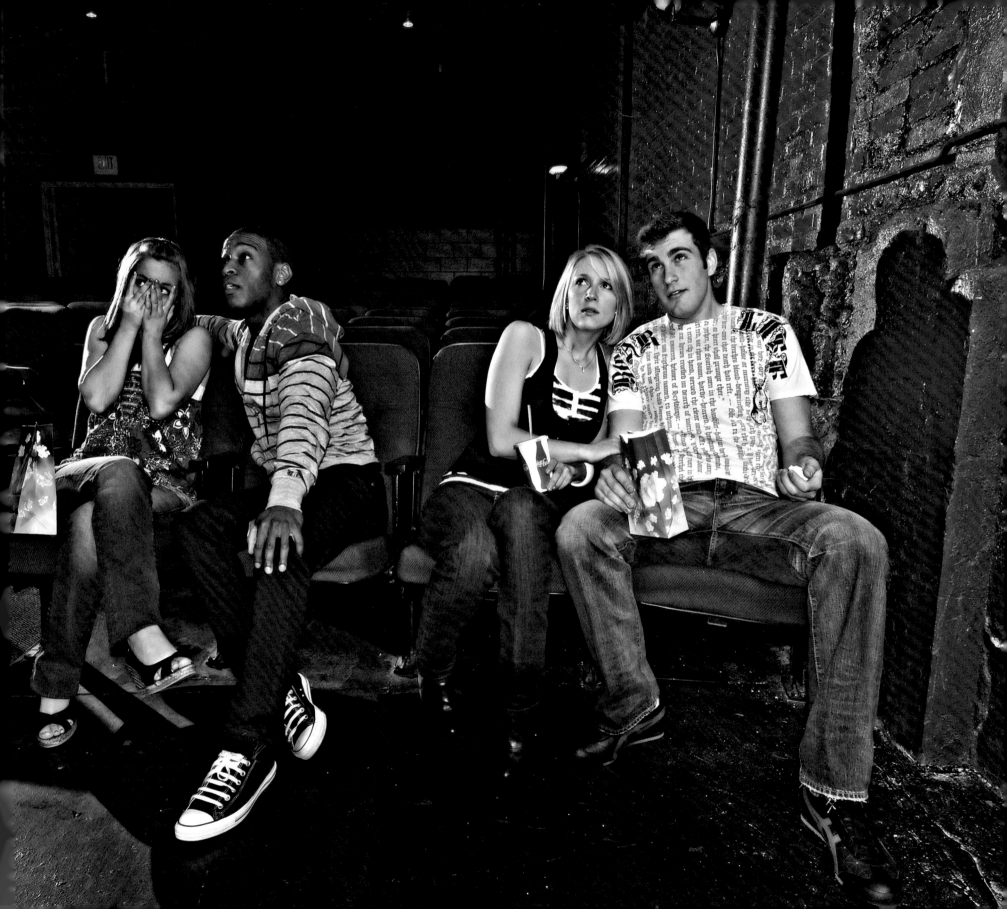

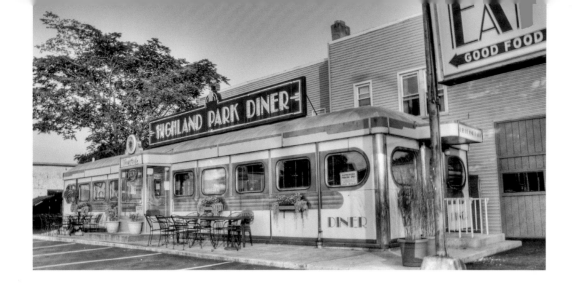

HIGHLAND PARK DINER *(above)*
Rochester
The Highland Park Diner is a popular spot to grab a quick meal. 📷 **MARY SHELSBY**

INSPIRED *(top right)*
Downtown Rochester
Layin' it down at the Big Tent during the Rochester International Jazz Festival located next to the Eastman Theatre. The tent was erected for a temporary hall while the theater was being renovated. 📷 **AARON WINTERS**

DRUM SPLASH *(right)*
High Falls Garage
Gary Foster of The Sunstreak pounds on his drum set during the filming of their music video. 📷 **RICH PAPROCKI**

STARRY NITE *(opposite)*
Universtiy Avenue
Starry Nite Cafe is a favorite spot for a cup of coffee or a light lunch. The mural on the wall often reflects off the table tops at certain times of the day. 📷 **DON MENGES**

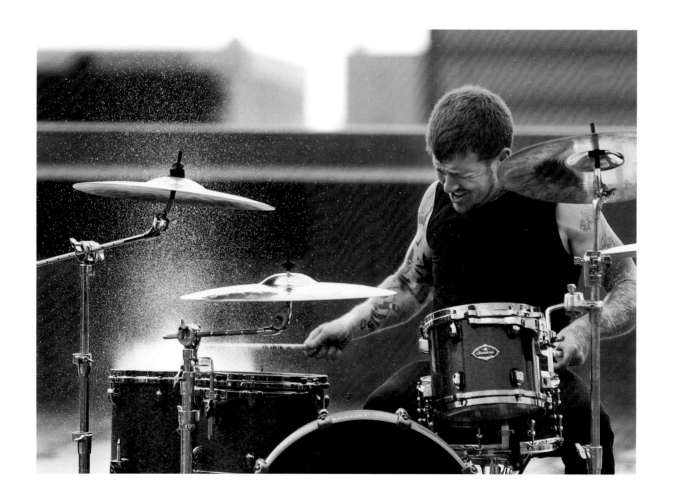

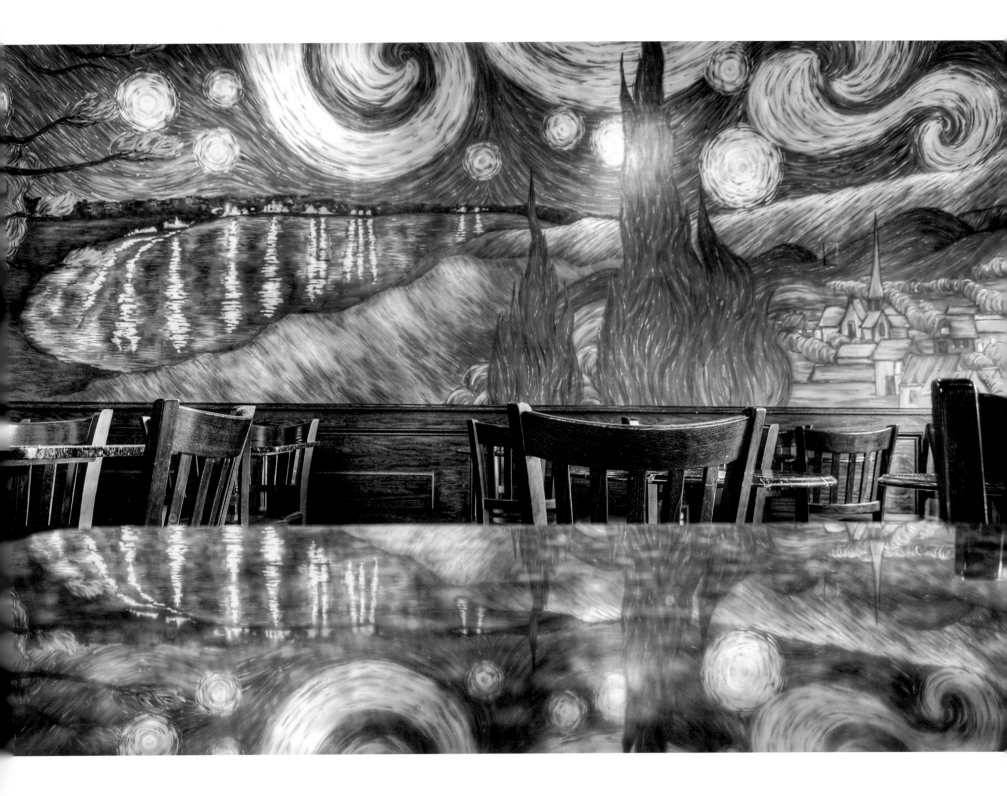

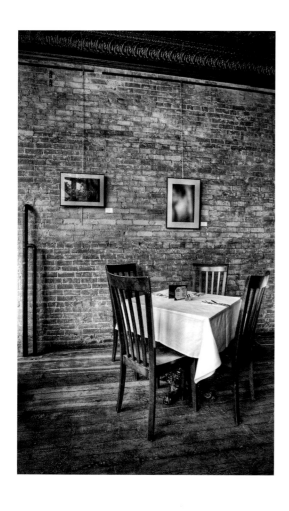

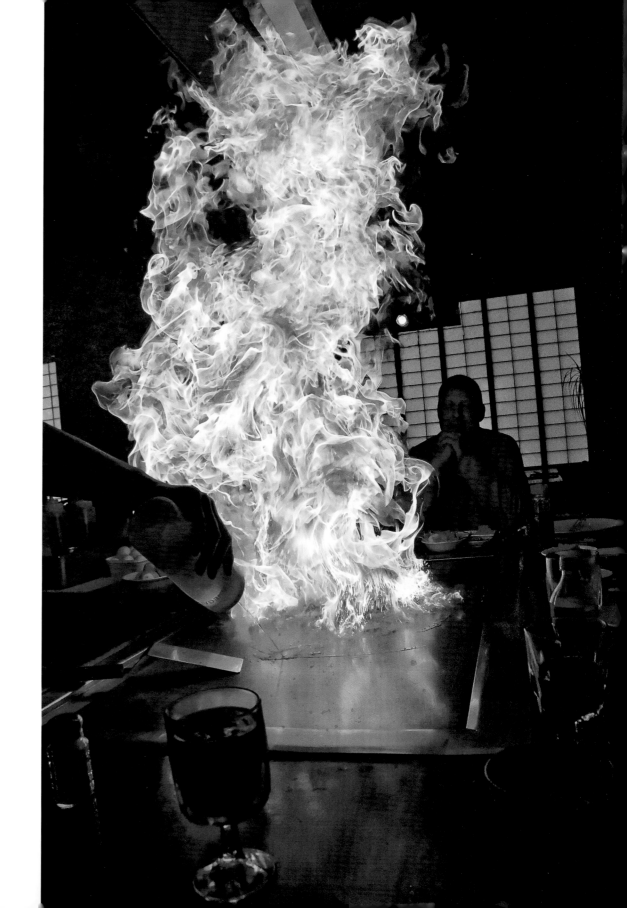

"Although small, the space is intimate. A very private atmosphere can be yours.
— DON MENGES/PRIVATE PARTY

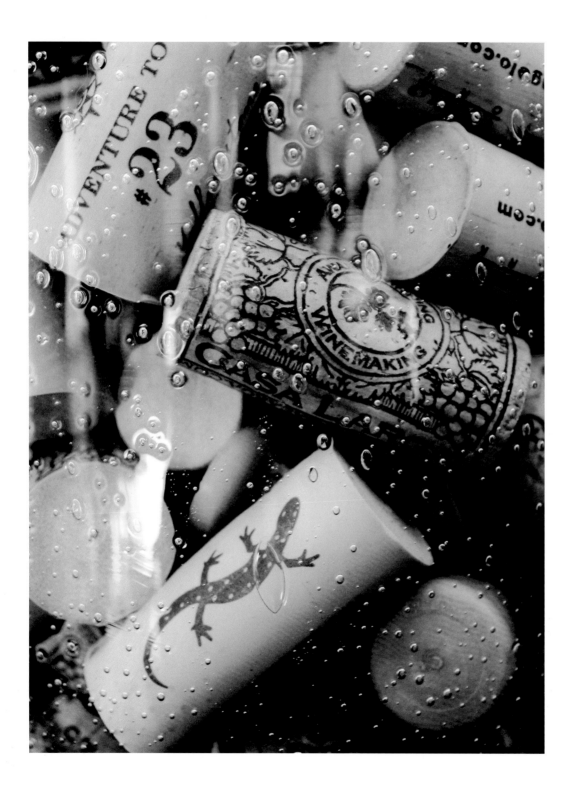

PRIVATE PARTY *(opposite left)*
Edibles on University
Located in the locally famous Flat Iron Building, Edibles is one of Rochester's finest and most unique restaurants. 📷 **DON MENGES**

HIBACHI CALIENTE *(opposite right)*
Bring the Heat! 📷 **ELIUD RODRIGUEZ**

CORKS *(left)*
Irondequoit
I took this photo of a glass container full of corks, many from local wineries. 📷 **SHERRY GRIFFO**

CHEESEBURGER GARBAGE PLATE *(below)*
Nick Tahou's
Garbage Plate: A Study. 📷 **JONAS WILSON**

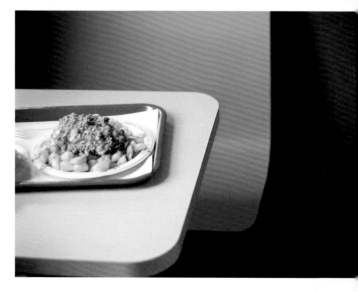

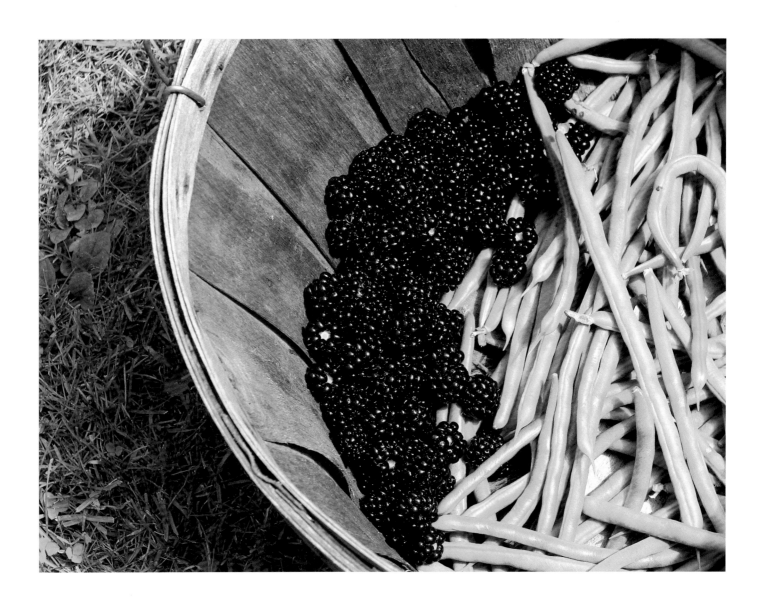

SUMMER HARVEST (above)
Webster
Some blackberries and beans from our garden.
I love the colors together. 📷 **KRISTEN KOEHN**

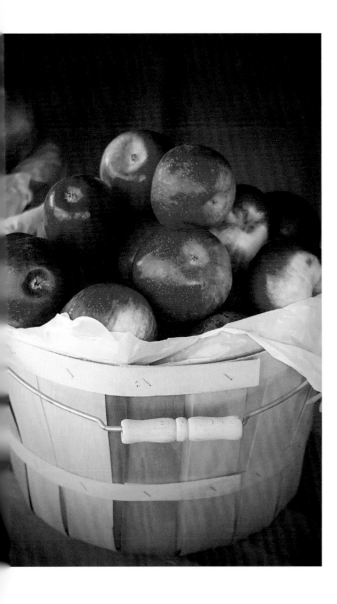

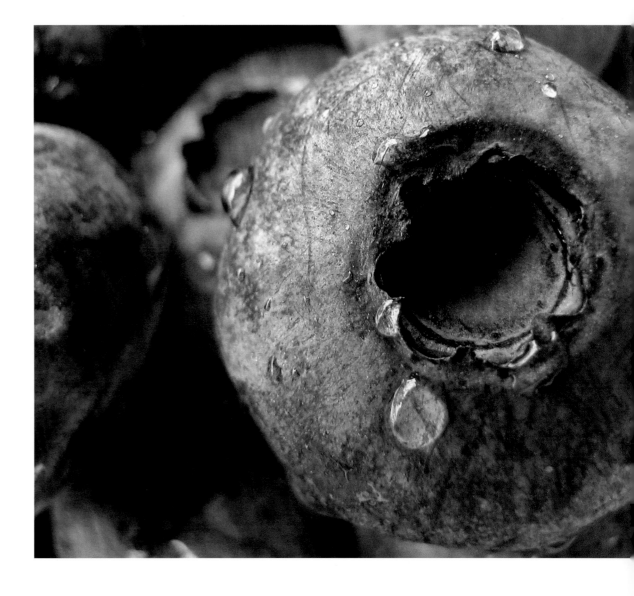

APPLES TO APPLES *(above)*
Hilton
A basket full of tempting treats at Kelly's Farm
Market! 📷 **STEVEN GEER**

★ **BLUE AND WET** *(above)*
Come mid-July, local farms in the Rochester
area have an abundance of blueberries ripe for
pickin'. 📷 **KELLY LUCERO**

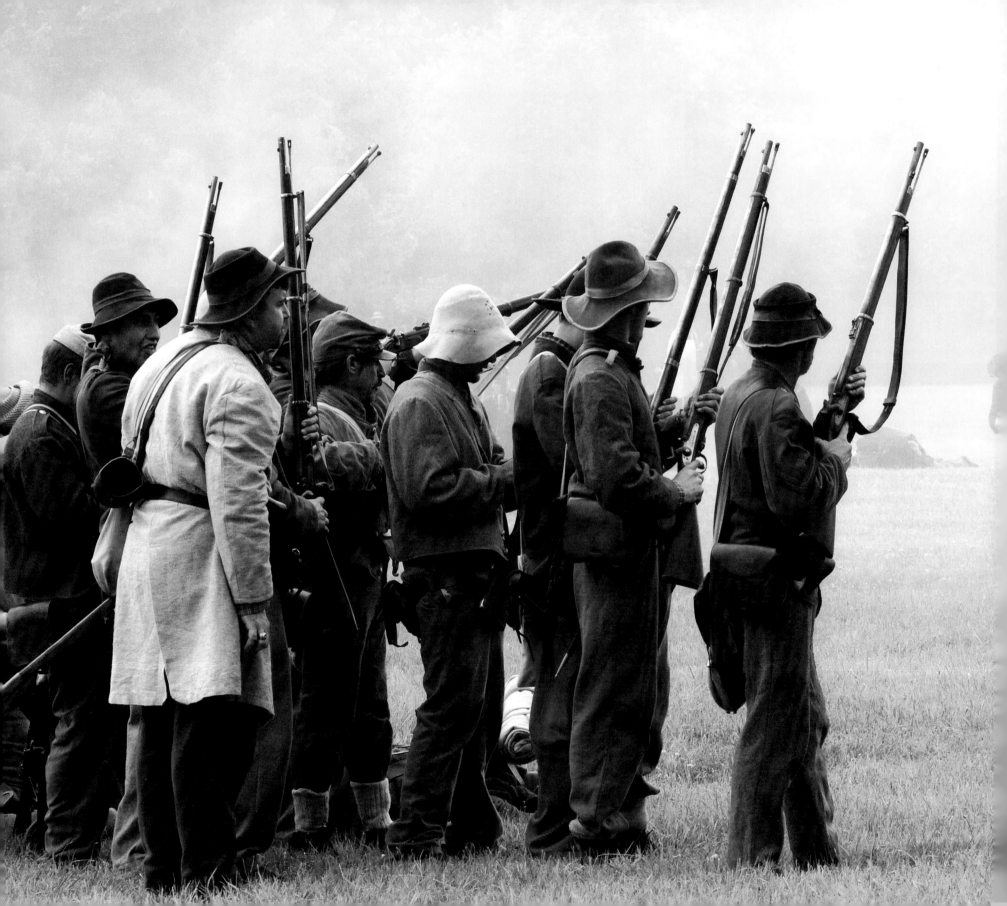

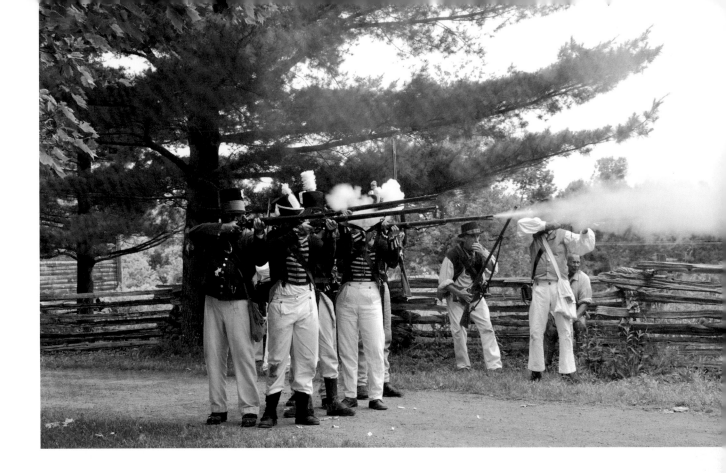

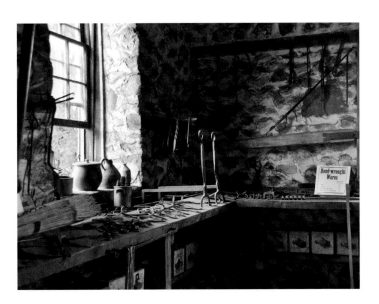

FIRE *(above)*
Genesee Country Village and Museum
Reenactment of the War of 1812.
📷 **MARY CHURLEY**

**INSIDE THE
BLACKSMITH'S SHOP** *(left)*
Genesee Country Village and Museum
The lack of artificial lighting gives this shot a
natural glow. 📷 **MARY CHURLEY**

RUN FOR COVER *(far left)*
Mumford
This battle scene was captured during the
Civil War re-enactment at the Genesee
Country Village and Museum, July 19, 2009.
📷 **JIM FORGER**

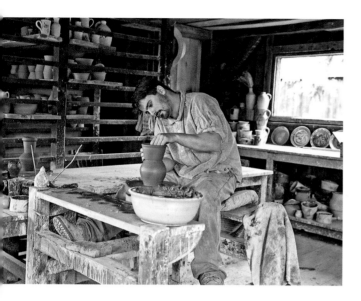

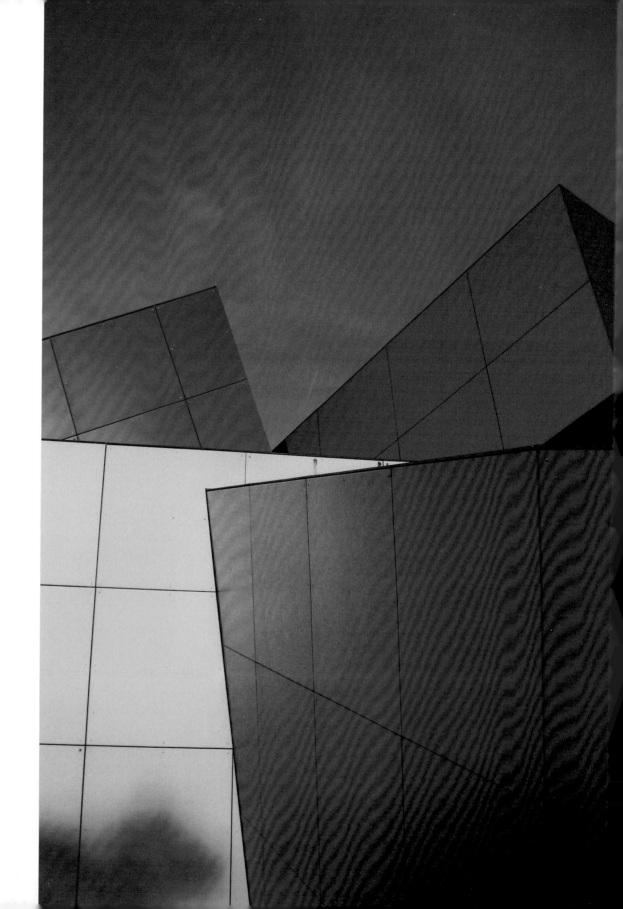

FAITH AND BEAUTY (left)
Holy Apostles Church, Lyell Avenue
I love the way lighting comes through the glass
panes. 📷 **BRIAN ONEIL**

POTTER (opposite top)
Potter making pots at Genesee Country Village
and Museum. 📷 **DAVE VALVO**

CRAFT NIGHT (opposite bottom)
My son and so many other kids love to
eat, play, and create at Melon Bean Eatery.
📷 **HOLLY FARRELL**

BLOCKS (opposite right)
Blocks sculpture outside of the Strong National
Museum of Play 📷 **SARA HUGHES**

Photographer Directory

Capture Rochester was made possible by local photographers who were willing to share their talents with the rest of us. Here's a list of everyone you'll find in these pages and on the DVD. If you know any of these folks, give them a ring and say thanks for the great book!

(Photographers with Web sites in following list.)

RITA AGOSTINELLI
ASHLEY AINLEY
ANTHONY ALBANO
EDWENA AMANUEL
MYA AMANUEL
STEVE AMICO
JENNIFER AMICO
WINNIE ANKRUM
KOREEN APPLEBY
LESLIE ARDUSER-BROGAN
CINDY ARENA
JOSEPH ARENA
ERIC ARROYO
BLAIR ASKEY
SALLY ATKINS
MORGANNE ATUTIS
EMILY AU
DANA C. AULTMAN
AMANDA AYERS
CHRIS BACH
CRAIG BAILEY
CINDY BARLOW
SUSAN BARUCH
CINDY BAUER
KRISTIN BEHR
ROBIN BEMENT
KIMBERLY BENEDETTO
CHRISTIAN BENJAMIN
CHRISTINE BERG
LENNY BILLS
SHAWN BISHOP
KAREN BLACK
KARIN BLASCHEK
JAMIE BLASZKOWIAK
LISA BLOSER
KRISTY BRANDON
KEN BREESE
JESSICA BRICK
CATHY BRISTER

SARA BROWN
ELIZABETH BRYCE
KEITH BULLIS
BOB BURDEN
JAMES BURTON
EILEEN CAHILL
JIM CALLAHAN
KARI CAMERON
TRACIE CANTIE
JILL CARLIER
LILA CARNEY
CHRISSY CARPENTER
ERIN CARTER
JENNIFER CASASANTA
TOM CASSIDY
ALEXANDER CHERNYAK
MICHAEL CHMIEL
JILL CHURCH
VICKI CICERO
KRISTIN CLARK
ROBERT CLEMENS
BRIAN CONHEADY
ROBERT CONWAY
NANCY COOK
DELANEY COUGHLIN
MATTHEW CROMWELL
PATRICIA CRONMILLER
CLARA CUCIUREAN-ZAPAN
THOMAS CULLIGAN
PAM CUNLIFFE
M D
TIM DALTON
PAUL DAME
JENNIFER DAME
ARLENE DANDREA
MELISSA DANKO
PRESTON DAVIS
SANDI DEBRUYCKER
HANS DEBRUYN

SARA DELLAQUILA
PAT DIGIACOMO
LENE DIMARCO
EMMA DIMARCO
DEEDEE DIMARCO
LAURIE DIRKX
DOREEN DRISCOLL
JOE DRISCOLL
NADINE DYKES
CHAD EDMONDS
JAN ELY
LYNNE ENGELBRECHT
DEBRA ERPENBECK
LAURIE FAITH
HOLLY FARRELL
DENNIS FARRELL
ROBIN FLANIGAN
PAT FLYNN
RUBY FOOTE
ANDREA FORD
JENNIFER FORRESTER
JILL FRIER
ANDREA FUEHRER
LINDA GANCI
SCOTT GABEL
TOM GARIGEN
DANIEL GEEN
AVA GEREW
JILL GIBNEY
SONDRA GJERSOE
DONNA GOLDEN
BEN GOLDEN
JACKIE GOLDSTEIN
BRIAN GRAY
APRIL GREEN
LESLIE GREGG
TOM GRIFFO
SHERRY GRIFFO
HOLLY GROCKI

TAMI GROTH
LAURA GRUSCHOW
LAURIE GUCK
ROBERT GUYER
LAURA HAHN
MARILYN HALLY
CATHY HANDT
SHANNON HARDER-GRACIE
KEVIN HARDY
APRIL HATHAWAY
MIKE HEBERGER
TRACIE HEISE
MIKELL HERRICK
KEVIN HERRICK
JASMINE HERVAS
ROB HICKEY
LARRY HILF
K HILL
LAURA HITE
KYLE HOBART
TRACI HOGAN
DOUG HOLLAND
T.J. HOUPPERT
DEBORAH HOWARD
SARA HUGHES
BOB HUTCHINS
DAN IPPOLITO
REBECCA IPPOLITO
SUSAN JANOWSKI
DEBORAH JOHNSON
JORDAN JOHNSON
RANDALL JOHNSON
CHARLES JOHNSON
CATHY JOHNSON
ERIC L. JOHNSON
MARITA JONES
CINDY KAROL
NANCY KELLER
KATHLEEN KELLER
TINA KELLY-HOUGHTLING
MAURA KERKEZIS
ROBERT KILMER
FRANK KIRCHGESSNER
DANIEL KLEIN
JULI KLIE
CINDY KLINE
ONNO KLUYT
PRESTON KNOWLES
KRISTEN KOEHN

KEVIN KOEHN
LESLIE KOFRON
TIFFANY KOTA
RON KOWNACKI
NICK LAMENDOLA
SARAH LANGE
ROBERT LANGEN
TYLER LEPAGE
KIM LEDTKE
MICHAEL LEMPERT
SAM LEMPERT
FRANK LIBERTI
ROBERT LITOLFF
GANNON LONG
JIM LONGUILLO
WILLIAM LYLE
AMY LYONS
SEAN MACIEJEWSKI
TERRY MAHONEY
RON MARCILLE
NATASHA RATH MARCUS
ASHLEY MARIE
RENEE MARZOVILLA
BONNY MAYER
CAROL MCALPINE
LINDA MCANDREWS
FRANCES MCCABE
ERIN MCCARTHY
JANA MCCUTCHAN
RYAN MCDONELL
STACEY MCGRAIN
MEGHAN MCNAMARA
ANNE MEAGHER
PAUL MENDEZ
MICHAEL MENDOZA
JIM MENG
KAREN MERRITT
MERRILL MEY
BECKY MEYERS
ADAM MILAK
MICHELLE MILLIMAN
DAVID MITCHELL
JULIE MOHANLALL
MARY MOON
CONSTANCE MOORE
BARBARA MOREY
SANDRA MORSCH
LAUREN MULDOON
DENNIS MULHEARN

SHEILA MUMPTON
LAUREN MURACO
JIM MYERS
KATHLEEN NAGLE-ROIDES
SHARON NEVEU
TODD NEWLAND
SUZANNE NICHOLAS
BETH NIELSEN
KERRY O'CONNOR
KEVIN O'LEARY
SHERYL O'REILLY
SANDRA O'MEARA
ELIZABETH OSBORNE
D P
JOEL PAIGE
MIKE PARK
YVONNE PARKER
LAUREN PARKER
KARLENE PARSHALL
DAVID PAXSON
GLENN PECK
AARON PEER
KELSEY PERRINE
SUSAN PERRY
ELAINE PERRY
BERNI PETERS
JIM PETRILLO
JACK PETZ
TOMMIE PIER
DEBORAH PIERCE
KIMMYLEE PITULEY
SAMANTHA PLESZEWICZ
KYM POCIUS
DAN PRICE
LORI PRINCE
DARLENE PRITCHARD
GAIL QUATAERT
ALEX QUATAERT
DIANA RAPP
TRENT RASCOE
TERRI RAWNSLEY
MARK REA
CHRISTINE REUTER
BONNIE REYNOLDS
TERRY RIORDAN
ROBERT RITCHIE
JESSICA RITCHLIN
THOMAS RODRIGUEZ
MEGHAN RODWELL

BRITTANY ROGERS
MARTIN ROGERS
SANDRA ROTHENBERG
JAY ROWE
DICK ROWE
KAREN RZONCA
MARCI S.
ADELA SACKLEY
MELISSA SALGADO
JONI SANDFORD
SEAN MCGINNIS SCANLON
CHET SCERRA
JOE SCHAUB
LOU SCHNEIDER
TINA SCHREIB
BILL SCHUBMEHL
ROBERT SCHULZ
PETER SCHWARZ
LAURENCE SCHWEICHLER
DAVID SCRIBNER
KRIS SHANAHAN
AJ SHARLOW
AMANDA SHARPE
HANK SHAW
JON SHEEHAN
JAMES SHERRON
NASIR SIDDIQI
ALOUN SIHARATH
KATRINA SILVA
ANTHONY SIMMONS
ROBERT SIMON
STACY & JEFF SIMPSON
DAVID SLOMAN
MAGGIE SMITH
EDWARD SNYDER
MARY F. SPACHER
BONNIE SPEAR
LYNN SPRIGGS
HANNAH SQUIRES
PATTI STEEB
GARY STEELE
VERONICA STEMP
TRACIE STRONG
KAREN STRUCZEWSKI
SCOTT SULLIVAN
KRISTEN SWING
BRENT SWITZER
ANTHONY SYRACUSE
PAUL SYZDEK

ROSS TALLENTS
PATTY TAUSCHER
KIMBERLY TAYLOR
MARC TAYLOR
THERESA THOMAS
SANDI THOMAS
RON THOMAS
MARIANNE THOMPSON
PETER THOMPSON
RICK TIERNAN
PEGGY TIRRELL
DAVID TOPA
ROBERT TORZYNSKI
MELISSA TRAUGOTT
CAROL TRUESDALE
VICTORIA TUCCI
KATE TURNER
CHELSEY TUTTLE
TAMMY TUTTOBENE
KATHLEEN UDAVCHAK
THEO VALENTINE
JESSA VANANTWERP
DOUGLAS VANDERWEGE
CARLY VECCHIOTTI
LESLIE VECCHIOTTI
CHRISTINE VELLA
NANCY VENDEL
KEVIN VICKERS
SONIA VIEIRA
ANNE VINCENT
MICHAEL WALKER
CASEY WALSH
STEVEN WALSH
TOM WALTON
DAVID WARNER
PHILIP WATKINS
LAURIE WEBB
AMANDA WEBSTER
JIM WEICK
ADAM WELCH
ROGER WELCH SR.
KAREN WESTON
VALERIE WEYAND
CHERIE WHIPPLE
SEAN WHITCOMB
STEPHEN WHITCOMB
ERIN WHITCOMB
TED WHITE
KRIS WHITEMAN

MOLLY WILSON
JONAS WILSON
LUCY WILSON
MAURA WINNICK
MATT WITTMEYER
SUSAN WOLFE
CHRISTINE WOODWARD
JENNIFER YOCKEL
PAULA ZACK
JOSEPH S. ZELAZNY
ROBERT ZIEGLER
SIMON ZMUIDZINAS
HEATHER ZONNEVILLE
JULES ZYSMAN
MICHELLE ALDRICH
MARTIN BOOR
KATHLEEN BRUNDEGE
MIKE CARDELLA
KIMBERLY CORDARO
CARRIE CUSKER
MARINUS DE WIT
MARK DOYLE
STEVE FLAGG
MARK GRILLO
CHARLENE HAUST
CHRIS JONES
ANNALIS KAMINSKI
JACKIE KENNY
ERIKA KLEPPAN
TONY KOSCUMB
BUNNY KRAMER
JANE MILLER
CARLA MOJICA
RANDIE MURDOCK
TRACY NALEWALSKI
BRIAN ONEIL
KELVIN OSBORNE
MARK PAPKE
DAVE PAPROCKI
KATHY PILATO
MATT RIECK
JANINE SANGER
LAURIE SMITH
JOEL SWARTZ
SUSIE SZCZEPANSKI
JAMES TRENTON
ANDREW VON RATHONYI
MELISSA WHITE

If you like what you see in the book and on the companion DVD, be sure to check out these photographers' Web sites. A few even sell prints so you may be able to snag your favorite photos from the project to hang on your wall.

MARSHALL ASHWORTH
marshallcashworth.com

EILEEN ASKEY
myspace.com/eileenaskeypix

RHIANNON BAIRD
forgottenchild40977.deviantart.com

PAUL BAKER
flickr.com/photos/pbaker/

JOY BENNETT
joybennett.com

DICK BENNETT
dickbennettphotos.com

MATTHIAS BOETTRICH
mboettrich.com

LYDIA BOETTRICH
masterkamon.webs.com/

BRIAN BOORMAN
boorman.us

BARBARA BOYCE
anothertimeantiques.com

RYAN BRADFORD
flickr.com/ryanbradford

WILLIAM BUCKLEY
photos.buckleyw.net

KRISTIN BUFFER
kristin-buffer.fineartamerica.com

ANDREW BURCH
lineplace.tumblr.com

DAN BUSCH
flickr.com/photos/dannybusch/

BRETT CARLSEN
brettcarlsen.tumblr.com

PATRICK CASTANIA
flickriver.com/photos/patrickcastania

CHRISTOPHER CECERE
rochesterccphotography.com

ETHEL CHADWICK
bagelsandblessings.com

ANDREW CHATMAN
flickr.com/photos/macnmotion/

JOANNE CHURCHILL
joannesfotos.com

MARY CHURLEY
flickr.com/photos/churleyton/

MATTHEW CONHEADY
nyfalls.com

LISA COOK
flickr.com/photos/26068576@N06/

CHRISTOPHER COVE
chriscove.photoblink.com

MICHAEL D'AVIGNON
flickr.com/photos/wickedmartini/

DAN DANGLER
flickriver.com/photos/dangler/

LUTICHA DOUCETTE
flickr.com/photos/78423912@N00/

SARAH EMBREY
xkyana13.deviantart.com/

CHRISTINE FARNUM
farnums.com

LISA FAUBER
tigerwingsphotographyii.shutterfly.com/

CHRIS FENISON
chrisfenison.com

ANGEL FISCHER
halodesigns.net

JIM FORGER
flickr.com/photos/jforger/

KENNY FRISCH
community.webshots.com/user/slickk123

MICHAEL FRY
michaelfryphotography.com

BENJAMIN GAJEWSKI
northstreetstudios.exposuremanager.com/g/

STEVEN GEER
stevengeer.com

JEFF GEREW
C7Photo.com

MIKE GOVERNALE
rochestersubway.com

JOE GRANITA
granita.zenfolio.com

MICHAEL GROVER
flickr.com/photos/grovedawg/

MARILYN GUADAGNINO
abandontheherd.com/AbandonTheHerd/Welcome.html

ROBERT GUZMAN
thebmwrider.blogspot.com/

DONALD HAMPTON
donaldhampton.blogspot.com/

JEFF HAMSON
flickr.com/photos/mightyslam/

MICHELE HEINE
moneyforstuff.wordpress.com/

MATT HOLMES
flickr.com/photos/mattsplaylist/

SCOTT HOOKER
scotthookerphotography.com

JOSH JONES
joshjonesphoto.com/

CHRISTOPHER KELLER
facebook.com/home.php#/DreamMaster1973?ref=profile

DAN KILMER
nyspic.com

MICHAEL KING
flickr.com/photos/mike_king/

ALLEN KING
drvpro.com

JUDY KNESEL
flickr.com/photos/jknesel/

CHRISTOPHER LAROSA
photo.clarosa.info/

HILARIE LAMBERT
hlambert.com

MARY ANN LANA
flickr.com/photos/maryann712/collections/

TIM LEVERETT
flickr.com/photos/timleverett

STEVE LIGUORI
stevelig.com

AARON LONG
flickr.com/photos/alongphotograph/

TINA LONGWELL
redbubble.com/people/Tinany63

EVAN LOWENSTEIN
greenvillage.us

KELLY LUCERO
freewebs.com/thegardenpathphotography/

LAUREN MACKSON
flickr.com/photos/laurenhasforce/

PETER MALFATTI
malfatti.net/213

AMANDA MCFAUL
flickr.com/photos/aphoenixrain

DON MENGES
mengesphotos.com

RODGER MERRITT
rodgermerritt.com

REGINA MIGLIORINI
flickr.com/photos/ginamig

EMILIE MONEFELDT
flickr.com/photos/ejmono

JOSEPH MOROZ
picturerochester.com

KEVIN O'BRIEN
flickr.com/photos/24344744@N03/

AMY O'KEEFE-HYSER
amyoh.com

MELISSA PAKUSCH
melsphotography.livejournal.com

JEFFREY PALM
jpalmphotography.com/

RICH PAPROCKI
richpaprockiphotography.com

EMILY PARTRIDGE
flickr.com/photos/e_christine/

ERICA PERRY
flickr.com/photos/destinationdiscovery/

MARTIN PINKER
flickr.com/photos/martypinker

ANGELA POSSEMATO
angeposs.zenfolio.com

KIM PRICE
flickr.com/photos/kpricewicked/

JORDAN PRICE
flickr.com/photos/29928617@N03/

CAURIE PUTNAM
caurie.com

LINSEY RAMPELLO
flickr.com/photos/linseyrampello

BOB REEVES
northerncraftsman.vpweb.com

MICHAEL REIDOSH
freewebs.com/mreidgraphics/

DONNA RENELT
flickr.com/photos/drenelt/

JOE RICCI
flickr.com/jrlasers

BRITTON ROBBINS
photo.brittonrobbins.com

NICHOLAS ROBINSON
xelex.net/nyrphotography/

ELIUD RODRIGUEZ
pixartprophotography.com

LEANNE SARUBBI
flickr.com/photos/leanne42/

DANIELLE SAUERS
dhphoto.origin-nknwn.co.uk

AARON SCHOCK
flickr.com/photos/haccamopooly/

DAVID SCHROEDER
dps7777.redbubble.com

MAX SCHULTE
DemocratandChronicle.com

BRIAN SCIARABBA
gargimil.dotphoto.com

DAVID SELBY
learnslr.com

DAMIAN SERAFINE
serafinephotography.com

NIGEL SHAW
nigelshaw.smugmug.com

MARY SHELSBY
RochesterScoop.com

CARL SMITH
thecolorblindphotographer.com

SIERRA SPARKS
twitter.com/ladynevada

JASMINE STAFF
redbubble.com/people/jasminelee

ROBERT STEWART
robertstewartphotography.shutterfly.com/26

GAVIN THOMAS
gavinthomasphoto.com

MICHAEL TOMB
michaelino.com

DAVE VALVO
DaveValvo.com

CHARLES VAUGHN
flickr.com/photos/26861627@N07/

SHERIDAN VINCENT
SheridanVincentPhotography.com

PAUL WALLACH
meetup.com/rochester-naturephotog/

BRENDA WASHINGTON
bjw-photo.com

ED WELCH
edwelchphotography.com/gallery/main.php

JASON WILDER
flickr.com/photos/jasonspaceman/

CHRISTOPHER WILLIAMS
cwwphotos.com

NICK WILSON
nickwilson159.com

AARON WINTERS
flickr.com/photos/steeladw/

CLAIRE ZARCONE
clairehawley.com

ALEX ZYUZIKOV
az-design.net

ANDREW BLOOM
flickr.com/photos/lollypoppictures

RICH ENGELBRECHT
rengel134.redbubble.com/

ANDREA HUGHES
melonbeaneatery.blogspot.com

WILLIAM KERR
flickr.com/photos/walking_trails/

TIMOTHY MALONE
timmalonesports.com

APRIL MCEVOY
aprilmcevoy.webs.com

KATHY SALVATORE
frptlady.multiply.com

PRAMODH SENEVIRATNE
pramodhsphotos.com

Chapter Introduction Photographers

The many photographers listed below helped shape the introduction page of each chapter. Many thanks to these fine folks (listed in order of appearance from left to right, top to bottom):

Friendly Faces: Andrew Chatman, Deedee Dimarco, Michael Fry, Rob Hickey, Lydia Boettrich, Theresa Thomas, Kim Price, Michael Fry, Joel Paige, Jules Zysman, Rob Hickey, Jeff Hamson, Emma Dimarco, Robert Kilmer, Jeff Gerew, Trent Rascoe, Michelle Milliman, Holly Farrell, Jeffrey Palm, Jennifer Forrester, William Kerr, Jamie Blaszkowiak, Sherry Griffo, Brian Conheady, Jeff Hamson, Ron Thomas, Tim Leverett, Nadine Dykes, Don Menges, Thomas Rodriguez, Jeff Gerew, Timothy Malone, Timothy Malone

Everyday Life: Alex Zyuzikov, Britton Robbins, Kim Price, Ruby Foote, Robert Kilmer, Kim Price, Kathleen Nagle-Roides, Jim Forger, Frank Liberti, Tim Leverett, Amanda McFaul, Victoria Tucci, Kristen Koehn, Craig Bailey, Jim Forger, Alex Zyuzikov, Angela Possemato, Michael Tomb, Aaron Winters, Meghan Rodwell, Karen Black, Andrew Bloom, Aaron Winters, Andrew Bloom, Peter Malfatti, Mary Moon, Nigel Shaw, Sherry Griffo, Aaron Winters, Debra Erpenbeck

Schools & Institutions: Jeffrey Palm, Robert Langen, Kim Price, Marshall Ashworth, Nadine Dykes, Dan Busch, Christopher Cove, Don Menges, Kelly Lucero, Tim Leverett, Mary Shelsby, Debra Erpenbeck, Sherry Griffo, Paul Wallach, Robert Kilmer, Timothy Malone, Rob Hickey, Don Menges, Linsey Rampello, Sheila Mumpton, K Hill, William Kerr, Christopher Cove, Kevin O'Brien, Tim Leverett, Dan Busch, Dan Busch, K Hill, Dan Busch, Christopher Larosa, Joseph Moroz, Jeff Hamson

Sports & Recreation: Matthew Conheady, Beth Nielsen, Christopher Cecere, Dick Rowe, Cindy Arena, Christopher Cecere, Jeff Gerew, Jeff Hamson, Jim Petrillo, Holly Farrell, Jim Petrillo, Christopher Cecere, Jim Petrillo, Robert Langen, Jim Petrillo, Kim Price, Benjamin Gajewski, Judy Knesel, Steve Liguori, K Hill, Paul Wallach, Dennis Mulhearn, Jeff Gerew, Kym Pocius, K Hill, Peggy Tirrell, Mikell Herrick, Robert Clemens, Andrew Chatman, Aaron Winters, Rich Engelbrecht, Matthias Boettrich

Scapes Of All Sorts: Joel Paige, David Selby, Christopher Cove, Lydia Boettrich, Aaron Winters, Lisa Fauber, Angela Possemato, Matthew Conheady, Christopher Williams, Jon Sheehan, Kim Price, Aaron Winters, Steve Liguori, Sheridan Vincent, Matthias Boettrich, Christopher Williams, Patrick Castania, Kim Price, Aaron Winters, Aaron Winters, Sheridan Vincent, Tom Cassidy, Steve Liguori, Angela Possemato, Beth Nielsen, Aaron Winters, Sheridan Vincent, Rich Paprocki, Aaron Winters

Pets: Laurie Dirkx, Jennifer Forrester, Kym Pocius, Patrick Castania, Kris Whiteman, Carla Mojica, Lisa Fauber, Matthew Conheady, Laurie Dirkx, Michael Tomb, Christopher Cove, Jeff Gerew, Laurie Dirkx, Valerie Weyand, Donna Renelt, Patrick Castania, Angel Fischer, Joel Paige, Andrew Chatman, Matthias Boettrich, Brian Sciarabba, Laurie Dirkx, Mikell Herrick, Judy Knesel, Britton Robbins, Eileen Askey, Eileen Askey, Jennifer Forrester, Jeff Gerew, Alex Zyuzikov, Aj Sharlow, Lisa Fauber

Newsworthy: Dan Busch, Dan Busch, Brian Oneil, Dave Valvo, Eliud Rodriguez, Maura Kerkezis, Tom Griffo, Rob Hickey, Alex Zyuzikov, Doug Holland, William Kerr, Jon Sheehan, Sandi Debruycker, Eliud Rodriguez, Jessica Brick, Michael Tomb, Glenn Peck, Michael Tomb, Charles Vaughn, Eliud Rodriguez, Eliud Rodriguez, Dan Dangler, Kathy Salvatore, Rob Hickey, Rich Engelbrecht, Angel Fischer, William Kerr, Andrea Ford, Sherry Griffo, Ruby Foote

Arts, Culture & Food: William Kerr, Don Menges, William Kerr, Suzanne Nicholas, Aaron Winters, Sally Atkins, Don Menges, Judy Knesel, Aaron Winters, Kelly Lucero, Tim Leverett, Christine Berg, Mike Park, Emilie Monefeldt, Dan Busch, Valerie Weyand, Tim Leverett, Valerie Weyand, Judy Knesel, Dan Dangler, Glenn Peck, Joseph Moroz, Natasha Rath Marcus, David Schroeder, Andrew Bloom, Aaron Winters, Dan Busch, Aaron Winters, William Kerr, Tim Leverett, William Kerr, Angela Possemato

Prize Winners

When picking from 9,296 photos, it's difficult to nail down what separates the best photos from the rest — especially when so many photos are so good. To help, we enlisted thousands of local folks to vote for their favorite shots. The response was epic: almost 1 million votes were cast. The voting helped shape what would eventually be published in this book. Along the way, the votes produced the prize winners below. Here's a brief explanation of how prizes were determined:

People's Choice: This one's as simple as it sounds. The photo that gets the highest score, according to how folks voted, is given this award. We picked a different winner for the Editors' Choice award, but we think local folks are pretty smart too, so we wanted to reward the photo that people like the most. This is also one of the ways we figure out the grand prize.

Editors' Choice: This award goes to the photo our editors determine to be the best in a chapter. Sometimes it'll be a photo that fits the chapter so well that it stands out above the rest. Other times it could be a photo that is technically excellent. Our editors poured over submitted photos daily during the contest and were constantly thinking about which photo should be the "Editors' Choice." Our editors also helped pick the grand prize photo from a pool of People's Choice photos.

People's Choice in Friendly Faces
PHOTO BY JOEL PAIGE
page 5

People's Choice in Everyday Life
PHOTO BY REGINA MIGLIORINI
page 26

People's Choice in Schools & Institutions
PHOTO BY DON MENGES
page 30

People's Choice in Sports & Recreation
PHOTO BY MATTHIAS BOETTRICH
page 39

People's Choice in Scapes of All Sorts
PHOTO BY MATTHEW CONHEADY
page 96

People's Choice in Pets
PHOTO BY DAVID SELBY
page 112

People's Choice in Newsworthy
PHOTO BY TOM GRIFFO
page 120

People's Choice in Arts, Culture & Food
PHOTO BY TIM LEVERETT
page 127

Editors' Choice in Friendly Faces
PHOTO BY DEEDEE DIMARCO
page 12

Editors' Choice in Everyday Life
PHOTO BY SEAN MCGINNIS SCANLON
page 20

Editors' Choice in Schools & Institutions
PHOTO BY JEFF HAMSON
page 31

Editors' Choice in Sports & Recreation
PHOTO BY CHRISTOPHER CECERE
page 42

Editors' Choice in Scapes of All Sorts
PHOTO BY DICK BENNETT
page 75

Editors' Choice in Pets
PHOTO BY KIM PRICE
page 117

Editors' Choice in Newsworthy
PHOTO BY ELIUD RODRIGUEZ
page 119

Editors' Choice in Arts, Culture & Food
PHOTO BY KELLY LUCERO
page 135

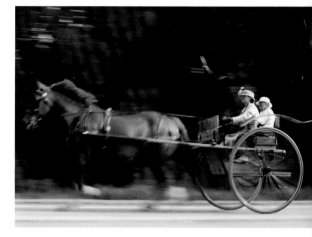
Grand Prize Winner
PHOTO BY PRAMODH SENEVIRATNE
page 53

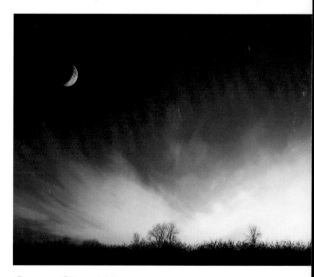
Cover Shot Winner
PHOTO BY CHRISTOPHER WILLIAMS
cover, page 82

Sponsors

The Garden Factory opened for business on March 22, 1974 by Robert and Patricia Martell. Located in Rochester, this family-owned business has grown into one of the largest nursery/garden centers on the East Coast. The Garden Factory takes pride in offering its customers the latest in home and garden décor, annuals, landscaping products and a vast selection of nursery stock.

The Garden Factory is now run by second-generation Martell family members who continue to grow, improve and upgrade the business. "The key to our success is loving what we do, having a great team of employees and our dedicated and loyal customers."

The Garden Factory | 585.247.6236 | www.gardenfactoryny.com

Home Theater | Audio | Camera | Video

Since 1898, three generations of the Rowe family have been serving Rochester and upstate New York with quality products at fair prices with personalized service. In that same spirit Rowe continues to expand our product and service offerings as we grow. Rowe is now pleased to offer custom installation of flat panel TVs and multi-room audio systems. Rowe is proud to offer Rochester a large selection of home theater options, HD TVs and home audio solutions. Rowe's professionals can show you how easy it is to customize any living space today!

Rowe Photo Audio & Video | 585.442.8230 | www.rowephoto.com

St. John Fisher College is an independent, liberal arts institution in the Catholic tradition of American higher education. Guided by the educational philosophy of the Congregation of St. Basil, the College emphasizes liberal learning for students in traditional academic disciplines, as well as for those in more directly career-oriented fields.

The campus is situated on 154 acres with 24 modern building and a friendly campus community of 2,600 full-time undergraduates, 200 part-time undergraduates and over 1,000 graduate students. The College offers 31 majors in the humanities, social sciences, natural sciences, business and nursing, as well as 10 pre-professional programs. Fisher also offers 11 master's programs and three doctoral programs.

St. John Fisher College | 585.385.8000 | www.sjfc.edu

Proving our community is "Made for Living," VisitRochester promotes the greater Rochester area as a place to visit, live, learn and play. VisitRochester urges local residents to invite family and friends to visit the area—from world class arts and culture to 12,000 acres of parkland—there are thousands of reasons to be proud of our community. VisitRochester also encourages individuals belonging to state, regional, national or international organizations to consider inviting their colleagues to "Meet in Rochester!" VisitRochester's convention sales and service staff make it easy, and it's a great economic driver for the community.

VisitRochester | 800.677.7282 | www.visitrochester.com

1152